Oil Painting
Workbook

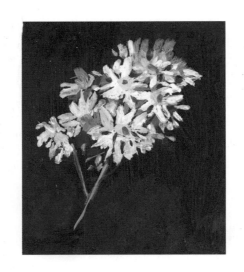

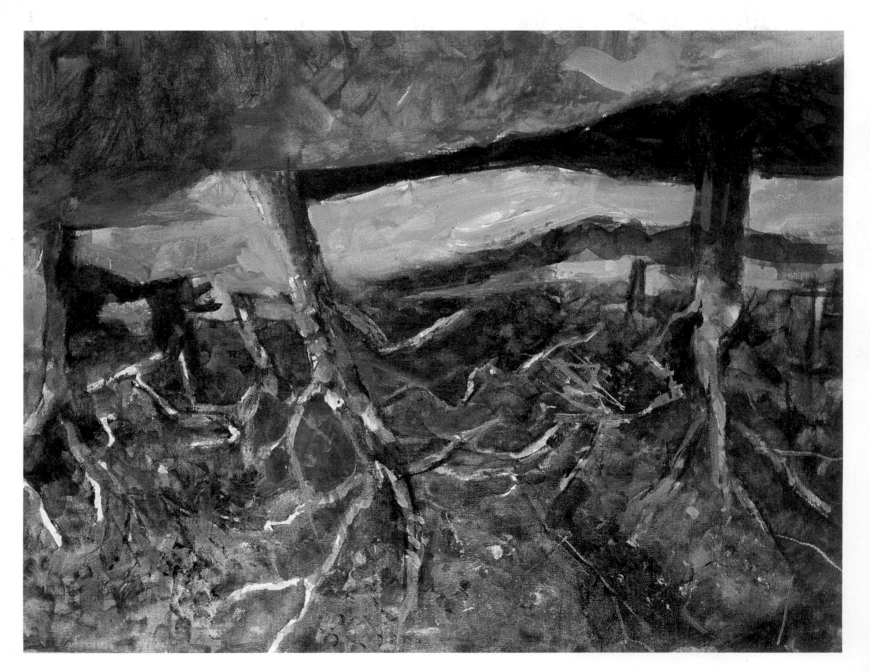

Oil Painting Workbo

Stan Smith

D&C
David and Charles

ACKNOWLEDGEMENTS
I should like to thank Kate Gwynn as associate author and for providing some of the illustrations. Thanks are also due to Winsor & Newton for their generous help with materials.

A DAVID & CHARLES BOOK
Copyright © David & Charles Limited 1999, 2002, 2007

David & Charles is an F+W Publications Inc. company
4700 East Galbraith Road
Cincinnati, OH 45236

First published in the UK in 1999
First paperback edition 2002
New edition 2007

Text and illustrations copyright © Stan Smith 1999, 2002, 2007

A catalogue record for this book is available from the British Library.

ISBN-13: 978-0-7153-2770-8
ISBN-10: 0-7153-2770-4

Printed in Singapore by KHL Printing Co Pte Ltd
for David & Charles
Brunel House Newton Abbot Devon

Visit our website at www.davidandcharles.co.uk

David & Charles books are available from all good bookshops; alternatively you can contact our Orderline on 0870 9908222 or write to us at FREEPOST EX2 110, D&C Direct, Newton Abbot, TQ12 4ZZ (no stamp required UK only); US customers call 800-289-0963 and Canadian customers call 800-840-5220.

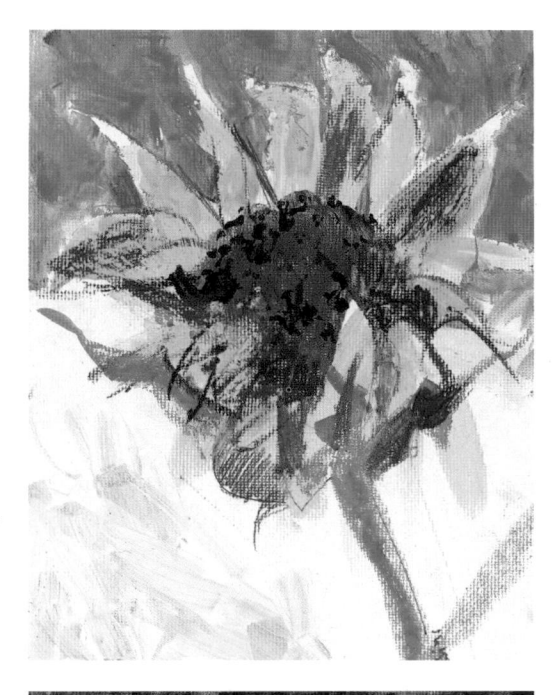

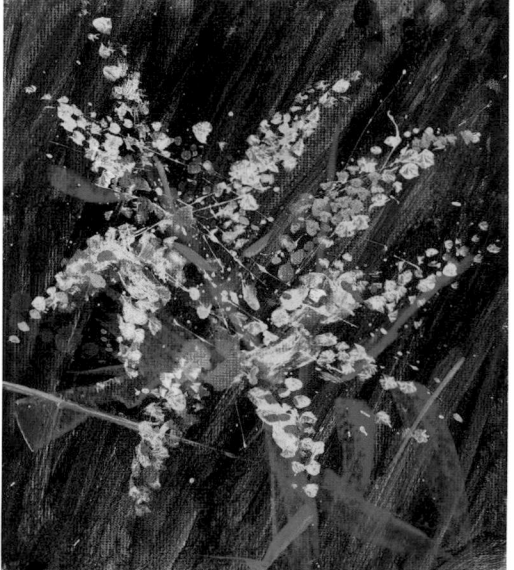

Contents

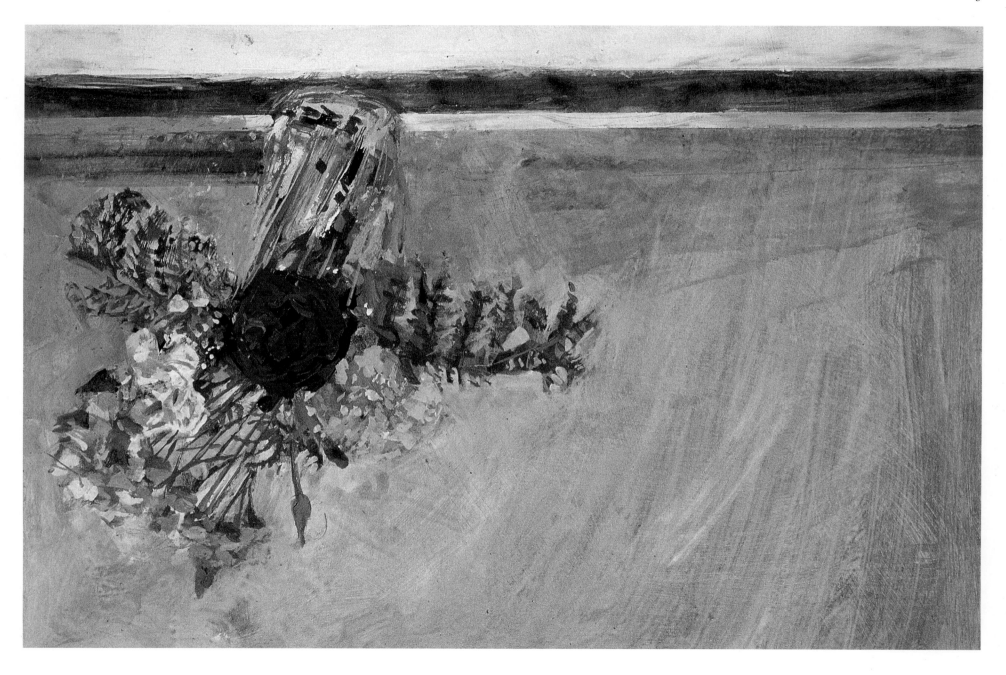

Introduction

The medium of oil paint has been widely used since the fifteenth century and most people are familiar with it, since there are so many well-known examples of oil paintings in art galleries and museums as well as reproductions in books.

Oils have always had the reputation of being the professional artist's medium, yet they really should be the first medium that springs to mind when the amateur artist considers taking up painting for his or her own pleasure and enjoyment. Oil paint has a versatility no other medium can match, and its slow drying time means that it can be extensively manipulated on the canvas, allowing ample time for reflection and adjustment. If you make a mistake, you can simply scrape off the wet paint and start again, or work over the paint once it is dry. Of all the painting media, oil paint has the most physical, tactile feel. It has a rich, buttery consistency when used straight from the tube, which means you can build it up on the canvas and move it around, and it retains the marks made by the brush, which can be very expressive. Conversely, it can be thinly diluted with turpentine and used almost like watercolour to create delicate stains of

BOUQUET

colour. Last but not least, there is something about the smell of oil paint, as well as all the paraphernalia that goes with it, that gives one a true sense of being part of the long tradition of art and artists.

With painting, as with any art form, you need to be able to think about several things at once. It's a bit like playing the piano, where you are required to play different rhythms and notes with each hand, read the music with your eyes, use the pedals with your feet, and interpret the music with your heart. When painting any subject you have to consider colour, form, texture and composition, amongst other aspects, in addition to physically manipulating the paint on the canvas and, most important of all, interpreting your subject and expressing your feelings about it.

This workbook takes you through each part of the painting process in a logical sequence. From the very beginning, making the initial tentative marks with paint, the first five lessons are devoted to the basic tenets of painting. These lessons will provide you with the foundation you need to tackle more complex subjects. Eventually, with practice and experience, these tenets will become second nature.

Your response to a colour that was a challenge to mix initially will now be much quicker and you will know how to modify it to suit your purposes, whereas before it would have taken several attempts. You cannot possibly learn everything at once, so be patient and concentrate on one aspect at a time. At first, your progress may seem haphazard and you may find yourself taking steps backwards as well as forwards. Sometimes you will find that many hours of effort will reap little reward, but that effort will not have been wasted because it will add to your repertoire of skills.

Remember that you don't necessarily have to master one area before you move on to the next. This book has been designed to be worked through in a logical sequence, but if you prefer to dip into it as the fancy takes you, that's fine. Whether you master the ability to create three-dimensional form before or after you understand the subtleties of colour really doesn't matter. The most important thing is that you enjoy painting. It may not necessarily be easy, but like all skills it takes practice and as you practise your skills will become more refined and you will see an improvement in your work.

Materials and Equipment

Oil paints have changed relatively little since artists first started using them some five hundred years ago. The only difference is that early artists had to grind their own pigments and mix them with oils and resins, whereas nowadays paints come ready-mixed in tubes. Pictures were always painted on canvas stretched in the studio or on pieces of seasoned wood, whereas now we can choose from a range of ready-made canvases and boards (though many artists still prefer to prepare their own canvases and boards). Life for today's artist is certainly more convenient, but the basic painting requirements remain the same: a painting surface, brushes, paint, and of course, the all-important desire and inspiration needed to record and interpret the world around us.

BUYING WISELY

Nowadays there is such a vast range of oil paints and equipment available that art shops that can be quite daunting and bewildering places! The result is that most of us end up buying far too much 'kit' and this only leads to confusion because it takes longer to become familiar with the materials. It is possible, indeed preferable, to start out with just a few basic colours and materials and then add to them as you gain more experience. If you start with a limited range of colours, for instance, you will quickly become familiar with their characteristics and learn how to mix them together to create a wide, yet harmonious, range of hues. Similarly, using just a few brushes forces you to exploit the full range of marks they can make.

On the opposite page you will find a 'shopping list' of basic materials that will get you started on the exercises in Lesson One. On the following pages you will find more detailed advice about equipment and a more extensive list of recommended colours, enabling you to make a more informed and personal choice about what you need to buy.

WHAT ARE OIL PAINTS?

Oil paints are made from pigments ground with linseed oil, which gives them their characteristically rich, glossy brilliance. The pigments are either naturally obtained from earth materials, minerals or plant extracts, or produced chemically. Raw sienna, for instance, is made from a naturally occurring colour in the earth, whereas viridian is a synthetic pigment.

Some colours are more permanent than others. In other words, certain pigments are more susceptible to fading on exposure to light or discolouring in contact with oxygen in the air. To this end, manufacturers have developed a permanence coding system for their colours. These codes are printed on the tube labels and their key is found in manufacturers' catalogues and leaflets. It's not something you need worry about now, but it is

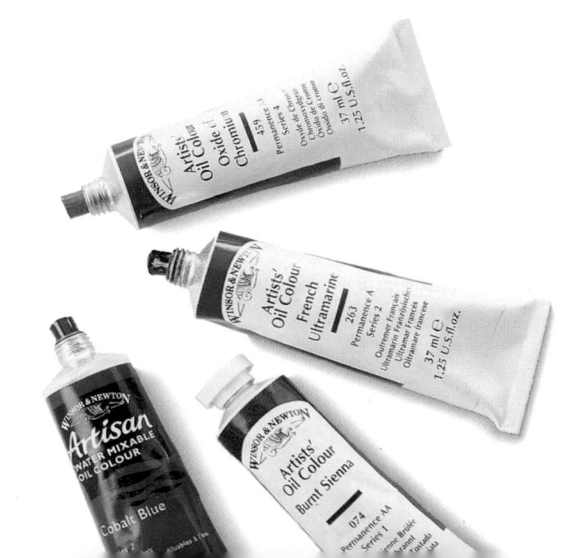

something to be aware of later on.

Oil paints are sold in tubes in various sizes. They are available in two different grades: artists' and students'. Artists' paints are more expensive, due to the better quality of the colour. Students' colours cost less because they contain less pure pigment and more fillers and extenders. You may not notice much difference between the two initially, but if you mix a colour with white you will discover that artists' colours have more strength and clarity.

When used straight from the tube, oil paint has a thick, buttery consistency, and it can also be diluted with distilled turpentine to produce thin washes of colour.

WATER-MIXABLE OIL PAINTS

A recent innovation is water-mixable oil paints. These are made with linseed oil and modified safflower oil, but they can be thinned and cleaned with water as opposed to an oil-based spirit such as turpentine. They have been specifically developed for artists who are allergic to volatile spirits such as turpentine or who have to work in enclosed spaces. A range of water-based mediums is also available which react in a similar way to traditional oil mediums. See the landscape project on pages 90-95 for more information on using water-mixable oil paints.

A Starter Kit

Use the basic starter kit listed below initially and have fun playing around with the paints and trying out some of the basic brushstrokes and effects in Lesson One. As your confidence grows you can start to add more colours, brushes and so on. Eventually you will discover your preference for particular colours and a certain type of surface or brush.

Colours Titanium white, cadmium red, alizarin crimson, cobalt blue, cadmium yellow, Payne's gray, raw umber. This gives you a selection of the primary colours, from which all colours are mixed, plus a grey and a brown.

Supports Initially you can start with several sheets of ready-primed canvas board or canvas paper.

Brushes A No. 12 round bristle brush is versatile as it covers large areas and linear marks can be made with the tip. A No. 4 long flat bristle brush is useful for applying thick colour and the square end makes fine lines.

Palette These are available in wood or melamine. Disposable tear-off paper palettes are convenient if you hate cleaning up. Your palette should be big enough to allow plenty of room for setting out and mixing colours.

Distilled turpentine for thinning and diluting the paint (do not use ordinary household turpentine, which contains too many impurities). Later on you may wish to use linseed oil as well as turpentine, but keep things simple for now.

White spirit or turpentine, jam jars, cotton rags and newspaper for cleaning brushes, palettes, etc.

SOLVENTS AND MEDIUMS

Oil paint can be used thickly, straight from the tube, but usually it needs to be thinned down to make it easier to work. Paint may be diluted to the required consistency using a solvent such as distilled turpentine, or with a combination of a solvent and an oil such as linseed oil – what artists call a medium. It is the mixture of linseed oil and turpentine which gives an artist's studio its characteristic smell.

Paint mixed with turpentine alone dries to a matt finish. Always use distilled turpentine for diluting paint: ordinary household turpentine should only be used for cleaning your brushes. There are other solvents, such as oil of spike lavender, which are suitable for those who are allergic to turpentine or don't like its smell.

A medium consists of an oil or resin mixed with turpentine and added to the paint to alter its properties and the way it handles. These can variably speed up or slow down drying times. They can also increase the transparency of the paint while maintaining its richness and thickness.

The most commonly used medium is a mixture of linseed oil and turpentine, usually in a ratio of 60 per cent oil to 40 per cent turpentine. Linseed oil dries to a glossy finish. Ready-mixed painting mediums are also available from artists' suppliers, designed variously to produce a matt or a gloss finish, thicken it or speed up its drying rate. Initially you may not feel the need to experiment with mediums. It is better to get fully acquainted with the properties of oil paint itself before you start changing its qualities.

PALETTES

When it comes to palettes, you can choose from the traditional kidney or oval shape, well balanced for standing at an easel, or the rectangular shape, which fits neatly into a painting box and is good for outdoor work. They usually have a thumbhole at one end, which allows you to move about while resting the palette on your forearm. You can also buy pads of peel-off disposable palettes, made of oil-proof paper. These are handy for outdoor work, but they are rather expensive and generally too small in size. A large palette is more satisfactory as it will hold squeezes of paint around the edge and generous mixtures in the middle, without intermingling. If you prefer to rest your palette on a table, you can use any piece of smooth, non-absorbent board or a sheet of glass and make it as big as you like.

DIPPERS

Dippers are small, shallow metal containers that can be clipped onto the edge of the palette. Use one dipper for the turpentine or medium that you use to thin the paint, and the other for cleaning brushes as you are painting. You can buy single or double dippers, with or without lids. Dippers are useful for outdoor painting, but when working in the studio you can simply use a small jar with a screw-top lid.

EASELS

There are several different types of easel available, from sturdy studio easels to light-weight sketching easels. Your choice will depend on how much space you have to

work in and whether you intend working mostly indoors or outdoors.

Studio easels are sturdy and robust enough to support large canvases and they are adjustable, but they cannot be easily dismantled and put away, so you might choose the more compact and portable radial easel for space reasons. Lightweight folding sketching easels are available in wood and aluminium. They are ideal for working out of doors and are also fine for studio painting unless you work on a very large scale. The practical box easel combines paintbox and easel in one compact unit that can be folded up into a case for carrying. The table easel, adjustable to various heights and angles, can support a canvas for indoor subjects and is good for people who cannot stand for long periods.

ACCESSORIES

You will find sticks of charcoal useful for marking the main elements of the composition on the canvas. The charcoal lines should be dusted off with a rag, leaving only faint outlines, so that the paint is not sullied by the charcoal dust. Charcoal is also useful for making preliminary sketches.

Other essential items for oil painting include jam jars for holding white spirit for cleaning brushes, and of course a large supply of absorbent rags and newspaper; oil paint is very messy and needs to be cleaned up frequently and carefully.

Below: A selection of palettes, a dipper, bottles of linseed oil and distilled turpentine, a jam jar, sticks of charcoal and a rag.

Tip

You will find paint rags an indispensable item when painting in oils, both for cleaning and for use as a painting tool. Rags need to be of an absorbent cloth and preferably not of a man-made fibre. Worn-out cotton T-shirts and cotton or flanelette sheets, cut into about 45cm (18in) squares, are ideal.

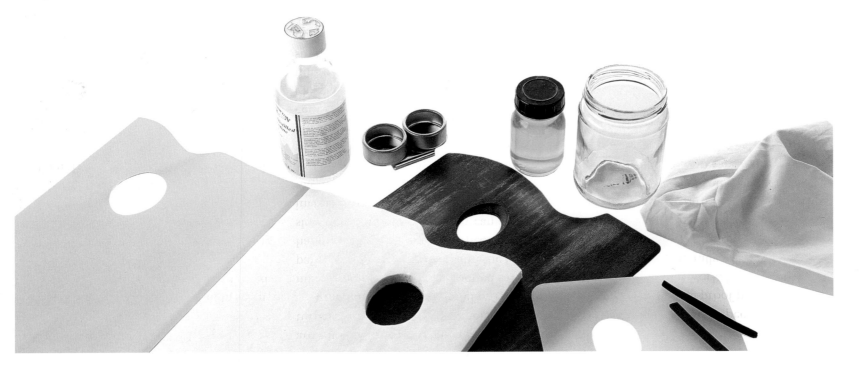

PAINTBRUSHES

Brushes for oil painting have long handles designed to keep the hand away from the wet canvas and to allow the artist to stand back from the work while painting. They come in a range of shapes, sizes and materials, and each makes a different kind of mark. Don't feel daunted by the wide choice available. A selection of just three or four brushes will satisfy your initial needs; having too many to choose from only leads to confusion and indecision!

BRISTLE BRUSHES

Bristle brushes are the most popular choice for oil painting. They are made of hog's hair, which has the strength and flexibility to cope with the thick, heavy texture of oil paint. Bristle brushes are stiff and durable, allowing you to push the paint around or scrub it into the canvas.

SABLE BRUSHES

Sable brushes are soft and flexible, similar to those used in watercolour painting but with long handles. They are used for fine work, such as filling in areas without leaving any discernible brushmarks, for applying thin layers of paint or for glazing. They may also be used for accurate work such as feathering, stippling and fine blending. Sable brushes are expensive, and for oil painting many artists find synthetic-fibre brushes just as adequate.

SYNTHETIC-FIBRE BRUSHES

Brushes made from synthetic fibres are an economical alternative to hog's hair and sable brushes. In the past they lacked the spring of natural-hair brushes and quickly lost their shape, but their quality has improved considerably in recent years. Some brushes are made from a combination of natural and synthetic material, combining the responsiveness of the former with the durability of the latter.

BRUSH SHAPES

Brushes come in four main shapes: flats, brights, rounds and filberts. There are other brushes designed for specific purposes, but they are not essential.

Rounds have long bristles, tapered at the ends. This is the most versatile brush shape as it covers large areas quickly and the tip is useful for doing finer work. They give a softer effect than flat brushes.

Flats have square ends and long bristles that hold a lot of fluid paint. They are useful for applying broad strokes, blending colours and for working up to a clean edge. The thin, chisel edge is good for making sharp, angular lines.

Brights are also known as 'short flats'. They are the same shape as flats but with shorter, stiffer bristles that give more control when painting details. They are good for impasto effects because they make textured marks.

Filberts are similar to flat brushes but they taper slightly towards the end. They are good for laying on dabs of colour and produce less angular lines and shapes than a flat brush.

From left to right

No. 6 fan hog brush

No. 4 long filbert hog brush

No. 4 long flat hog brush

No. 12 round hog brush

No. 14 short flat/bright hog brush

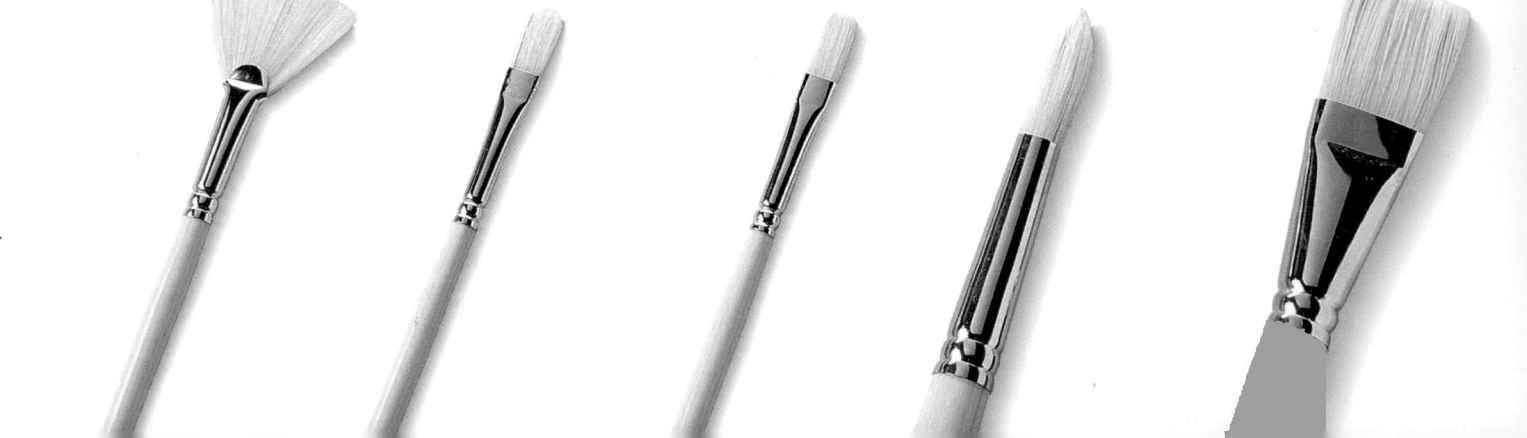

Fans are used for blending colours together and for fine work such as rendering fur or hair. Beginners often buy fan brushes because they are such a fascinating shape, but then find that they are less useful than other brushes.

Riggers have very long, flexible hairs and produce very fine lines.

Decorator's brushes are hard-wearing, cheap and useful for applying primer to the support prior to painting.

BRUSH SIZES

Each type of brush comes in a range of sizes, from 000 (the smallest) to around 20 (the largest). Brush sizes are not standardised and vary between brands, but only very slightly. Larger brushes are good for underpainting and laying thin washes, while smaller brushes are good for adding details. Beginners tend to buy brushes that are too small for the purpose. A good rule is to buy a brush two sizes larger than the one you intended. Small brushes can be frustrating if you are working on an area that really demands a large brush because they quickly run out of paint. You'll be surprised how much control and detail you can get out of large brushes, and they encourage you to adopt a broader, less fussy approach.

LOOKING AFTER BRUSHES

If you look after your paintbrushes they will last a long time. After use, wipe the brush on newspaper to remove any excess paint. Rinse it out in white spirit and wipe it on a rag. Never leave brushes standing with bristles down in a jar as this will distort their shape. Rinse the brush in warm running water and work some soap into the bristles, massaging the brush in the palm of your hand to loosen any remaining paint. Rinse the brush thoroughly, shake it dry, then smooth the bristles into shape and leave to dry, bristle end up, in a jar.

PAINTING KNIVES

Although not an essential item, painting knives can be used to apply thick paint to create a richly textured surface to your painting. You can also use the edge of the blade to make fine linear marks or to skim wet paint off the canvas in order to re-work an area.

Painting knives come in a variety of shapes and sizes, including trowel, diamond and elliptical, for creating a range of marks and textures. They have a flexible blade and a cranked shank to prevent the hand from accidentally brushing against the canvas when applying the paint.

From left to right
2.5cm (1in) decorators' brush used for painting as well as applying primers
No. 3 short flat/bright sable brush
No. 6 filbert sable brush
No. 8 round sable brush
A selection of painting knives in different shapes

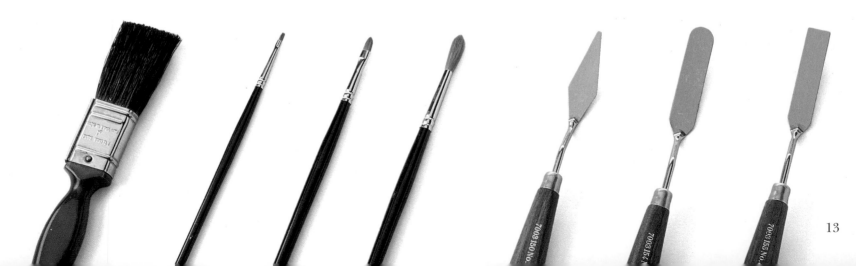

PAINTING SURFACES

A painting surface is called a support, and oil-painting supports can vary from stretched canvas to canvas board, hardboard, and even cardboard and paper. I would advise you to try out several different supports in order to find out which one best suits your way of working.

CANVAS

The most popular support for oil painting is canvas. The two main types are linen and cotton. Linen is expensive, but it has a fine, even grain that is easy to paint on. Good-quality cotton canvas, such as cotton duck, is the next best thing, and much cheaper. Linen and cotton are available in various weaves and textures. The denser the weave, the better the quality. Finer canvases are good for thin washes of paint and detailed work. Coarse-grained canvases have a better 'tooth' to hold paint applied thickly with a knife or brush.

You can buy canvas by the metre from a roll, ready for stretching (see page 16), or pre-stretched and primed. Canvas has a natural weave and texture that is pleasant to work on and takes the paint well. When stretched it has enough 'give' in it to allow you to push the paint around, but also has some resistance. No other support offers this quality since the rest are all hard surfaces. A stretched canvas is lightweight and easy to store, although you should avoid leaning anything against it as this could make an indent in the canvas that is difficult to remove.

As an alternative to canvas you can use other fabrics such as linen and cotton mixtures, hessian, or muslin glued to board.

BOARDS AND PAPERS

Various types of board, and even cardboard and paper, make excellent supports for oil painting. Most of them are inexpensive,

Canvas is the traditional support for oil painting. You can buy it either raw, ready-primed or primed and stretched. Canvas papers and boards are also available.
From left to right: Ready-stretched canvas, canvas board, ready-primed canvas, fine linen, cotton duck.

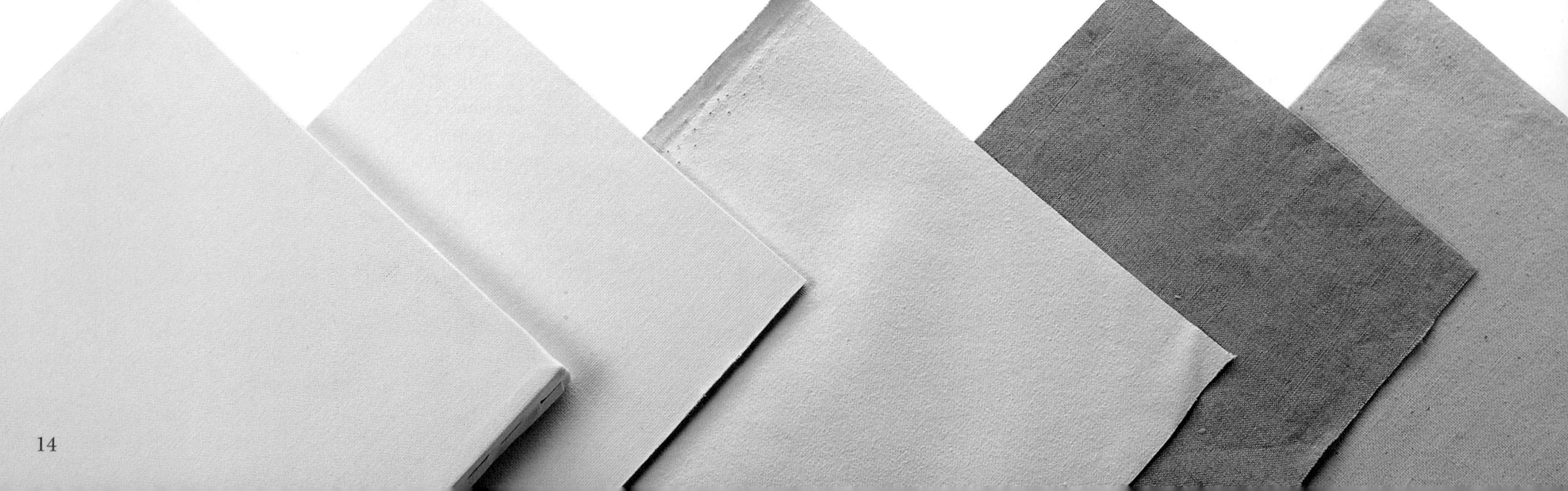

There is a wide range of inexpensive alternatives to canvas which are easy to prepare.
From left to right: MDF (medium-density fibreboard), hardboard, paper, canvas paper, cardboard.

allowing you to practise and experiment without fear of spoiling an expensive canvas, but they must be primed before using them (see page 17).

MDF (medium-density fibreboard) is a relatively smooth surface that takes well to priming. It is available in a range of thicknesses, but it is best for smaller paintings as larger sizes will get very heavy. Your local hardware store will cut it to size for you, but if you cut your own you must wear a dust-mask as the dust released by sawing is very fine and is a health hazard.

Hardboard can be used on both the rough and the smooth sides, although the rough side is a little too coarse for most people's taste. The smooth surface will need to be sanded to give it a 'tooth' for the primer to adhere to. Muslin and other fine fabrics can be glued to hardboard using diluted PVA glue, thus giving a solid support that has the texture of fine canvas.

Ready-primed boards consist of a piece of primed canvas mounted on board to give a firm support. They come in a range of sizes and surface textures.

Cardboard is a more traditional surface for oil painting than you might think: it was frequently used by Toulouse-Lautrec. So long as it is sized or primed properly, it can be a pleasing, economical and stable surface to work on. It is even possible to cut up grocery boxes and cereal boxes and paint on them!

Paper is another excellent, economical support for small paintings and sketches. Thin papers tend to buckle, so choose a heavy one with plenty of tooth to hold the paint and either size it or prime it.

Oil sketching paper is primed paper textured to resemble canvas weave. It is available in single sheets and in tear-off blocks, which provide a firm surface to work on and are handy for outdoor sketches and practice work.

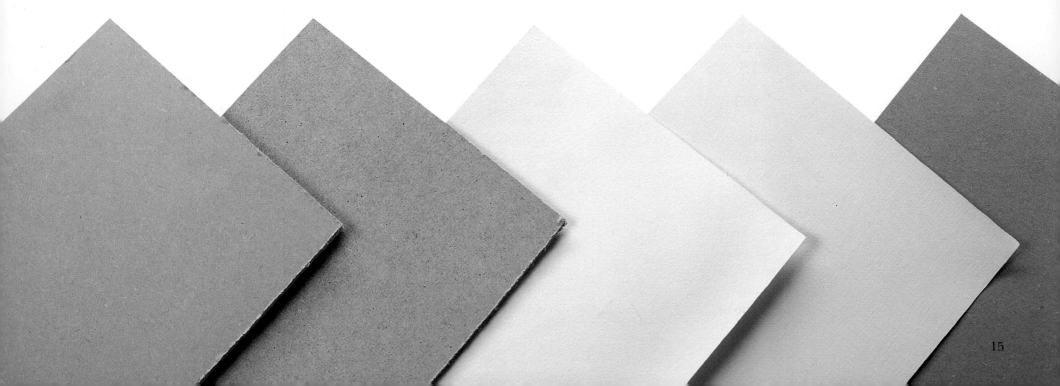

STRETCHING CANVAS

Buying ready-stretched canvases is expensive and it is more economical to stretch your own canvases. It is not difficult and you will have the added advantage of being able to make a support to your own specific proportions and requirements.

MATERIALS AND EQUIPMENT

Below is a list of the equipment you will need for stretching a canvas.

- A piece of canvas slightly bigger than the size of your intended picture.
- Four wooden stretcher pieces. These come in various lengths so you can make your stretched canvas to a specific size and proportion. The pieces have pre-mitred corners that slot together easily and the front edges are bevelled.
- Eight wooden corner pieces or 'keys'. These fit into slots inside each corner of the assembled stretcher. Should the canvas ever sag, the wedges can be driven in further with a hammer to expand the corners and make the canvas taut again.
- Scissors to cut the canvas.
- A hammer and tinned tacks to fix the canvas to the frame. Alternatively use a staple gun and non-rusting staples.
- A T-square to check that the assembled stretcher is square.

HOW TO STRETCH CANVAS

Assemble the stretcher pieces, checking that all the bevelled edges are at the front. Use a T-square to check that all the corners of the assembled stretcher make right-angles. Double-check by measuring diagonally from corner to corner. Lay the canvas face-down on a table, then lay the stretchers bevel-side down on the canvas. Cut the canvas to size, allowing an extra 8cm (3in) all round for stapling. Ensure that the warp and weft threads of the canvas run parallel with the edges of the stretchers.

Tack or staple the canvas to the reverse of the stretcher. Start in the middle of one longer side, then stretch the canvas taut and secure the middle of the opposite side. Repeat on the two short sides. Working on alternate sides of the stretcher, continue tacking or stapling at 5cm (2in) intervals, working from the middle out towards the corners but leaving the corners free. Finish off the corners. Pull the point of the canvas across the corner of the stretcher, then fold in each side of the canvas smoothly and neatly. Tack or staple down both flaps, taking care not to staple across the mitre joint. Repeat on the remaining corners. Tap two wooden corner pieces temporarily in place in each corner until the canvas is taut but not over-stretched.

The longest side of each wedge should lie alongside the stretcher. The canvas is now ready for sizing and priming.

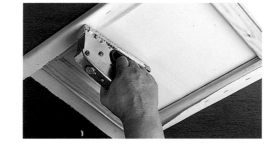

1 Assemble the stretcher and cut the fabric allowing 8cm (3in) extra all round. Staple the fabric to the reverse of the stretcher, starting at the middle of the longest side.

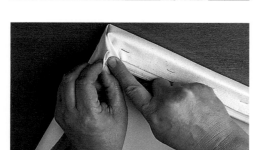

2 Make the corner by folding one edge over the other and stapling diagonally.

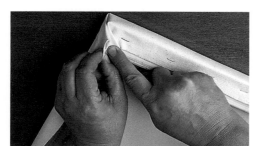

3 Tap the wooden corner pieces into the slots provided until the fabric is uniformly taut but not stretched.

Tip

If dents appear in a canvas, rub lightly over the dent on the back of the canvas with a damp rag. As the canvas dries, it will tighten up and the dent will disappear.

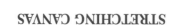

PREPARING GROUNDS

Commercially prepared canvases and boards can be painted on straight away. But if you are preparing your own support from raw canvas, paper or board, you will need to seal the surface before painting in order to separate the paint layers from the support. Without this protective barrier, oil will be sucked from the paint by the absorbent surface, leaving the paint impoverished and liable to cracking. If you brush some paint onto an unprepared surface, you will eventually see a ring of oil around the paint where it has leached out, and the paint will have a dull, matt appearance.

Traditionally, oil-painting supports are prepared with a layer of glue size plus a layer of white oil-based primer, known as a

Preparing your own painting surfaces is enjoyable as well as economical. Many artists prepare a whole batch at once, of different sizes and types, so that they can work on more than one painting at a time.
Right
Rabbit-skin granules must be soaked before they are heated to make a glue size.
Far right
Apply the primer to the painting surface with a decorator's brush.

ground. Alternatively, you can use an acrylic-based primer, in which case no sizing is needed. Some artists like the warm brown tone of surfaces such as board and cardboard, finding it more sympathetic than white, and they prefer to paint straight onto the sized surface, without applying any primer first.

SIZING

Surfaces which are to be given an oil ground must be sized with rabbit-skin glue. The glue is available in jelly form which you melt down to the right consistency, or in the form of sheets, powder or crystals which need to be soaked overnight in a jar of water until they swell (roughly one part glue to 15 parts water is a good recipe for sizing canvas; use a slightly stronger solution for board). Place the jar in a double boiler and heat gently until the glue melts. Apply the size lukewarm with a household brush, starting from one edge and stroking in one direction only. Once dry, repeat in the opposite direction.

PRIMING

The primer, or ground, provides a sympathetic surface on which to paint. Oil primers take a long time to dry, but provide a stable, flexible surface for the subsequent painting. Apply the primer in two thin coats rather

than one thick one, allowing each coat two days to dry. You can also use a good-quality, oil-based household undercoat, thinned with a little turpentine, as a primer.

Acrylic primers are convenient because they are quick-drying and you don't need to size the support beforehand (in fact, they should never be used over a sized support or they will crack badly). Another advantage is that you can paint over an acrylic ground with quick-drying acrylic paints in the underpainting stage, again saving time. The only disadvantage of an acrylic ground is that it can feel a little 'plastic'. You can make an economical version of acrylic primer using roughly equal measures of household emulsion and PVA glue. Dilute it with water to the consistency of single cream.

Getting Started

It is a good idea to get acquainted with the feel of oil paint, and how you can push it about and play with it, before you try anything more ambitious. Because oil paint is flexible and slow-drying, it is important to learn how to manipulate it, otherwise you will become frustrated when you start making images because the paint will not do what you intend it to!

On these pages are some simple exercises that will teach you about the elementary characteristics of oil paint. All you need are some sheets of inexpensive oil-sketching paper, a bristle brush (something like a No. 8 – too small a brush will encourage tight, fiddly brushmarks), tubes of cobalt blue and raw umber oil paint, a jar of distilled turpentine and some rags, newspaper and white spirit for cleaning up.

Work freely: don't worry about 'getting it right', just enjoy the sensation of pushing the paint around. It is fun to experiment with paint in a relaxed, unpressurised way, without the demands of creating a realistic image. Oil paint can be scraped or wiped off while still wet and then painted over, so nothing is ever a disaster.

The examples here show you how to paint blocks of colour, but of course you can also paint with lines, using the tip or end of the brush.

Don't worry if your efforts look different from the examples shown here. Everyone has a way of handling paint that is personal to them. With experience you will develop your own way of working and develop your own painting style, which is as individual to you as your handwriting.

A

OPAQUE PAINT

A Start by squeezing some cobalt blue onto your palette. Dip your brush in and load it well with paint. Make a thick blob on the paper and push the paint around a little with the brush. Notice how the paint retains the marks made with the brush.

B

B Clean your brush with white spirit. Squeeze some raw umber onto the palette, dip your brush in and place some paint close to the wet blob of cobalt blue. Now work your brush back and forth between the two colours so that they blend together where they meet. You have just discovered that you can mix colours together on the painting surface as well as on the palette!

Aims

- To learn to manipulate and control both thick and thin oil paint
- To create a range of effects using different tools and brushes
- To learn the importance of painting 'fat over lean'

A

TRANSPARENT PAINT

A Oil paint can also be thinly diluted to create transparent washes, almost like watercolour. Squeeze a small amount of cobalt blue onto your palette, then mix some distilled turpentine into it until the paint has a runny consistency. Brush it onto the paper and let it dry. Notice how the white of the paper shows through the colour.

A

SEMI-TRANSPARENT PAINT

A Another way of using oil paint is to mix it with little or no turpentine, pick up a tiny amount on the brush and scrub it into the canvas until there is no paint left on the brush. This leaves a thin film of dry colour through which the texture of the canvas is visible. This technique is called scumbling, and is particularly useful when painting skies and landscapes.

B

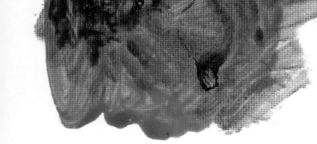

B When the cobalt blue wash is dry, paint a thin wash of raw umber over it. Notice how the blue layer is not completely obscured but glows up through the brown layer. This is a way of creating interesting colour mixes on the painting surface: the two colours blend in the viewer's eye to create a third colour, but because the colours each retain their identity the effect is richer and more lively than if you mix them together on the palette. This is known as optical colour mixing.

B

B Allow the blue layer to dry and then brush a thin scumble of raw umber over it. The textural effect created with this dry paint is quite different from that of the transparent wash in the previous stage, but as before, the two colours blend in the eye.

BRUSHMARKS

The marks you make with a brush are an important part of the visual language of a painting. Just as in conversation you use different expressive qualities in your voice, the way in which you use a brush on the canvas conveys different feelings. So using vigorous marks can be the equivalent of shouting, while fluid lines and marks are more like gentle intonations. The rich, buttery consistency of oil paint is ideal for creating interesting brushmarks that not only help to define forms and suggest textures, but also give the finished picture a pleasing tactile quality.

It is well worth experimenting with a variety of brush shapes – rounds, flats and filberts – and with bristle brushes and soft brushes, to find out what kinds of marks each one can make (see pages 12-13 for more information on brushes). It is also possible to make a range of marks with just one brush, depending on how it is held, the amount of pressure applied with the brush, and the way it is pulled across the canvas. I know several artists who have acquired a studio full of brushes over the years, yet they use the same two or three favourite brushes for everything, until they are worn down to little more than a stump!

PRESSURE

The sort of mark you make depends on whether you pull the brush lightly across the surface or whether you push it into the surface, using a scrubbing action. The effect will also depend on whether the paint is thick or fluid, and whether the brush is well loaded or fairly dry. Hold the brush at various angles to see how this affects the weight of the stroke, and try twisting it as you paint. Stipple thick paint on with the tip of the brush to make small, textured marks, or lightly drag it over the surface so that the colour is broken up by the textured weave of the canvas. Bristle brushes are good for this kind of punishing treatment, which is why they are popular with oil painters. They can withstand rough work far better than sable brushes, which are more suited to lighter strokes and soft blending with thin paint.

SPEED

The speed with which you make a stroke also affects its character. A brush rapidly skimmed over the surface makes a light, broken mark, but the same brush dragged slowly and deliberately will make a more solid mark because more paint is deposited.

Except for close-up detailed work, try not to hold the brush too near the ferrule as this limits your movements to the wrist and fingers and results in tight, restricted brush marks. Stand well back from the easel so you have room to paint from the shoulder or elbow. This will encourage you to make more fluid and expressive strokes.

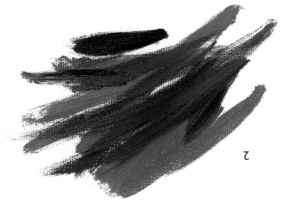

1 Slightly diluted paint, applied with speed in a diagonal direction using a small decorator's brush.

2 A flat bristle brush applied at speed, again working two colours together. Twist the brush, using the body of the brush as well as the tip.

Tip

If your work is too tight and detailed, try working with bigger brushes, or even paint with rags. This will force you to apply the paint with loose, broad marks that have a more painterly feel.

3 A long flat bristle brush applied slowly and with pressure. Use the body of the brush to make broad marks and the chisel edge to make linear marks.

4 Short, comma-like strokes made with the tip of a long filbert brush. A filbert has a softer edge than a flat.

5 Dryish paint applied at speed in different directions with a fan brush.

6 Long, fluid strokes made with diluted paint and a round sable brush. Apply varying pressure with the brush and twist it as you drag it across the canvas.

7 A fluid wash of dark paint applied with a flat hog brush. When dry, overlaid with dots and dashes made with a small short flat sable brush.

8 A round bristle brush held vertically and applied with pressure in short, quick movements in various directions.

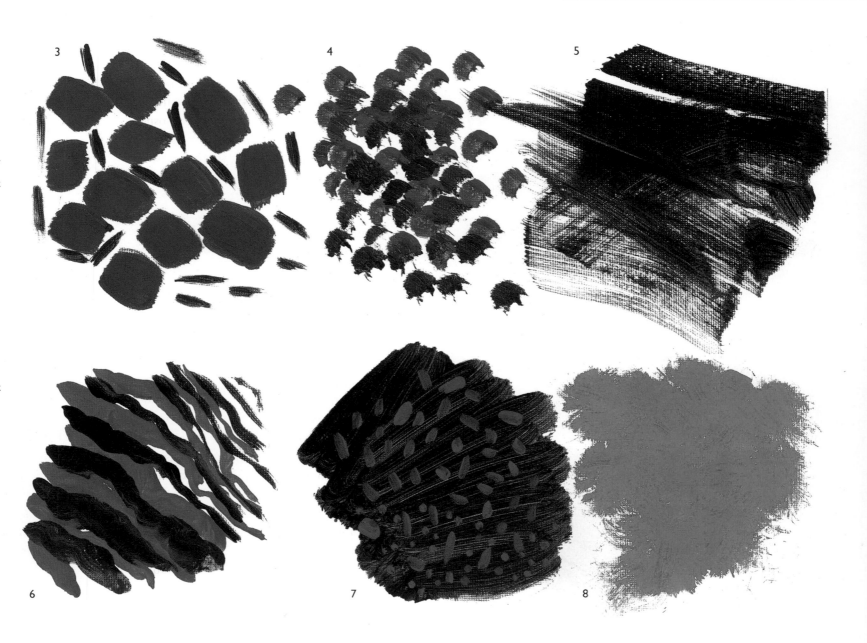

THE VERSATILITY OF OILS

Oil paint is a highly versatile and responsive medium, capable of producing an infinite range of textures and effects. The way the paint feels under the brush, and the resulting marks and textures, are an exciting and enjoyable part of the painting process. Unlike, say, watercolour, oil paint has substance, and it dries slowly, so you can push it around on the surface, wipe it off and build it up again. Paint can be used straight from the tube to produce thick, opaque layers, or thinly diluted to produce transparent washes and glazes, and there are many fascinating variations between these two extremes. You can use a knife to 'sculpt' the paint, to scratch into it, or to scrape it back, leaving a thin translucent stain that reveals the weave of the canvas. You can manipulate the paint with rags, sponges and pieces of card, scratch into it with a sharp point, and even mix substances into the paint to give it texture. The creative possibilities are endless!

When we first set out to paint, however, we tend to be a little cautious and hesitant

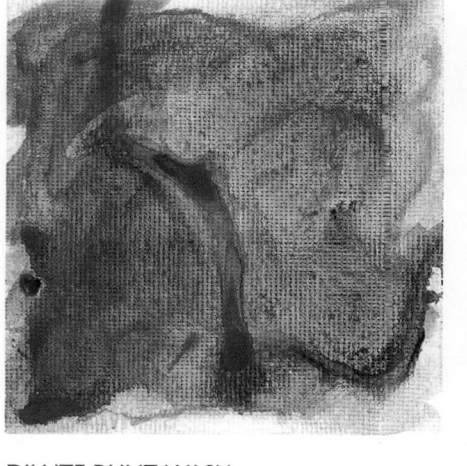

DILUTE PAINT WASH

This is a traditional way of starting an oil painting, with an underpainting done in thin washes of paint diluted with turpentine. While this is still wet, you can use either a broad brush or a rag to lift out colour to create highlights.

USING A TONED GROUND

Rather than painting on a white canvas, you can tint the whole of your support with a colour such as burnt or raw umber. This makes the surface less intimidating to work on than a white surface. You will feel as though you have less to cover and you will get used to working with light colours over dark colours as well as dark over light.

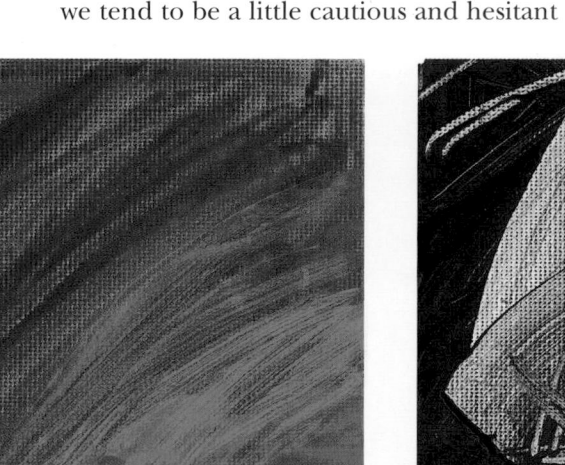

PAINTING LIGHT OVER DARK

Here a light colour (cadmium orange) has been painted over a darker colour (French ultramarine). You can modify a colour quite subtly by overlaying it with a thin, transparent wash of another colour. Try some experiments in a sketchbook.

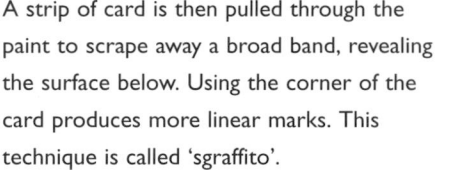

SCRAPING WITH CARD

A mix of burnt sienna and ultramarine has produced a very dark, almost black colour. A strip of card is then pulled through the paint to scrape away a broad band, revealing the surface below. Using the corner of the card produces more linear marks. This technique is called 'sgraffito'.

in our approach. Instead of painting with broad sweeps and masses of colour, our first inclination is to draw outlines with the brush and then fill them in neatly. Those outlines are a sort of security blanket, making us feel in control, but the finished picture will in all likelihood be disappointing because it looks tight and disjointed and lacks spontaneity. There are no outlines in nature, and in any case the very nature of paint demands that we express what we see in terms of masses rather than lines.

The best way to overcome this reticence and loosen up is to work on a large scale using big brushes. Even better, try painting with a rag: this forces you to look at your subject in terms of broad masses instead of details and outlines. All of the examples below have been created with rags and large brushes, and even with a piece of stiff card. Try them out on canvas paper or pieces of prepared cardboard (see page 17). I guarantee it won't be time wasted!

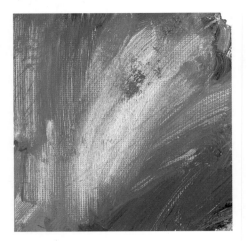

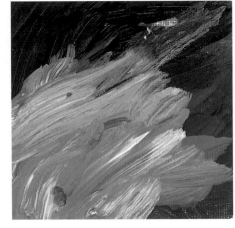

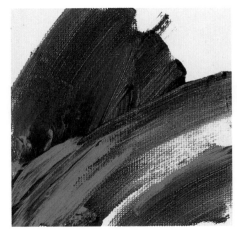

LIFTING OFF WITH A RAG
A mix of ultramarine blue, cadmium orange and burnt sienna has been applied in vigorous brushstrokes and the paint is then partially lifted off with a rag. This is the same technique as scraping off with a piece of card, but the edges are softer.

LIGHT OPAQUE OVER DARK
One of the characteristics of oil paint is that you can obliterate quite dark, strong colours with paler opaque paints laid over the top. This allows for greater flexibility and means you need never be worried about any marks you make.

PAINTING WITH A RAG
This is a particularly good way of starting a painting as it forces you to keep the painting fresh and free before you get too involved in detail. Often the tool you use will dictate the way you are able to work.

BLENDING
As oil paint dries slowly, it is easy to blend colours together. Allow the paint to dry slightly and use a soft brush to stroke gently over the two colours and blend them gradually together. How this works will depend on the wetness of the paint, and whether you want the blending to be gradual over a broad band, or whether you want a sudden transition.

PAINTING WITHOUT A BRUSH

Once you have got used to handling oil paint and have gained more confidence, there is no reason why you should not experiment with more unconventional techniques and painting implements. The examples on these pages demonstrate various ways of applying and manipulating paint without using a brush. I should stress here that technique is not an end in itself, rather it is a means of expressing what you want to say about your subject. Too much reliance on clever tricks and effects will render your work facile and superficial. Nevertheless, techniques such as knife painting, finger painting and spattering, if used with discretion, will broaden your visual language and help you to create specific textures and effects that might be difficult to achieve using the more conventional brush techniques.

FINGER PAINTING

If you don't mind getting your fingers dirty, they can be an invaluable painting tool! Use them to soften outlines, dab in highlights, achieve soft gradations of colour, or to 'print' textures. Bear in mind that some pigments are toxic, so always clean your hands thoroughly afterwards.

SPATTERING

Spattering paint from a brush to release a shower of droplets on to the painting is great fun, if a little nerve-racking. The results are unpredictable, depending on the thickness of the paint and the distance of the brush from the canvas. To produce a fine spatter, dip an old toothbrush into the paint and draw your thumbnail through the bristles. To achieve a more random spatter, load your brush with paint and then tap it sharply with your finger or with another paintbrush.

KNIFE PAINTING

Painting with a knife is a very physical way of pushing the paint about on the canvas and you can really enjoy the texture of the paint. The paint can be laid on thickly and a large area can be covered quickly. Knife painting is not so controllable as brush painting and there is an element of chance which often produces exciting, unexpected effects. See page 13 for information on painting knives.

Different effects can be produced by using different parts of the blade and varying the speed and the pressure applied. Use the flat base of the blade to spread the paint thickly, or the edge of the blade to scrape paint away; use a brisk patting motion with the tip of the blade to produce a stippled texture, and the edge to make sharp linear marks. You can also use the tip of the knife to scratch into the wet paint, to create a sgraffito effect.

1

2

I Textured effect created by dipping the fingertips into paint and printing off onto the canvas.

2 Spattered pattern made by flicking with a well-loaded round soft-hair brush.

Opposite page
3 Impasto effect produced by applying paint with the flat of a painting knife and spreading it in short, curved strokes. The paint is scraped off again in places, leaving a thin stain of colour which reveals the texture of the canvas.
4 Paint applied with the narrow tip of a painting knife using a quick, press-and-lift motion.
5 Fluid linear marks made by dipping the edge of the knife blade into paint and pressing

it to the canvas while twisting and turning it with the wrist to make rhythmic marks that vary from thick to thin.

6 Angular marks made by pressing the flat underside of the knife into paint and printing it onto the surface. The marks are thick at first, becoming more ragged as the paint on the knife is used up.

7 A flat area of colour made with fairly thin paint spread over the canvas with the underside of the knife. Sgraffito lines made by scratching back into the wet paint with the tip of the knife.

8 A flat area of colour painted with a knife and overlaid with a second colour, used thick and undiluted, printed off with the underside of the knife.

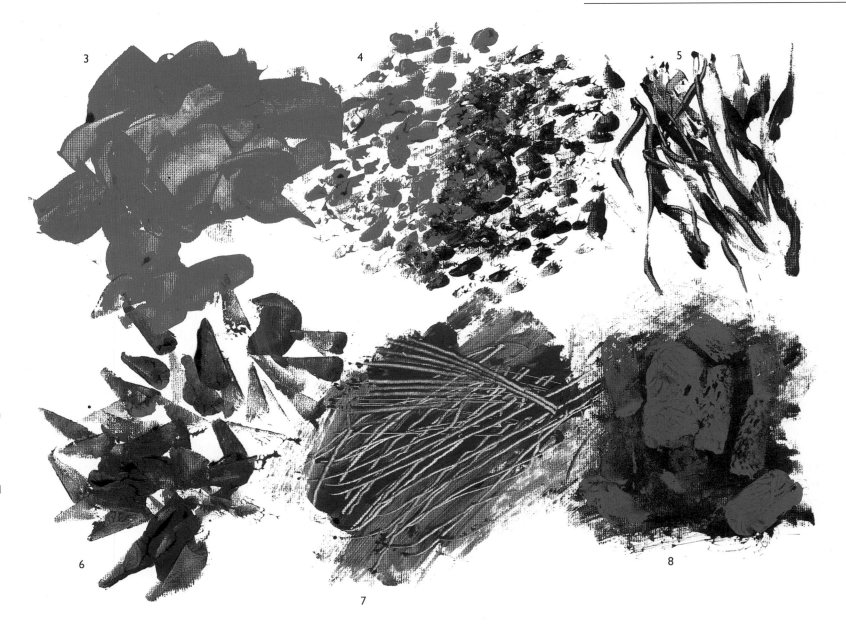

OIL-PAINTING SYSTEMS

There are basically two different approaches to painting in oils: the classical method of building up in layers over a period of time and the more modern method of completing the painting in one sitting, known as 'alla prima'. The classical and alla-prima painting systems have now become more or less interchangeable. Many of the paintings in this book are based loosely on the classical tradition, starting with a thin underpainting over a toned ground and building up with increasingly thick layers of paint, but usually completed in one sitting.

THE CLASSICAL SYSTEM

This is the time-honoured system of painting used by the Old Masters, and it is still relevant today. Starting with an underpainting, the image is built up in layers, using thin paint in the early stages and thicker, oilier paint as the painting progresses. It may seem complicated, but in fact some of the stages can be omitted; it all depends on what materials you are using and how you like to work. For example, if you use an acrylic ground you won't need to size the canvas (see page 17), and you may prefer to go straight into the painting without first making an underpainting. The sequence below describes the progression of an oil painting completed using the classical method.

1 Sizing the canvas A layer of glue size prevents oils in the paint and primer from seeping into the canvas, which could eventually rot the canvas and leave the paint layer starved and dry.

2 Priming the canvas A layer of white primer, called a 'ground', gives a sympathetic surface on which to paint. Refer to page 17 for more information on sizing and priming.

3 Toning the ground Some artists dislike painting on a stark white ground, preferring to tint it with a colour. You can either add colour to the primer, or wash colour over the primer once dry. Refer to page 38 for more information on using toned grounds.

4 Grisaille A grisaille is a monochrome underpainting done in thin paint which artists use to establish the arrangement of lights, darks and mid-tones before adding colour. The project painting on pages 74-77 starts with a grisaille.

5 The over-painting The painting is now built up in layers, starting with thin paint and building up with oilier paint in the final layers, according to the principles of working 'fat over lean' (see opposite).

I painted this study using the 'classical' method of painting in oils. After sketching in the outlines with charcoal, I indicated the lights and shadows in thinly diluted grey paint. When this was dry, I applied the first layer of colour with 'lean', turpsy paint and built up further layers using 'fat' paint straight from the tube with no turpentine added.

Working 'Fat over Lean'

There is only one rule that you need to observe in oil painting, which is that you should always paint 'fat over lean'. 'Fat' describes paint that comes straight from the tube or is mixed with an oily medium such as linseed oil. 'Lean' describes paint thinned with turpentine. If lean paint is applied over fat, your painting may eventually start to crack. The reason for this is that fat paint is more flexible than lean paint and takes longer to dry. So if lean paint is applied over fat, the top layer will dry before the lower layer, and as the lower layer dries it moves, causing the hardened top layer to crack. Thus you should use thin paint diluted with turpentine in the initial layers and gradually reduce the amount of turpentine in the succeeding layers.

PAINTING 'ALLA PRIMA'

The term 'alla prima' means 'at the first attempt', and describes a technique in which a picture is completed in a single session rather than being painted over a period of time. It was explored and developed by the French Impressionists when they were painting landscapes outdoors and attempting to suggest light effects that changed too quickly to be captured using the classical method.

In alla-prima painting the surface is built up quickly using vigorous, expressive brush-work in order to capture the essence of the subject. Each patch of colour is laid down more or less as it will appear in the finished painting, or worked wet-into-wet with adjacent colours. This is an exciting, intuitive way of working, but in order to achieve freshness and spontaneity it is important to have a clear idea in your mind of what you want to achieve before you start painting.

Here we have the same subject but a very different approach. I completed this study in one sitting using layers of thick, rich paint worked wet-into-wet. Because the painting is painted effectively in one layer there is no danger of the surface cracking in time because it will all dry at the same rate.

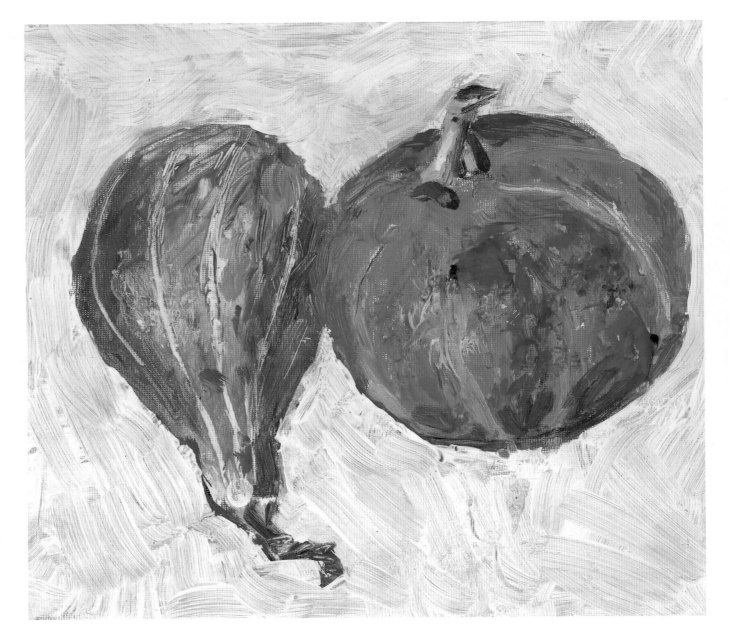

PUTTING PAINT EFFECTS INTO PRACTICE

At last it is time to put what you have learned about techniques and paint effects into practice by making some real images! Flowers are a good subject to start with because they are bright and colourful, and their wonderful shapes and forms offer plenty of scope for practising a variety of techniques and brushstrokes. You could, if you prefer, start with something simpler such as an apple or a pear, but you might find yourself getting bored rather quickly.

There is no need to worry about the accuracy of your drawing at this stage. This exercise is purely about learning to control and manipulate oil paints to create the illusion of form and texture. With regular practice and experience you will be able to control the paint almost instinctively and make it do what you want it to.

The most important thing is to have fun, and not to try to predict how something is going to turn out. Painting is a visual language. It is difficult to imagine something in your head and then put it down precisely on the canvas. In all likelihood you will have to make changes and adjustments to your painting as it progresses, because each colour, tone and shape relates to another and cannot be regarded in isolation. Don't

expect perfection every time, but look for the individual qualities in your work and try to build on them. Rather like handwriting, every artist's way of handling paint is different and unique to them.

PERSONAL INTERPRETATION

There is no point in attempting to make perfect copies of the subjects we paint: we might just as well take photographs of them. Part of the appeal of a painting is that it has certain qualities that go beyond mere representation. Through the imaginative use of colour and paint effects, the artist can express feelings and moods which a photograph cannot.

Try to find what interests you most about your subject and focus on that element, even exaggerate it slightly in order to express to the viewer how you feel about it. Look for hints of interesting colour that could be played up, for example, or think about the gestural quality of the brushmarks you make and how you can use these to express mood and emotions, movement and activity.

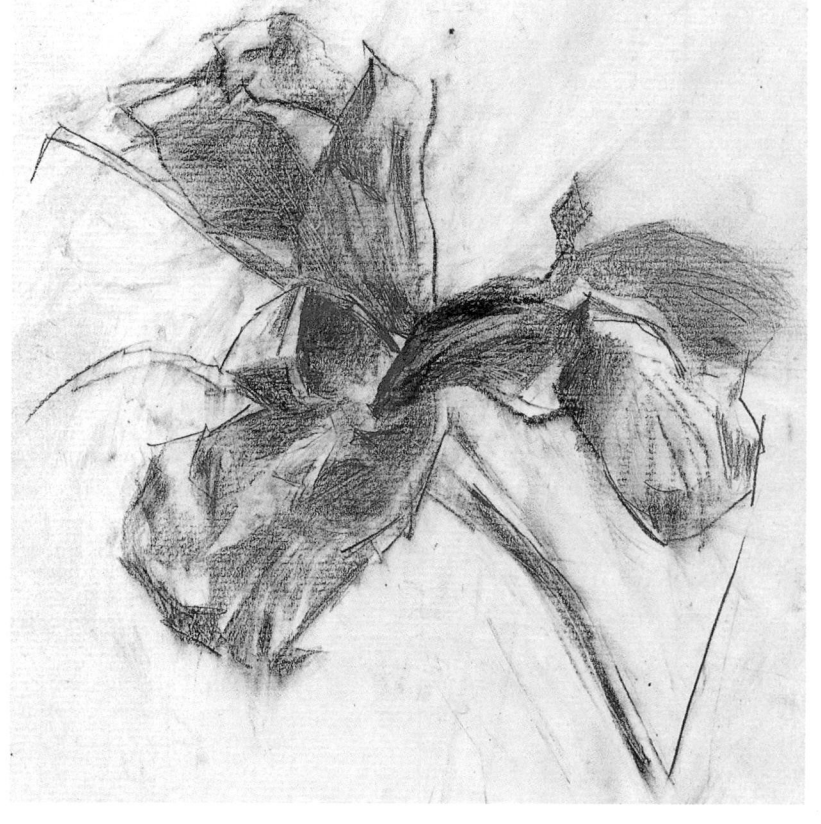

PRELIMINARY DRAWING

It is always helpful to make thumbnail sketches and drawings before embarking on a painting. Drawing helps you to understand what you are looking at and how it is put together. This iris at first appears quite a complex form, but if you first analyse it in a drawing it becomes simpler. Start with the big shapes – the three petals emerging from the centre – and then use tonal variations to suggest the wrinkles and undulations within them.

Tip

Avoid holding the brush too close to the metal ferrule as this will restrict your movements. Hold the brush further up the handle, where it feels naturally balanced, so that your brushmarks will be controlled yet confident.

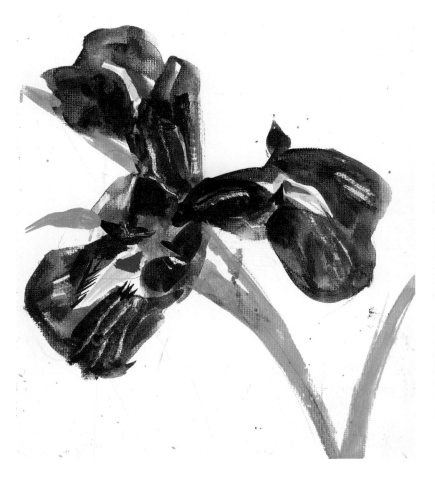

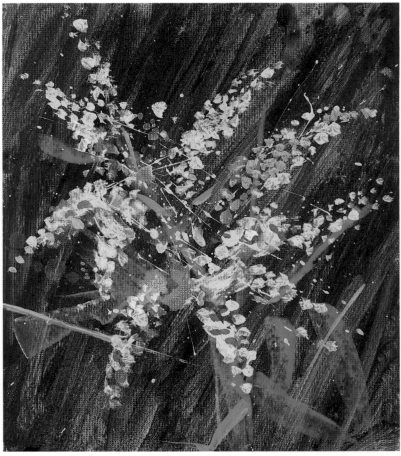

THIN WASHES

Oil paint can be thinly diluted and applied in thin, transparent washes. Here, the washes are overlaid one over another to build up form and surface detail. Although the technique is similar to watercolour painting, the effect is quite different; there is a richness of colour and surface quality exclusive to oil paint.

SPATTERING

Another technique 'borrowed' from watercolour painting, spattering is an excellent means of suggesting textures and details without overstating them. This plant has a profusion of tiny yellow blooms: suggest these by loading a bristle brush with creamy paint, holding it above the horizontal canvas and tapping it sharply across your outstretched finger. Vary the size of the spatters by varying the dilution of the paint and the distance between the brush and the canvas.

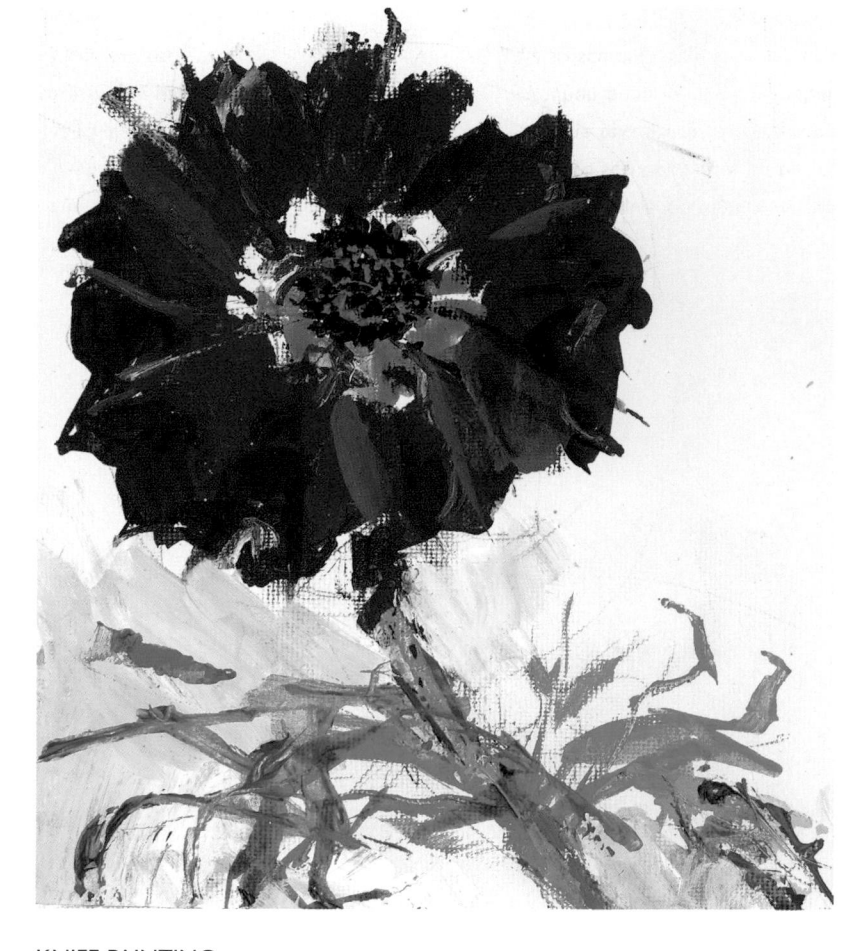

ONE-BRUSH PAINTING

It is a useful exercise to work with just a single brush and see how skilfully you can manipulate it to make as wide a range of marks as possible. Start by blocking in the overall shape of the lily with thin paint, using the broad body of the brush. Then elaborate the petals with thicker paint, using the side of the brush. Twist the brush as you paint the leaves and stem and use a dabbing motion with the brush tip to suggest the stamens.

KNIFE PAINTING

Painting with a knife produces fresh and immediate results. Start by painting the flower with a brush and thin paint, then use the knife to build up form and detail with thick, juicy paint. Use the flat of the blade to apply thick slabs of paint and the edge of the blade to 'draw' the twisted leaves. The effect is vigorous and robust, quite different in character to the soft, delicate lily on the left.

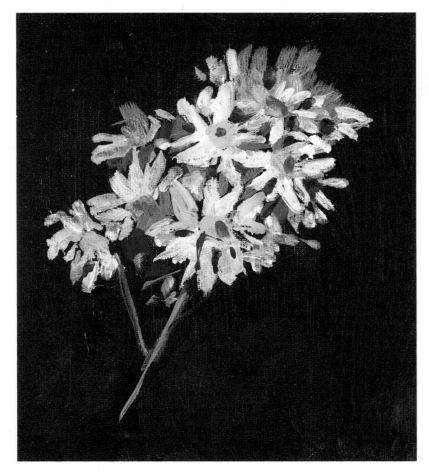

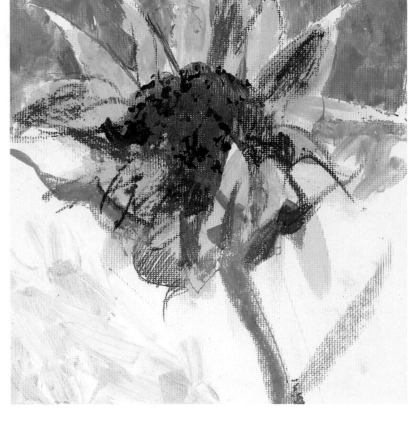

THICK AND THIN PAINT

The beauty of oil paint is that it can be applied both thickly and thinly, and artists often use a combination of the two. For example, use thick paint to bring foreground elements forward and thin paint to push background elements into the distance. Passages of thin paint also provide a foil for more thickly painted areas. Here, the white flowers stand out dramatically against the thin red ground.

SCUMBLING

A traditional oil-painting technique, scumbling involves brushing thin, dry paint onto the canvas with a rapid scrubbing motion to create a thin veil of colour that is slightly broken by the texture of the canvas weave. The effect can be very expressive, particularly when one colour is scumbled over another so that the two interact. You can also scumble with a rag or a painting knife.

Colour

Colour is a very individual and personal means of expression in painting. It is worth learning about the characteristics of colours and how they interact, because they will help you to express yourself more fully. The way colours are used together in a painting can contribute to the mood, atmosphere and expressiveness of the finished image.

Colour can also be used to enhance the composition of your pictures by leading the eye from one area to another or accentuating the centre of interest. As you will discover in Lesson Seven, 'cool' colours such as blue tend to recede, and 'warm' colours tend to advance; by manipulating these colours you can create the illusion of depth in your pictures.

Aims

- To understand basic colour theory and put it into practice
- To learn how to set out colours on a palette and how to mix them
- To use a coloured ground to enhance the mood of a painting

A BASIC PALETTE

Over time, most artists settle on a favourite 'palette' of colours which they use in most of their paintings. Palettes can be basic and simple, or quite extensive. Some artists, for instance, prefer to mix their own greens from the blues and yellows in their existing palette, while others prefer to use tube greens and modify them as required with other colours.

If you have no experience of mixing colours it is better to start with a limited palette. The smaller the range of colours, the better you will get to know them and how they mix with other colours. In addition, using a limited range of colours is a good way to achieve harmony in your paintings. The 12 colours listed right are basic 'workhorse' colours used by most artists. When mixed together they afford a broad mix of hues and tones. You'll notice that there is no black on this palette. Black has a rather deadening effect, and it is possible to make much more interesting darks by mixing colours such as reds and greens or blues and earth colours.

Basic Palette

CHROME YELLOW

CADMIUM YELLOW

RAW UMBER

YELLOW OCHRE

VIRIDIAN

CERULEAN

COBALT BLUE

ALIZARIN CRIMSON

CADMIUM RED

BURNT SIENNA

PAYNE'S GRAY

TITANIUM WHITE

Tip

Make colour notes in a sketchbook so that you can learn about different mixes of colours. It's very frustrating when you mix a wonderful colour but can't remember how you came by it! Make a series of two-colour mixes by adding very small amounts of one colour to another. Most beginners make the mistake of being too unsubtle. You only need add tiny amounts of one colour to another to make quite a significant change.

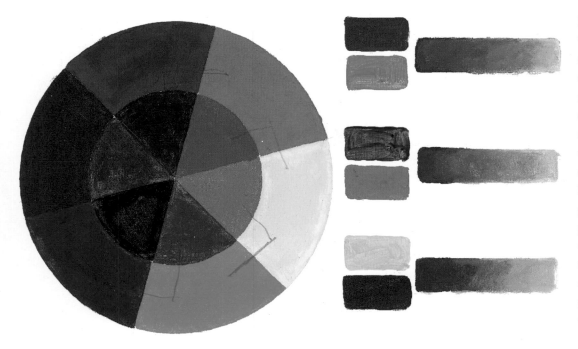

When complementary colours are mixed together (*left*) they neutralise each other and make a dark colour that, when mixed with white, becomes a coloured grey. This can be a warm or a cool grey, depending on the proportion of the colours used in the mix. Get into the habit of mixing colourful greys instead of simply using black and white.

COLOUR TERMS

Hue is simply a colour's name.
Tone refers to the lightness or darkness of a colour. For example, light and dark red are of the same hue but different in tone.
Tint When you add white to a colour to lighten it, you create a tint of that colour
Shade When you add black to a colour to darken it, you create a shade.
Intensity refers to a colour's brilliance.
Saturated colour is a colour that cannot get more intense than it already is. Think of the intense blue of a summer sky.
De-saturated colour is a saturated colour broken down by the addition of other colours, which can be either dark or light.
Temperature Colours are referred to as being 'warm' or 'cool'. Colours on the red/orange/yellow side of the colour wheel are classed as warm, while those on the blue/green/violet side are classed as cool. Colours can also be defined within their own temperature range: for example, cerulean is a cooler blue than ultramarine because it leans towards the green side of the spectrum, while ultramarine leans towards the red side of the spectrum. Cadmium red is warm because it leans towards the yellow side of the spectrum, while alizarin crimson is cool because it leans towards the blue side.

THE COLOUR WHEEL

The colour wheel is a useful 'tool' to refer to when learning colour terms and how colours relate to each other. It is simply the colour spectrum, formed into a circle.

Primary colours All colour originates from the primary colours – red, yellow and blue. These colours cannot be mixed from other colours.
Secondary colours These are mixed from any two primaries. Red and yellow make orange, yellow and blue make green, and blue and red make purple.
Tertiary colours are a mix of a primary colour with its adjoining secondary, eg red-orange, blue-violet and yellow-green.
Harmonious colours are those next to each other on the colour wheel. They share a common base colour, eg blue-green, blue and blue-violet all have blue in common.
Complementary colours lie opposite each other on the colour wheel. When juxtaposed they intensify each other; when mixed they neutralise each other (see above).

CREATING ATMOSPHERE

Your choice of colours and how you mix them can dramatically alter the mood of your pictures. Before you start painting, look carefully at the colours in the scene you wish to paint and judge which contribute most to the mood you want to capture and which detract. The overall colour impression of the scene is very important. If you look at a number of successful paintings you will find that, although many colours may be present, there is usually a single colour as the main theme, and this dictates the mood.

Use the colour wheel (see page 33) to help you create different moods. On one half of the wheel are the warm reds, oranges and yellows, which denote vitality, strength and vigour. On the other half are the cool blues, greens and violets, which impart more passive, restful emotions. Try using a selection of hues from one area of the colour wheel, adding a small touch of a complementary colour to create an accent or focal point. You don't need to be too rigid about it, though. Look at the examples on these pages and see how the colour harmonies within them have been loosely interpreted. You may need to brighten some colours and de-saturate (tone down) others in order to create a harmony.

OIL LAMP

This painting uses warm colours to create the intimate atmosphere of a domestic room. The pinks, yellows and browns are from the warm side of the spectrum. Even the blues are warm because they contain a hint of red. The greenish light cast by the oil lamp is the only cool colour, and it provides a note of contrast. Many of the colours have been de-saturated by mixing a touch of the relevant complementary with them. For example, a touch of viridian was added to alizarin crimson to make a soft pink.

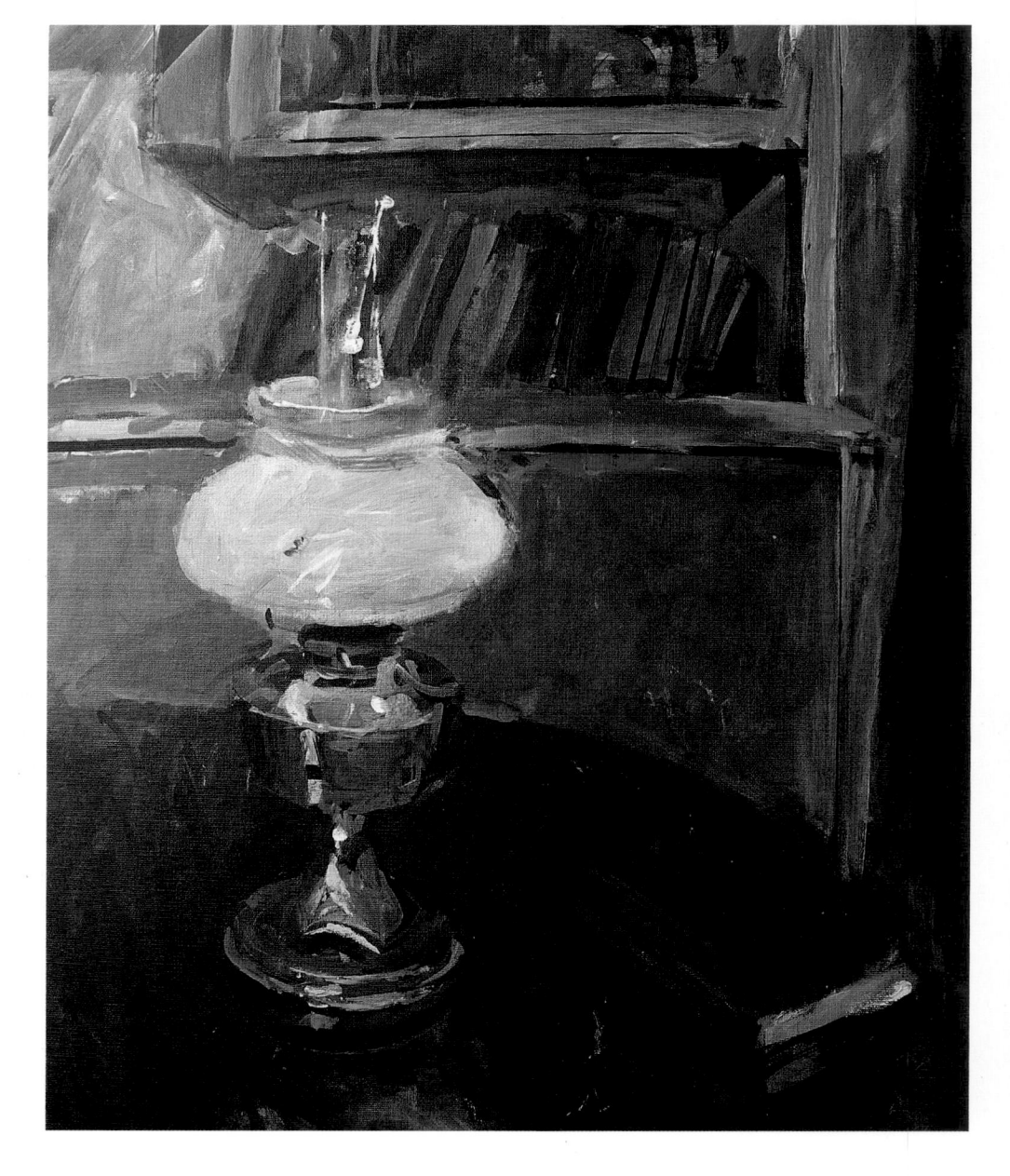

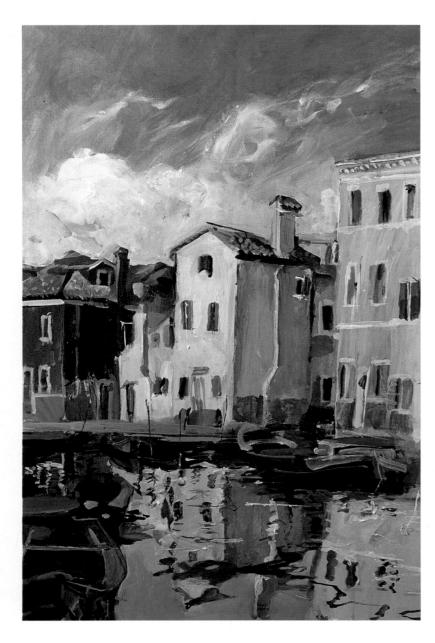

BURANO

This is a painting of houses on a Venetian island, which all have brightly painted exteriors. The colour harmony here is based on the three primaries: red yellow and blue. Notice, however, that the red is not a bright, primary red but is a burnt sienna. The blues and yellows are similarly 'knocked back' by introducing hints of other colours into them.

COLOUR HARMONY

Harmonious colours in a painting, just like harmonious notes in music, work together to create a coherent whole. There are several ways of creating a sense of harmony in a painting. For example, using a restricted range of colours will impose a natural harmony, since you will be weaving the same colours throughout the composition. Or you can emphasise warm colours or cool colours, earth colours or neutrals. Harmony generally exists between those hues from the same section of the spectrum, or colour wheel. Blue, blue-green and blue-violet, for example, work together well since they share a common base colour.

A painting doesn't have to be quiet in colour to be harmonious. In the painting on this page the colours are from opposite sides of the colour wheel, yet the effect is not jarring because they are all equally intense and bright, and this creates an intrinsic harmony. These intense colours create a cheerful, jazzy mood, but they could equally well have been de-saturated by mixing them with white, which would have created a quiet, restful mood.

Although the main colour idea in this painting is based on red, yellow and blue, touches of other related colours, such as orange and green, have also been introduced. This creates a lively, yet subtle effect.

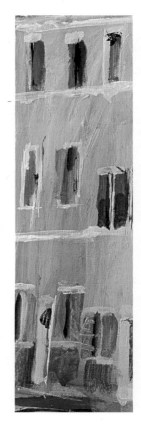

ORGANISING THE PALETTE

Most artists lay out their palettes before they begin painting, having already chosen the colours they are going to use. This works better than haphazardly squeezing out colours as and when you want them. Usually colours are laid out around the edges of the palette, leaving enough space between the colours so that they don't get mixed together by mistake. Leave plenty of space in the centre area for mixing colours.

How you organise your palette is a matter of personal preference, but if you get into the habit of laying out your colours in the same order each time you paint you will be able to reach for the right colour automatically. Dark colours can look very similar on the palette, so it's useful to know which is, say, Payne's gray and which is viridian. Some artists like to start with white at one end of the palette and then arrange their colours from warm to cool or vice versa. Others start with white and work from light to dark colours, or lay out their colours in the order of the spectrum.

HOW MUCH PAINT?

It can be difficult to know how much paint to squeeze out of the tube. On the one hand you don't want to be over-generous and end up throwing unused paint away at the end of the day, but on the other hand squeezing out miserly amounts of paint can restrict your creative flow and it's frustrating to have to stop in the middle of a passage to squeeze out more paint. A lot depends on the size of your canvas and brushes and whether you tend to paint thickly or thinly. With experience you will come to know instinctively how much of a particular colour you are likely to need.

You will probably find that you use a lot of white paint, and it is important to squeeze out enough of it so that you can lift it with a clean palette knife and place it in the middle of the palette in order to mix it with other colours.

During the course of the painting session the mixing area of the palette will inevitably become covered with muddy mixtures of colour. To keep your colours clean and fresh and to have space to mix new colours, scrape off the 'mud' from time to time with a palette knife onto newspaper.

CLEANING THE PALETTE

At the end of each painting session, scrape off the mixtures in the centre with the palette knife and wipe the palette with a rag. If you intend painting again within a day or two, the squeezes of paint around the edges can be saved for re-use by covering the palette with clingfilm to prevent a hard skin forming over the paint. Otherwise, rub the palette with a rag dipped in turpentine.

MIXING COLOURS

'How do I mix that colour?' is a frequent refrain. If you are aiming for a particular colour and are having difficulty mixing it, try the following method. It is not completely fail-safe, but is a good guide. Once you become more familiar with your colours you will find this exercise becomes easier.

Consider the colour you are aiming for and determine its basic hue. Now consider whether it is a warm or a cool version of the hue. If the colour is a blue, for instance, does it veer towards a purple or a green? Now consider whether it has any white in it, and whether it needs a small addition of another colour to nudge it in one direction or the other.

Colour mixes should ideally be achieved with no more than three component colours, otherwise they tend to become muddy. Don't forget that complementary colours and earth colours are useful for de-saturating colours (taking the brightness out of them) and for creating an interesting range of tertiary colours.

Tip

Once you are familiar with the palette of colours recommended on page 32, you may find the following colours useful additions to the list: French ultramarine, terre verte, cadmium green, cadmium orange, light red, burnt umber, raw sienna and lamp black.

When mixing colours, use
a palette knife to lift a
small but sufficient amount
of colour towards the
centre of the palette. Take
a second colour and add it
to the first. Use a brush
with your diluent or
medium to achieve a mix.
Add more colours by the
same means to achieve the
subtle tints you need.
When the palette gets too
crowded with paint mixes,
clean it with rags and
white spirit.

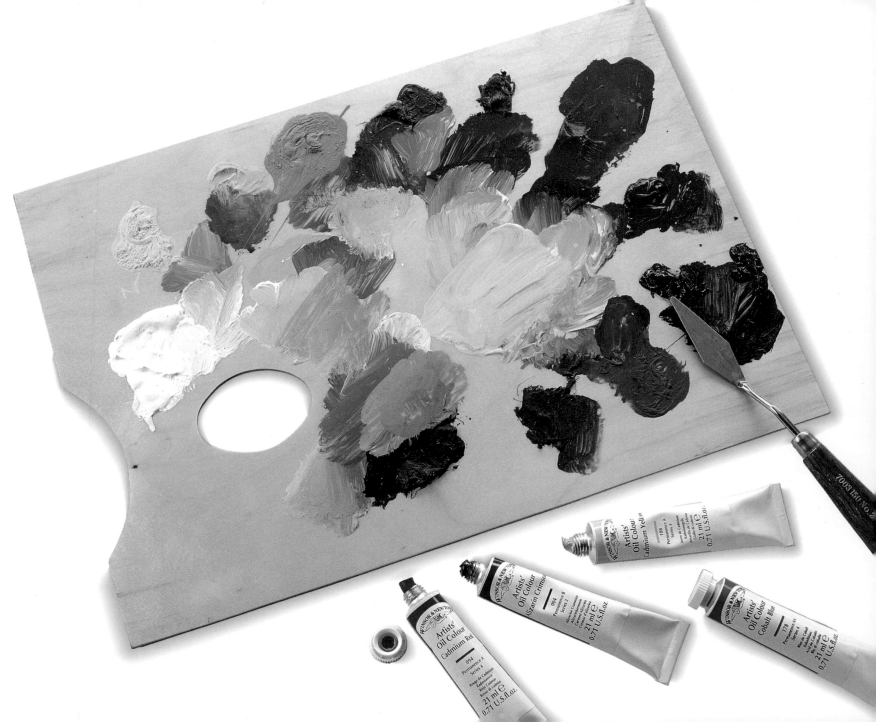

TONED GROUNDS

Supports for oil painting are generally prepared with a layer of white primer. However, many artists prefer to colour the support by applying a thin layer of paint, diluted with turpentine, over the white priming. This is known as a 'toned ground'. Working on a toned ground is a classical oil-painting technique that was frequently used by the Renaissance artists. The Venetians, for example, often painted on a ground of Venetian red, while the Florentines typically used a ground of terre verte (a soft green).

There are several advantages to working on a toned ground. First, a stark white canvas can be inhibiting, particularly for beginners, whereas a coloured surface is more sympathetic. Second, it is easier to assess colours and tones accurately against a coloured ground; when applied to a white ground they often appear darker than they actually are. In the project painting that follows, the coloured ground provides a useful middle tone, so that when you paint the white jug you can work up to the lights and down to the darks with equal ease. If you painted on a white ground, you would have to work through the complete tonal range.

Another advantage of a toned ground is that, if it is allowed to show through the overpainting in places, it helps to unify the picture as small areas of the same colour recur throughout.

The choice of colour is important as it will affect the colour-key and the mood of the finished picture. The most popular colours are soft earths, greys and greens which provide a neutral mid-tone that is subtle and unobtrusive. However, there is no reason why you should not choose a bold, exciting colour to paint on. Always make sure the toned ground is completely dry before you paint over it.

CIDER JUG

This project is designed to demonstrate how the ground colour can influence the mood of a painting. The subject is a simple jug, but I have painted two different versions, one on a blue ground and the other on a reddish ground. Although the difference between the two final paintings is subtle, nevertheless the underlying colour temperature is important: the blue ground gives a cool character to the first painting, while the red ground gives a warm character to the second painting.

START WITH A SKETCH
Make a tonal drawing of the jug in a sketchbook to establish how the light falls on it. Here, a single light source falls on the jug from the left, casting a shadow of the handle on to the side of the jug. The right side of the jug is furthest away from the light source and therefore receives less light. The inside of the jug receives least light of all and is therefore darker in tone.

Palette

BURNT SIENNA

PAYNE'S GRAY

RAW UMBER

ALIZARIN CRIMSON

COBALT BLUE

TITANIUM WHITE

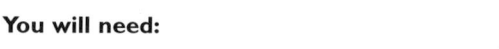

You will need:
- Two sheets of oil sketching paper, each approximately 51x38cm (20x15in)
- Bristle brushes: medium filbert, medium round, small flat
- Jar of distilled turpentine
- Conté pencils: black and white
- Mixing palette • Cotton rag

STEP I

Start by tinting both sheets of oil sketching paper. Paint the first with a fairly thin wash of Payne's gray, diluted with distilled turpentine. Cover the entire sheet, brushing the paint on randomly with broad sweeps. Paint the second sheet in the same way, this time using burnt sienna. Leave to dry thoroughly.

Make a careful drawing of the jug, using either white chalk or a white conté pencil on the Payne's gray ground and charcoal or a black conté pencil on the burnt sienna ground. Draw the jug as though it were transparent. This will make it easier to draw the ellipses accurately. Note that the upper ellipse is shallower than the lower one.

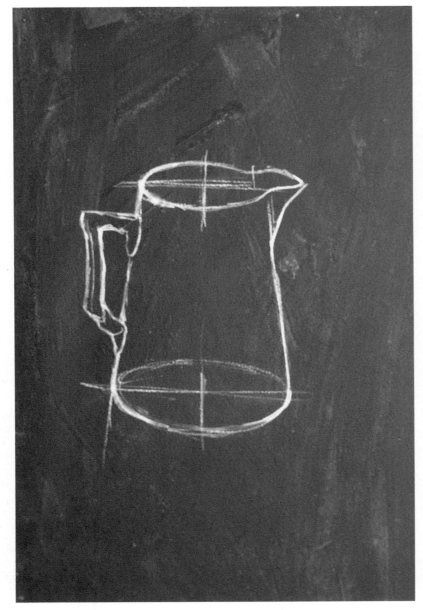

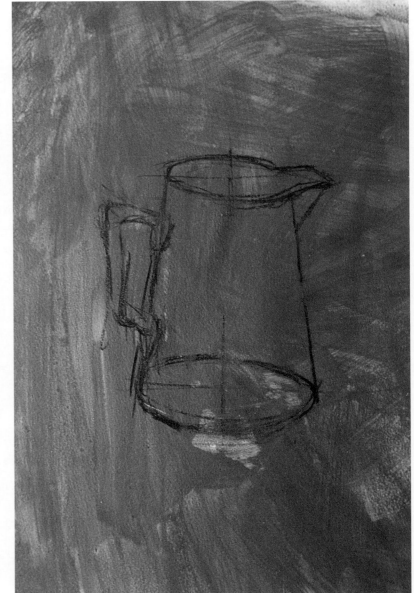

STEP 2

Block in the body of the jug using a mixture of alizarin crimson and titanium white. For the mid-tones, work some raw umber into the base colour, wet-into-wet. Add cobalt blue for the darkest shadows.

You can either fill in the first jug and then move on to the second, or work on both paintings simultaneously, ie painting the lights on both jugs, then the mid-tones, then the darks. In either case, avoid simply copying the first picture. Work constantly from direct observation of your subject.

It is important to relate tones and colours to each other across the work as you progress, rather than working on one area at the expense of another.

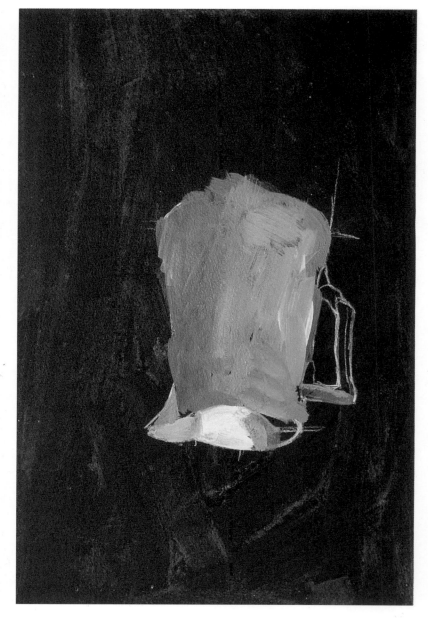

STEP 3

Add the handle of the jug using a middle tone and then put in the whiter areas, on the handle and the top of the jug. The greys make the handles appear solid and invite the eye to explore the hollow interior. Notice that the greys are a positive colour rather than a mix of white and black. Lighten the tone on the main body of the jug where the light strikes it and paint the highlights on the rim where the light glances off it.

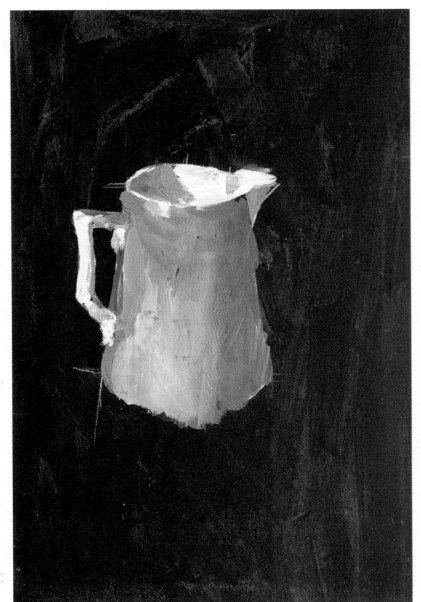

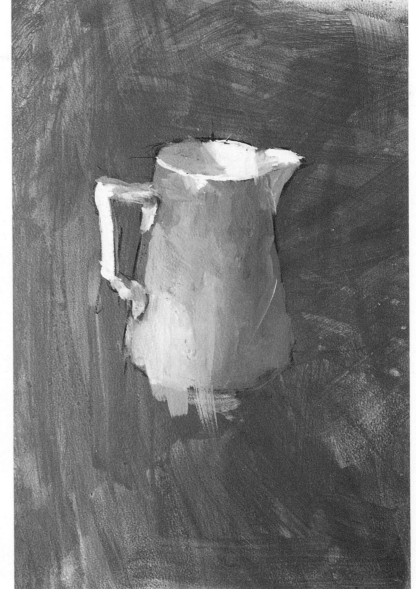

41

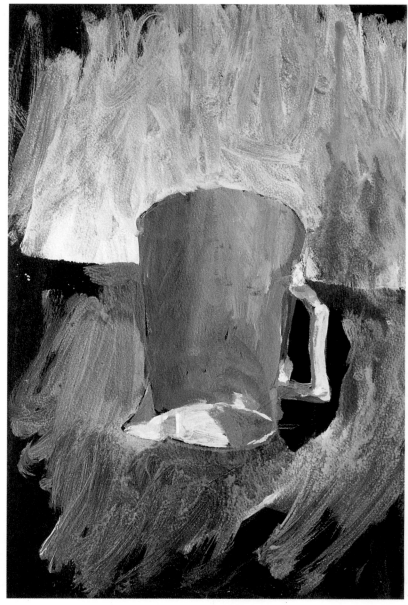

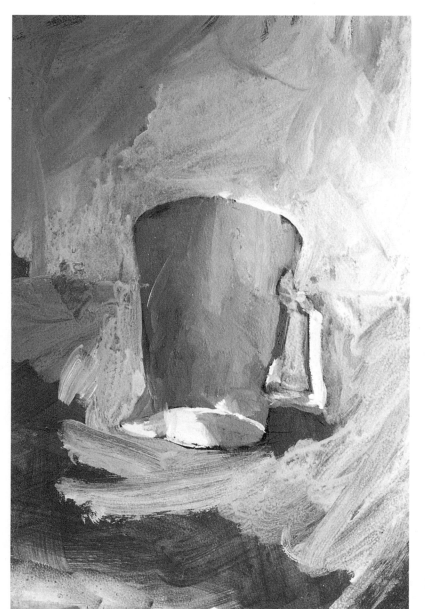

Step 4

Now it is time to relate the jug to the background. It is placed on a flat white surface with a neutral-coloured backdrop behind it. Define these with thin paint using loose, scrubby strokes, painting up to the form of the jug. Keep a lively feel to the brushstrokes so that the background retains some interest rather than being a flat, boring area. The individual characteristics of the cool and the warm coloured grounds are becoming more apparent.

STEP 5

Finish the paintings by making the backgrounds more solid using thicker, more opaque paint. There are variations in the two pieces, subtle though they are.

By doing this exercise, you will discover how much easier it is to paint on a coloured ground than on a white ground. It is almost as though you are 'pulling colour out' rather than 'applying it to' the canvas. The toned ground makes it easier to judge the lights and mid-tones accurately, and it also helps to make the objects in your picture look more solid. You will find that you need to apply less paint because the toned ground acts as a unifying base colour.

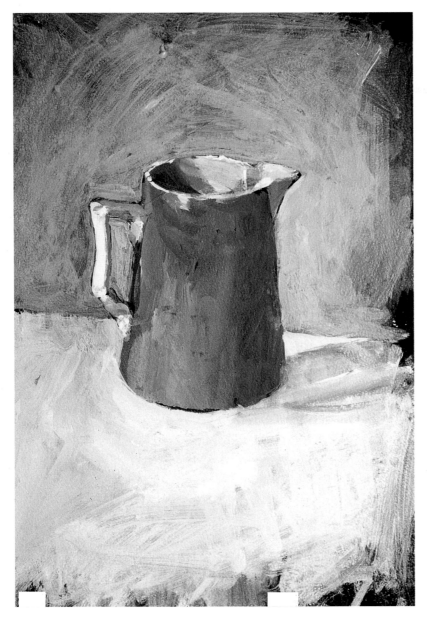

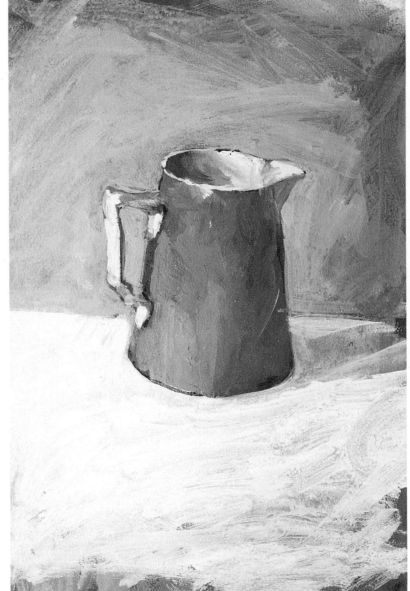

Creating Form

In order to make a painting look convincing and realistic, an artist needs to create an illusion of solid, three-dimensional form on a flat, two-dimensional surface. It's a bit like performing a magic trick, but there is nothing mysterious about it once you understand the way light affects the things we look at. As with all things, the more you practise, the more accomplished you will become, both at understanding what you see and at being able to paint it well. I suggest that you find a simple object such as an apple or an orange and place it near a window or a portable lamp so that, as you read the text below, you can observe for yourself the points I am making

Aims

- To create the illusion of three-dimensional forms on a two-dimensional surface
- To understand the difference between local colour, tone and shadow
- To understand how the direction of light affects and describes form

LIGHT AND FORM

When light falls on an object, its three-dimensional form becomes easy to 'read', basically because light and shadow show us which parts of the object are close to the light and which ones are further away. In addition, the way in which light changes to shadow tells us whether the object is curved or angular. On a box, for instance, there is a sharp division between light and shadow where the top meets the side. On a ball, there is a very gradual transition from light to shadow, which describes the curvature of its surface. These transitional tones between the lightest and the darkest are called mid-tones.

COLOUR AND TONE

When we look at an object, we are aware of its 'local' colour. For example, the local colour of an orange is orange, and that of a leaf is green. If we paint these objects with a single shade of orange, or green, they appear flat and formless. In order to

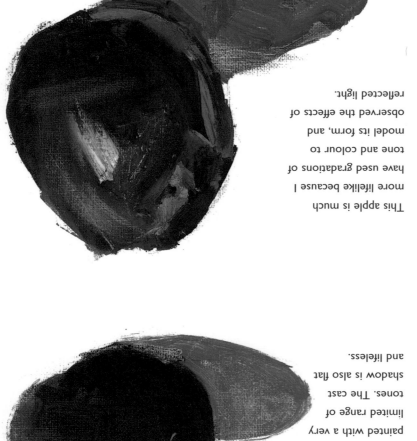

This red apple is painted with a very limited range of tones. The cast shadow is also flat and lifeless.

This apple is much more lifelike because I have used gradations of tone and colour to model its form, and observed the effects of reflected light.

describe form and solidity, we need to observe the way in which light affects the colours of an object.

Similarly, every object has a local tone. As we have learned in Lesson Two, tone is the relative lightness or darkness of an object: a yellow ball is lighter than a black one, for instance. The side of the ball nearest the light will have a much lighter tonal value than the side away from the light, in shadow. In fact, the shadow side of the ball can appear as dark in tone as the black ball.

One important point to note is that the darkest tone falls not at the extreme edge of an object, but just inside that edge. This is because light striking the surface on which the object rests bounces back onto the shadow side of the object. This is particularly noticeable on a sunny day and on shiny objects.

COMBINING COLOUR AND TONE

In a pencil drawing we have to rely purely on the use of shading to create light, middle and dark tones to make objects look solid. But in a painting, it is not enough simply to add black to our colours for the shadows, or white for the highlights; we must also learn how to modulate colour, because light affects colours in infinitely subtle ways. For example, where an object turns into the light it takes on a warmer hue, and where it turns into shadow the colour becomes cooler. If you look at a tree on a sunny day, you will notice how the foliage on the side facing the sun is light in tone and the greens are warm and yellowish in colour, whereas on the shadow side they are darker in tone and cooler and bluer. It is colour, as well as tone, that helps the viewer to 'read' the tree as a three-dimensional form.

To illustrate another effect of light on forms, examine a red apple and an orange under a lamp. You will see that the shadow side of the apple takes on a greenish tinge, while on the orange it tends more towards blue. This is because the shadows falling on an object always contain elements of that object's complementary colour. So, no more dull, lifeless shadows mixed from black and white! Use the information on page 33 to mix lifelike, coloured greys instead.

Highlights, too, are not always white, but often reflect surrounding colours. When the light comes from the sky, the highlight on an apple may appear pale blue; under artificial light, it may well appear yellow. By observing and recording subtleties such as these, you will find that your paintings will improve immeasurably.

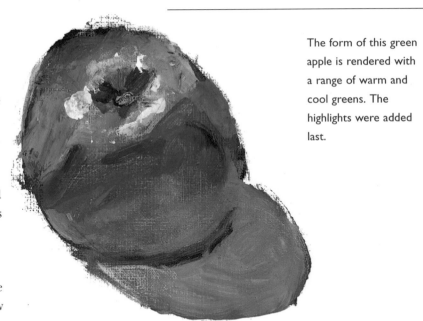

The form of this green apple is rendered with a range of warm and cool greens. The highlights were added last.

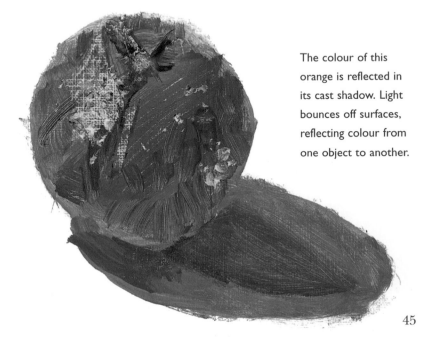

The colour of this orange is reflected in its cast shadow. Light bounces off surfaces, reflecting colour from one object to another.

45

THE LIGHT SOURCE

The way light falls on an object tells us about its form and solidity. But certain kinds of light define form better than others because they create greater contrasts of light and shade. Before you start painting, it is important to establish the angle and direction of the light source. If you are painting outdoors there is little you can do to control the light, but you can make life easier for yourself by choosing the right time of day to paint. At midday, when the sun is high in the sky, the cast shadows are strong, but short. The features of the landscape may appear somewhat flat and there will be a lack of tonal contrast due to the general absence of shadow. This will make it difficult to convey a realistic impression of depth and form in your painting. The same scene viewed in the early morning or late afternoon will look much more interesting because the sun is lower in the sky, casting long shadows that define contours, forms and textures.

Indoors, of course, you can control the amount and direction of the light by positioning lamps wherever you want them. Generally it is best to use a single light source, positioned slightly above and to one side of the subject, which casts shadows that bring out the forms clearly.

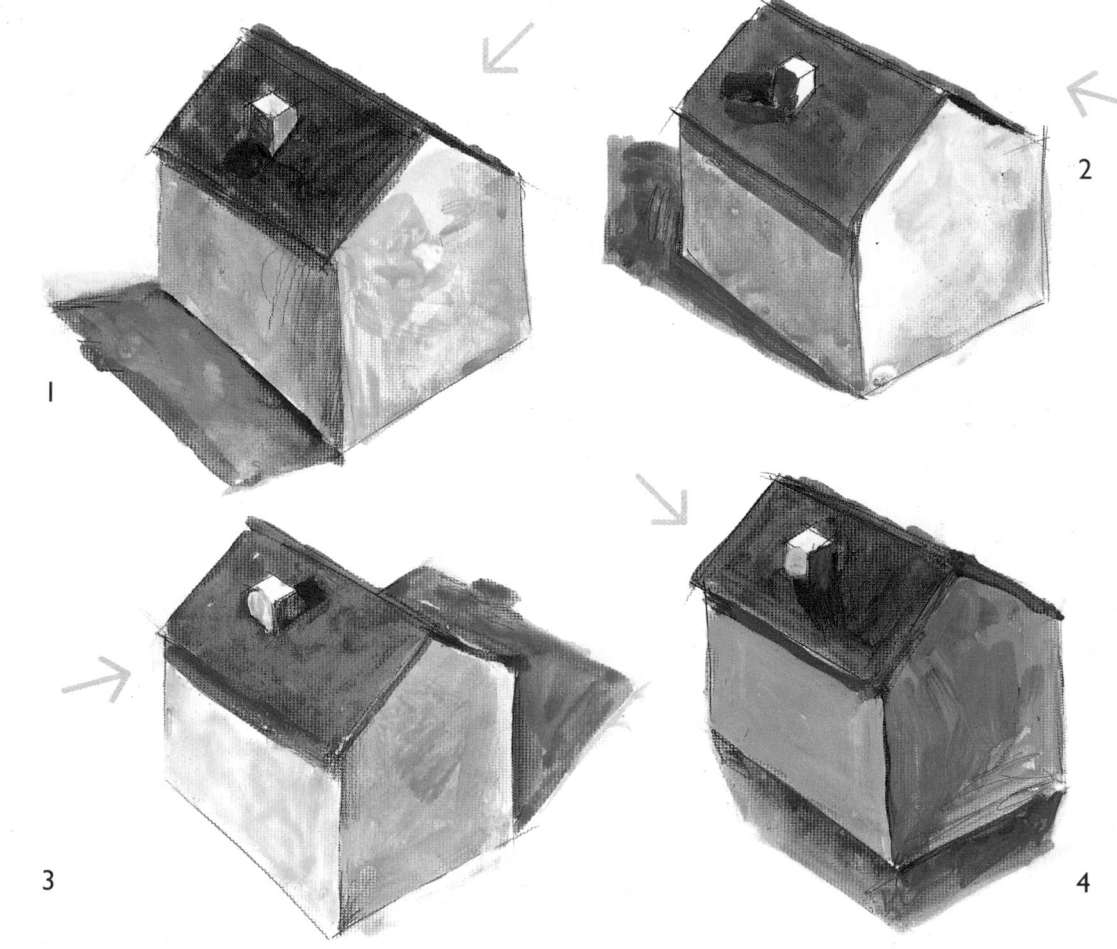

It is important that cast shadows are painted correctly in relation to the objects casting them and to the light source. These diagrams show how the height of the sun determines the length of a cast shadow, and its position in the sky determines the shape of the shadow and the direction in which it falls.

1 The sun is high in the sky and strikes the gable end of the house, casting shadows that run away from us.
2 The sun is fairly low and strikes the house from the right, casting shadows on the left of the house and the chimney.

3 Light from the left casts shadows to the right.
4 The sun is directly behind the house and high in the sky, throwing the whole building into shadow. The cast shadows are short.

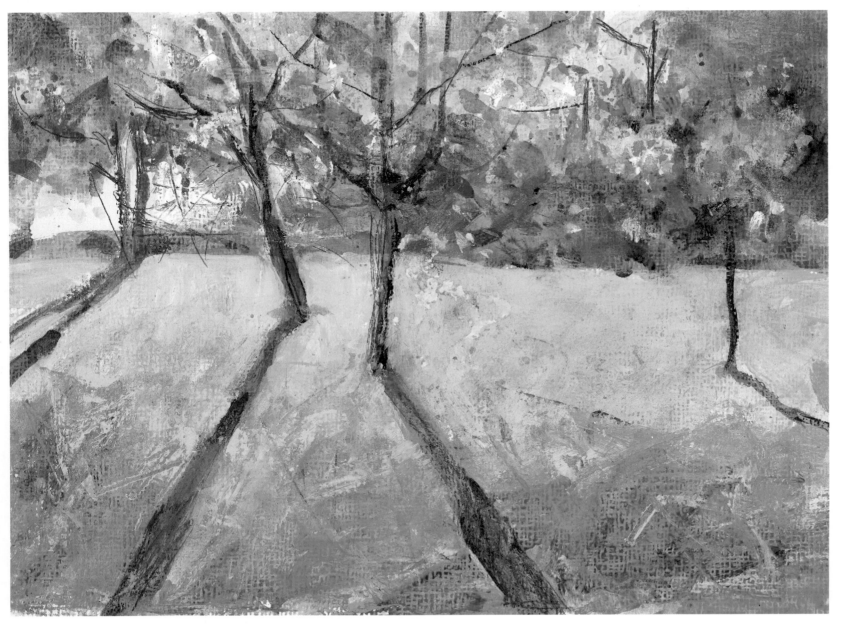

Backlighting can create wonderful dramatic effects. Here, the radiating shadows of the trees create a striking composition. Often, backlighting throws a bright halo of light around the contours of objects, which themselves are lost in shadow.

Tip

Shadows cast by the sun move continually as the day goes on. It is a good idea to draw the positions of all the shadows early on, and stick to them; they may have altered considerably by the time your painting is finished.

GEOMETRIC FORMS

Very often objects, whether they are trees in a landscape or objects in a still life, can appear dauntingly complex. As an artist you can make life much simpler for yourself if you start by reducing forms to simple geometric shapes. The cube, the sphere, the cylinder and the cone can be seen as the basic forms from which all of nature is comprised. A building is basically a cube, a tree trunk and branches are cylinders, an apple is a sphere, and so on. These simple shapes will help to clarify your understanding of any object and the way light strikes it and defines its form. There are very few objects that cannot be reduced either to geometric forms or portions of geometric forms.

SIMPLE STILL LIFE

This project shows you how to paint a cube, a cylinder and a sphere, so that you can learn how light strikes them, how their local colours are affected by light, and how the cast shadows fall.

THE SET-UP
Collect together three objects that resemble this simple set-up of geometric shapes. For example, you could use an orange or a child's ball for the sphere, a bottle or mug for the cylinder, and a tissue box or similar for the cube (it doesn't matter if your object is rectangular rather than square – the principle is the same).

Group the objects together on a flat surface, positioning the cube at an angle so that you can see three planes – the top and two sides. Direct a strong light source onto the group from slightly above and to the left.

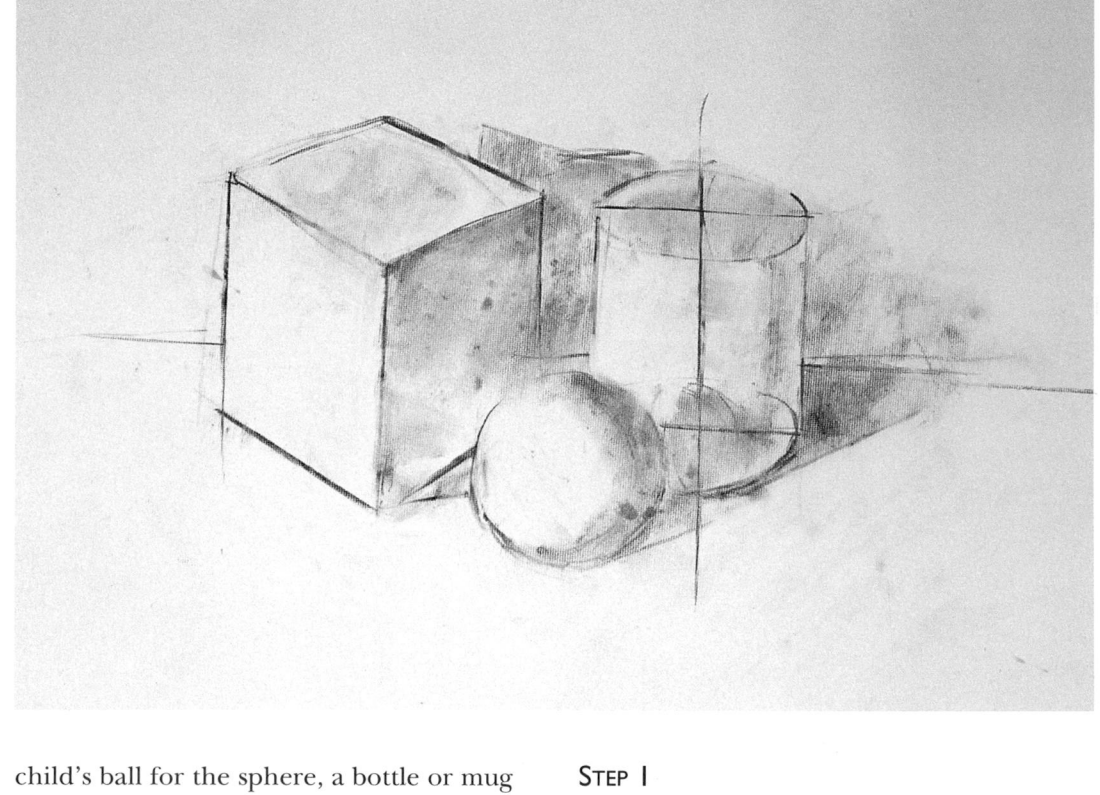

STEP I
Make a careful line drawing of the objects, making sure the proportions and perspective are correct. To help you draw the ellipses at the top and base of the cylinder accurately, imagine that it is transparent and plot central axis lines, both horizontal and vertical. Suggest solid form by blocking in the dark and mid tones with charcoal, dusting off the excess with a rag.

You will need:
- Sheet of canvas paper, approximately 56x76cm (20x30in)
- Brushes: large flat, small filbert
- Charcoal
- Jar of distilled turpentine
- Mixing palette

STEP 2

Using thinly diluted paint, block in the cube with a mixture of cerulean and Payne's gray and the sphere with a mixture of yellow ochre and chrome yellow. Suggest the background shadow with a light tone of yellow ochre and Payne's gray.

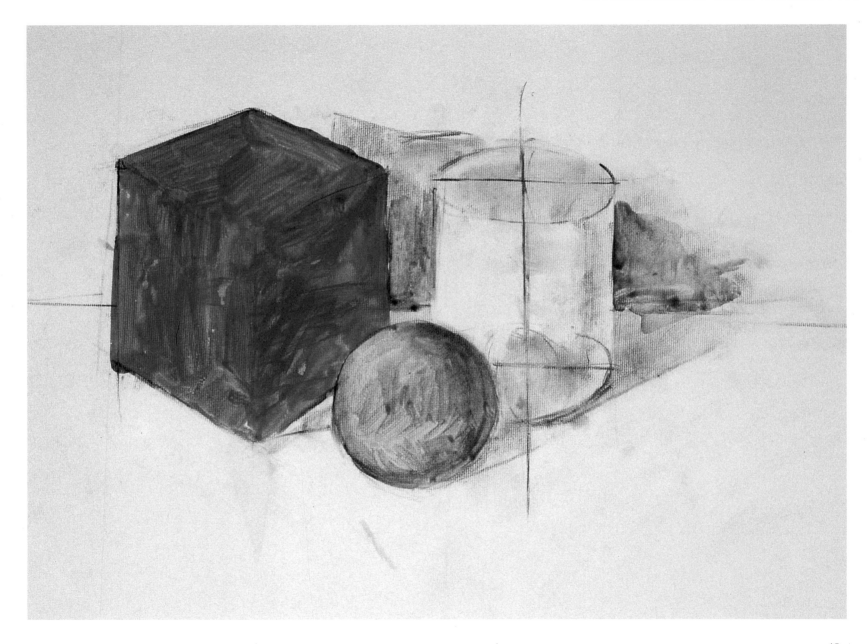

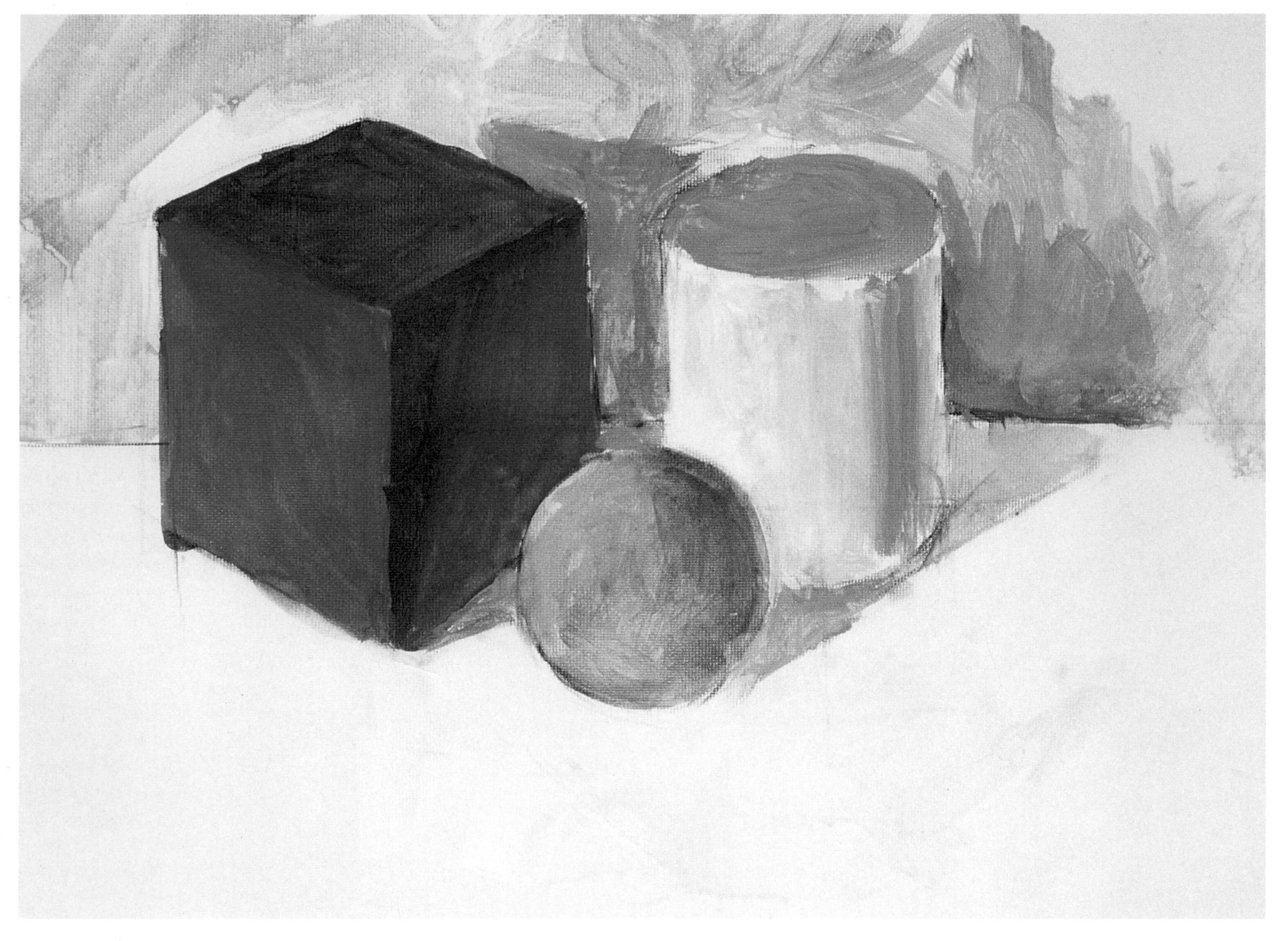

STEP 3

Using thicker paint, start to block in the shadows on the cube to suggest its solid, three-dimensional form. Mix cerulean with Payne's gray to make a dark blue for the top and side planes, which are in shadow. Darken the shadowy underside of the sphere with a mixture of yellow ochre, chrome yellow and Payne's gray. Paint the cylinder with titanium white and a little cerulean, then darken the top with some Payne's gray. Use the same colour for the strip of shadow on the right; notice how the extreme edge is light because it reflects light from its surroundings. Suggest the shadows cast by the objects on the table, and the shadow on the wall behind.

STEP 4

Complete the background shadow with loose strokes of white, yellow ochre and Payne's gray, varying the tone from light to dark. Add some warmth to the cast shadows on the table by adding some yellow to the grey mixture. These cast shadows link the three objects together into a coherent group. Darken the shadow on the ball with more Payne's gray, then add the brightest highlight with a touch of pure white using thick paint.

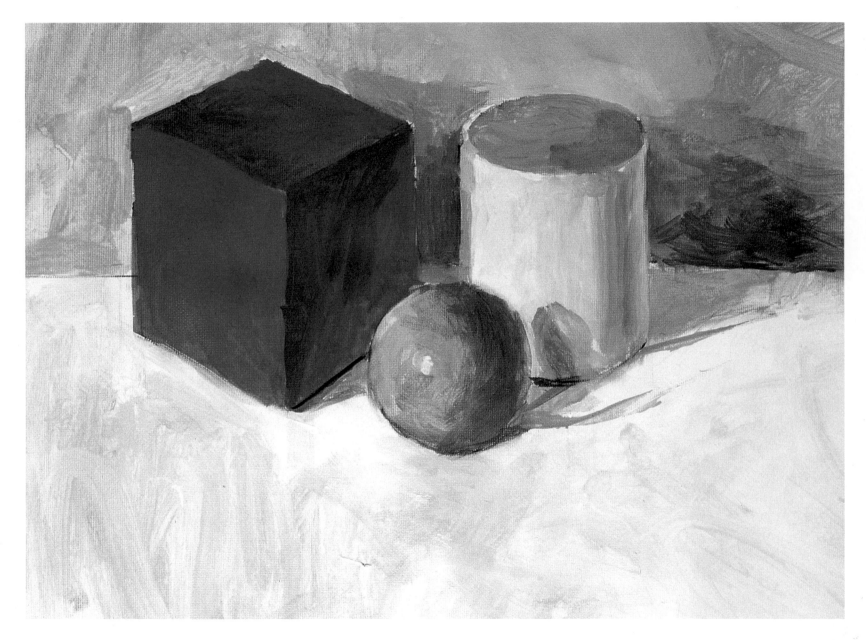

Creating Texture

Painting textures, whether man-made or natural ones, can be very rewarding and challenging. Oil paint, in particular, is a wonderfully tactile and responsive medium and you can have fun with the paint itself as well as recreating different surface qualities.

Every object has its own characteristic texture. Compare the smooth sheen of glass and porcelain with the rough graininess of wood; the soft folds of fabric with the craggy, angular planes of rocks; the soft, velvety surface of a peach with the hard, pitted surface of a lemon. How you choose to convey these varying textures depends on your approach. Some

artists enjoy painting textures in a realistic way: think of the still lifes of the Dutch masters, in which even a tiny droplet of water was rendered with photographic precision. Other artists prefer to use the quality of the paint itself to suggest textures, allowing the viewer's imagination to complete the picture.

RESPONDING TO THE SUBJECT

Suggesting a texture is largely a matter of responding to feelings. You might, for example, paint a calm stretch of water with thin paint and long, fluid brushstrokes, whereas the energy of waves crashing against rocks calls for rapid strokes, thicker paint and perhaps a bit of spattering. Apart from using different brush shapes to make a variety of marks, don't forget that you can also use knives, rags, bits of card and even your fingers to manipulate the paint (as you have learned in Lesson One). Oil paints are endlessly expressive. They can be built up thickly, manipulated with a brush or knife, scratched and scraped into, dragged and scumbled, or thinly diluted

Aims

- To develop a range of expressive brush marks and paint techniques for recreating different textures
- To understand the difference between texture in paint and painting texture
- To vary the paint texture by the addition of coarse-textured materials
- To learn about alla-prima painting

and applied in washes, giving you a wide 'vocabulary' with which to describe the textures around you.

Textures can be recreated not only using expressive marks, but also by suggesting the ways in which different surfaces reflect light. The smooth, shiny surface of a glass bottle, for example, tends to have clearly defined shadows and reflections. Convey this by accentuating the tonal contrasts and adding crisp, hard-edged highlights over a dry surface. In contrast, a velvet cloth absorbs more light and so the tonal variations between light and shadow are much softer. Here, you might use dry,

SEASCAPE
I created a textured ground for this painting by mixing sawdust, string and decorating filler with acrylic primer. This gives the painting a semi-random textural surface which underlines the rugged nature of the subject. The effect is more lively than a painting with smooth, even brushmarks.

This still-life group contains a variety of textures. The glass bottle has a smooth, hard, light-reflecting surface. The shell, too, is smooth, but it has a matt surface and sharp, angular planes. The skin of the grapefruit is pitted but it also has a slight sheen and so picks up some reflected light on the right. I have tried to suggest these textures rather than depict them with painstaking accuracy, and have introduced textural brushstrokes in the background so as to unify the picture.

scumbled strokes to convey the texture of the velvet and blend the edges where different tones meet to create smooth gradations that describe the soft folds.

A LIVELY SURFACE

As well as interpreting the texture of your subject through brushwork and tonal contrast, you can use the thickness of the paint to give the picture surface itself an interesting texture. It is worth remembering that, in oils, the texture of the painted surface can have an intrinsic beauty of its own. If you have ever seen a painting by Van Gogh 'in the flesh', I'm sure you will recall the beauty not only of the actual image but also of the swirling, sculpted brushstrokes, and the paint applied so thickly that it stands proud of the surface. The Impressionists often combined thick dabs of paint with thin, scumbled passages, which not only recreated the textures in nature but also gave their pictures a lively, active surface.

Another way to explore the tactile qualities of oil paint is by mixing coarse-textured materials such as plaster, marble dust, pumice powder or sawdust into the paint or the primer. In the seascape painting on page 52 for example, I made a ground by mixing decorating filler with acrylic primer and scored into it with a knife before over-painting in oils (you can see the score marks clearly in the bottom right corner). I have also added sawdust to the paint in places.

TEXTURE AND FORM

Form describes the solidity of an object and the volume it occupies in space, whereas texture describes the quality of its surface. When we paint a tree, or a figure, or an apple, it is all too easy to become preoccupied with surface texture or pattern and to lose sight of the forms beneath. The way to avoid this pitfall is to start by reducing the subject to a series of simple geometric shapes and studying the way light strikes those shapes. Thus, a tree's trunk becomes a tall, thin cylinder and its crown becomes an oval or a triangle, and the bird's nest on this page becomes a sphere. Now half-close your eyes so that you can see the lights and shadows more clearly. Block these in with thin paint so that you don't lose sight of them as you start to build up texture and detail. When I painted the bird's nest, for example, the light was coming from the right, so I blocked in the shadow tone on the left side of the nest as well as in the hollow. I also blocked in the shadows on the eggs to remind me of their rounded forms.

This is a preparatory study in charcoal for the painting on the opposite page. I loved the contrast between the smooth roundness of the eggs and the wild chaos of the rough-textured nest. It was difficult to define the underlying form of the nest because of the way the light was catching on the straw, but by peering at it through half-closed eyes I could see the lights and shadows more easily.

BIRD'S NEST

Painting knives are excellent for suggesting texture. You can use the flat of the blade to load on thick paint or scrape it off the canvas, and the tip to scratch into the paint, when either wet or dry. In this painting I used the edge of a knife blade, dipped into fairly thick paint, to create broken lines that suggest the angular twists and turns of the straw.

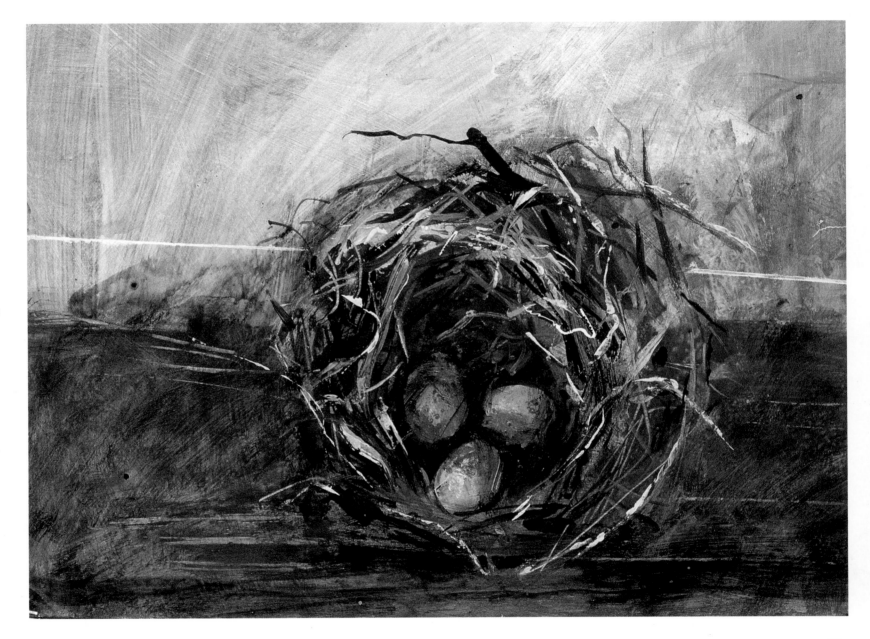

CAULIFLOWER

The humble cauliflower may not be every-one's first choice of painting subject, but I have chosen one for this project because it lends itself perfectly to the exploration of texture using knife and finger work. The painting is built up quickly to an impastoed surface that can be manipulated to imitate the knobbly texture of the cauliflower florets and the thick, tough stalks and leaves. This rapid, spontaneous way of painting is the 'alla-prima' technique, which was introduced briefly on page 27.

When you undertake an alla-prima paint-ing it is important to understand the subject and to be well prepared. Although you will be applying the paint in a sponta-neous way, it is not a good idea to 'make it up as you go along' and leave the decision-making until the last minute. Make preparatory sketches beforehand so that you become familiar with the subject; this will give you more confidence when you come to tackle the painting. In the two sketches opposite I have analysed the cauli-flower, first in a linear sketch and then in a tonal sketch.

Before starting to paint the cauliflower, it is a good idea to first apply a thin wash of colour all over the canvas to produce a toned ground (see page 38), creating a

Above LINE DRAWING
Start by making a thumbnail sketch of the cauliflower with a soft pencil, concentrating purely on shape and outline. Break the subject down into simple geometric forms: the cauliflower is basically a sphere, covered with a series of smaller spheres (the individual florets).

more sympathetic painting surface (because it softens the stark white of the canvas). Mix alizarin crimson and raw sienna and dilute with turpentine to a watery consistency. Apply the wash all over the canvas with a rag or a decorator's brush and leave to dry.

The white highlights of the cauliflower are seen more effectively against this mid-toned background. To save time, you can use acrylic paints diluted with water for toning the canvas: they dry within minutes, allowing you to start the painting without delay.

Below TONAL DRAWING
Make a second sketch, this time analysing form and texture. Look at the subject through half-closed eyes and note the main areas of light and shadow. Blend charcoal with your fingers to make the darks, then pick out the mid-tones with a putty eraser. Use chalk for the highlights.

You will need:
- Stretched canvas, approximately 30x41cm (12x16in)
- Large filbert bristle brush
- Painting knife
- Charcoal
- Chalk
- Putty eraser
- Soft pencil

Palette

PAYNE'S GRAY

YELLOW OCHRE

COBALT BLUE

CADMIUM YELLOW

VIRIDIAN

TITANIUM WHITE

STEP 1

Sketch in a rough outline of the cauliflower using cobalt blue and a large filbert bristle brush. Suggest the outer leaves with a bright green mixed from viridian and cadmium yellow. Paint the heart of the cauliflower with titanium white, broken with cobalt blue and yellow ochre in the darker parts. Use your fingertips to dab the paint on: they are the perfect implement for painting the little cauliflower florets!

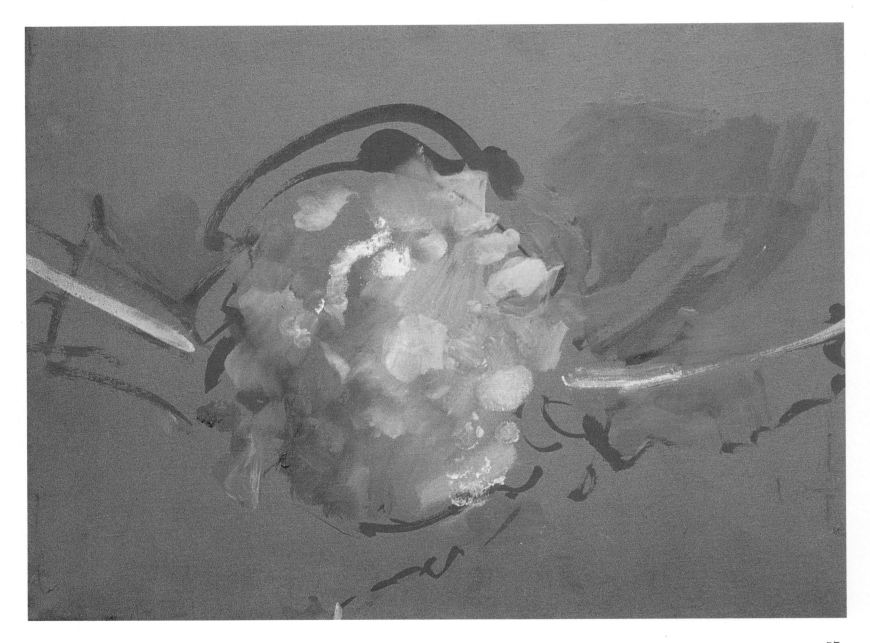

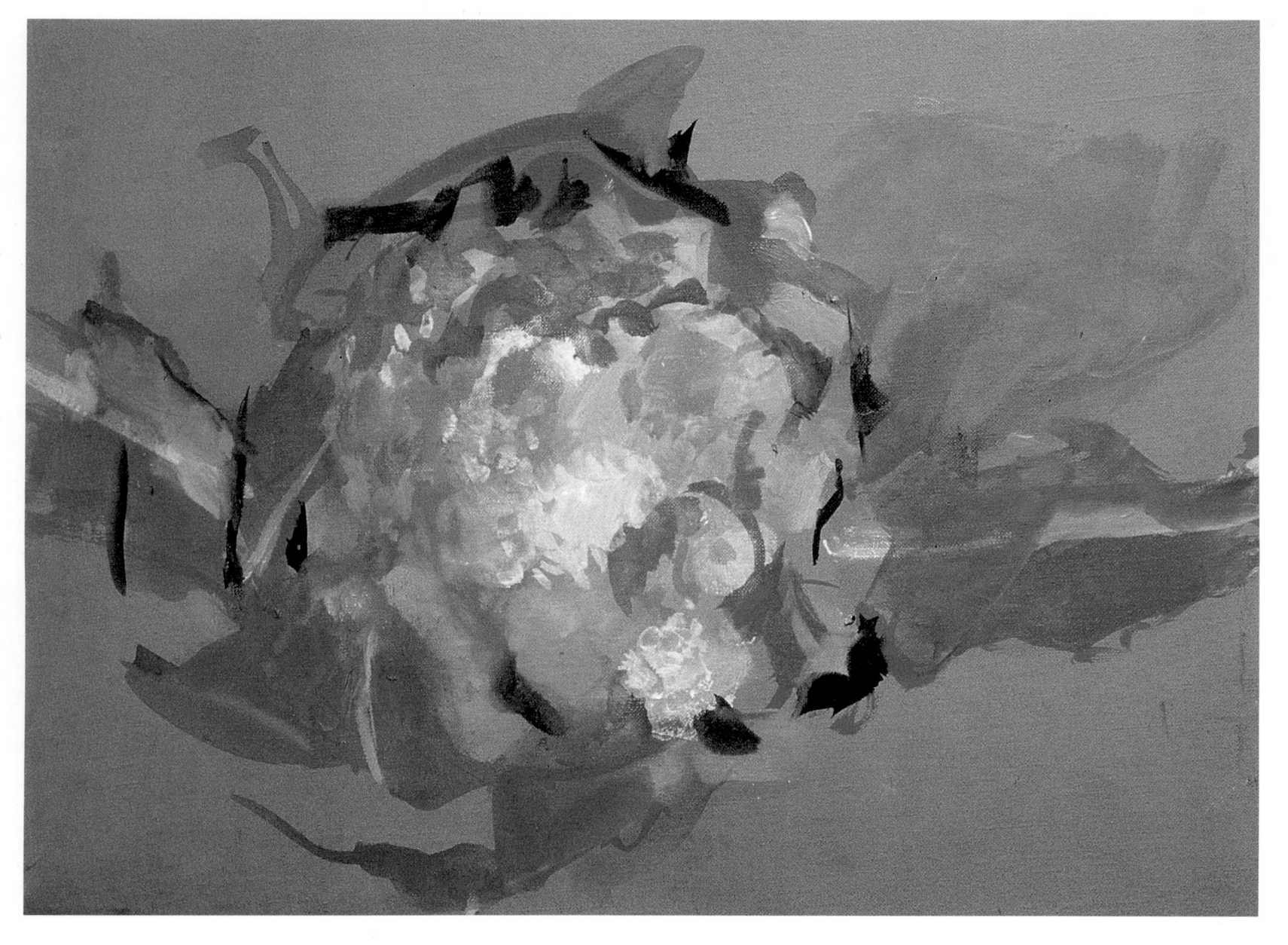

STEP 2
Strengthen the forms by stressing the light and dark tones. Use a cooler green mixed from viridian and cobalt blue for the darker leaves. Mix the darkest shadows from Payne's gray and cobalt blue.

STEP 3

Add more tonal detail on the leaves using thicker paint: use your brush and also the edge of a painting knife to capture the crispness of the leaves. Elaborate the rich 'clotted cream' texture of the cauliflower heart with thick paint used straight from the tube, again dabbing it on with your fingertips. It's messy, but great fun and it recreates the texture better than a brush!

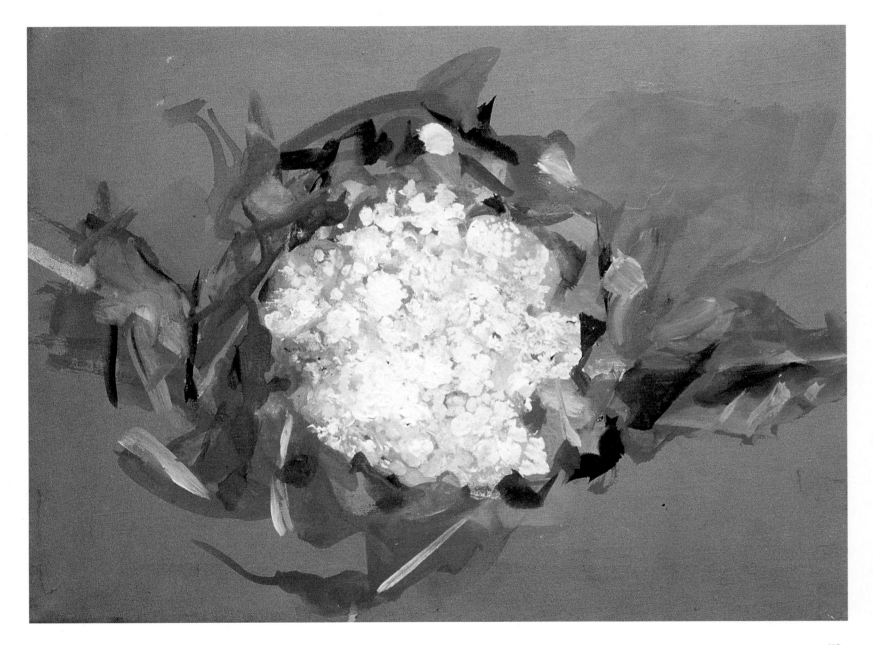

LESSON FIVE

Drawing and Composition

Underlying every good painting is the ability to draw. Drawing trains the eye to see and to understand what we are looking at. Practise drawing as often as you can, just as a musician practises scales and a dancer practises steps. You will be surprised how quickly your skills improve if you manage to draw regularly.

KEEPING A SKETCHBOOK

Get into the habit of carrying a sketchbook with you all the time and take every opportunity to use it. A sketchbook and pencil are easily portable and can be whisked out of a pocket or bag whenever you see something of interest. You should not feel under pressure to produce perfect finished drawings. Your sketches are personal observations that are important

Aims

- To use a sketchbook effectively
- To learn how to enlarge an image by squaring up
- To learn how to compose pictures well

DRAWING FOR PAINTING

Preparatory work is an important part of working towards a successful oil painting. It makes life a lot easier if you can work out a pleasing and well-constructed composition before you put brush to canvas. Sketchbooks are immensely useful for exploring compositional ideas and for resolving problems.

It is not always practical to paint in oils on location, perhaps because the weather is changeable or your time is limited. Oil-painting equipment can be cumbersome to carry, and then there is the problem of transporting wet paintings home again. With a sketchbook, on the other hand, you can make several studies of the same subject in a short space of time and use these as reference for a painting done later at home. Suppose you come across a

only to you, and what other people think of them does not matter. Think of your sketchbook not as a public showcase, but as a private 'visual diary' in which to record places and things that interest you.

landscape scene that you would like to paint. If you have your sketchbook to hand, you can draw the details of the scene, make thumbnail sketches to work out the best composition, do a tonal sketch for information on light and shadow, and make colour notes. Do not hurry over the sketching stage; while exploring your subject you will be absorbing a great deal of information – far more than you could get from taking a photograph.

I drew this quick sketch in coloured chalks on a tinted paper. Tinted papers are useful for sketching because their colour can be integrated into the drawing. I have used both lines and smudging to suggest the duck's soft, round body and its feathers, and a bit of hatching with bright green chalk is enough to suggest the background.

SKETCHING MEDIA

There is a wide variety of sketching and drawing media available, although the good old graphite pencil remains most people's favourite. Coloured pencils (and their watersoluble cousins), oil pastels, sketching pens, ball-point pens and felt-tips are also good for sketching outdoors as they are easily portable – and because they can't be rubbed out they concentrate the mind wonderfully! Charcoal, graphite sticks, pastels and pastel pencils are ideal for capturing soft, atmospheric effects in the landscape, but they do smudge and the sketch will need to be spray-fixed. For detailed and informative colour studies, perhaps as reference for a painting, try using water-based media such as watercolour, gouache and acrylics.

Tip

Pencils and pens are ideal for making quick sketches and notes, but if you are making sketches as reference for an oil painting it is better to use a more sympathetic medium such as oil pastel or chalk pastel. These have a natural affinity with oil paints as they make broad, generous marks and it is difficult to make small, fiddly marks with them.

I always take sketchbooks with me when I travel abroad, and I find that sketches conjure up memories far better than photographs. Coloured pencils are great for sketching because they are portable and clean to work with. I spotted the bunch of garlic hanging on the back of a door somewhere in the Dordogne, and I used coloured pencils to exaggerate the subtle colours in their purplish-white skins. Likewise, coloured pencils convey the complexity of the reflections in the sketch of a gazebo on a lake in Tuscany, Italy.

61

VIEWPOINT AND COMPOSITION

Composition is really all about creating order out of chaos. A landscape view, for instance, may be breathtaking to look at in reality, but if you then paint a picture of it and try to include everything you can see, you will only end up with a muddled and boring image. Good composition involves simplifying what you see in order to capture its essence. It also means thinking about the visual appeal of shapes, colours, tones, patterns and textures, and arranging them in a way that creates a balanced and satisfying image which attracts and holds the eye.

To become more aware of composition it is helpful to have a cardboard viewfinder. This can be made quite simply by cutting a rectanglar-shaped window in a piece of card, or cutting two L-shaped pieces of card to form a rectangle that can be adjusted to any proportion. Look through the frame at familiar objects, parts of your home,

Viewfinders

people's faces or landscapes. By imposing this frame on a potential subject, you see it not as a collection of 'things' but as a picture. Look at your 'picture' with a critical eye. Is the focal point slap bang in the middle of the picture? If so, move your position so that it is off-centre, but not too close to the edge. Do the same with the horizon line. Is the arrangement of light and dark shapes pleasing, or are they too scattered or unbalanced? If so, adjust your position or make a mental note to make some adjustments in the painting.

Whatever subject you are intending to paint, it is worth taking time beforehand to walk around it and observe it from different angles and viewpoints. You will be surprised how even small changes of viewpoint can dramatically alter the perspective, the mood and the composition of your proposed picture. You will also be delighted to discover just how many different compositions can be obtained from even the most basic subject!

When you first start painting you may prefer to view your subjects from a straightforward angle and at normal eye-level. But as you gain more confidence and skill you could try more challenging viewpoints. Seeing things from a 'bird's-eye' view, for example, is fascinating because it is relatively unusual. Taking a 'worm's-eye'

view can also create arresting images (see page 81), with elements of the composition towering above you, giving a dramatic sense of perspective.

Subject viewed from directly above.

These three paintings show just how different the same subject can appear when seen from various angles. By changing viewpoint you change the relationship between the size and proportion of the various elements in the picture area, and the spaces between them. Note how the dynamics created by the stripes on the background cloth give each painting a different mood.

Subject viewed from a low angle.

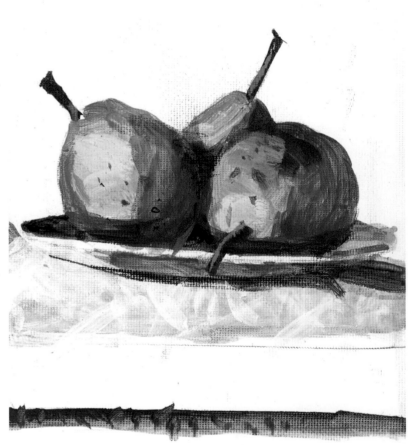

Subject viewed at eye level.

63

SQUARING UP

You may decide that you want to base an oil painting on a sketch or drawing. Sketches are usually smaller than finished paintings, and transferring information from the sketch to the canvas freehand, at the same time enlarging the scale, often leads to errors of proportion. This problem can be avoided using the simple method of squaring up (also known as scaling up or gridding up).

First, ensure that the canvas you intend painting on has the same proportions as your sketch (or draw a rectangle around your sketch so that it has the same proportions as the canvas). Using a pencil and ruler, draw a grid of equal-sized squares over the sketch (use tracing paper if you don't want to mark your sketch). The more complex the image, the more squares you will need. You can also subdivide the squares by drawing diagonal lines from corner to corner.

Repeat the grid on your canvas (adjusting the scale to the size of the canvas). The size of the squares will depend on the degree of enlargement required: for example, if you are doubling the size of your sketch, make the squares twice the size of the squares on the drawing. When the grid is complete, you simply transfer the information in each square of the sketch to its equivalent square on the canvas, resulting in an accurate enlarged version of your initial composition. You can transfer as much or as little detail as you need; often it is enough simply to mark in the main proportions and then work directly onto the canvas using the drawing as reference.

You can also use this method with photographs, the only problem being that they often include details which artists naturally edit out of a picture as they work. Photographs are useful as a back-up to drawings and sketches, but I would not recommend copying directly from them because you will inevitably end up with a rather stiff and lifeless painting.

DUTCH LANDSCAPE

Squaring up comes in particularly useful when the original subject or image features objects positioned at a perspective angle. In this painting of a group of Dutch houses, for example, the buildings are viewed in two-point perspective. The angles of the receding walls, roofs, windows and doors can be accurately gauged by comparing them with the horizontals and verticals of the pencil grid drawn over the sketch.

You will need:
- Reference sketch
- Sheet of canvas or board, approximately 27x38cm (10½x15in)
- Brushes: small bright bristle, medium round bristle
- Pencil
- Ruler
- Mixing palette
- Jar of distilled turpentine

STEP 1

Draw a rectangle around your sketch so that it has the same proportions as the canvas you have chosen for the painting. Use a pencil and ruler to draw a grid of squares over the the sketch. Here the squares are identified by numbers and letters, although this is not always necessary.

Palette

PAYNE'S GRAY

BURNT SIENNA

CADMIUM YELLOW

CERULEAN

ALIZARIN CRIMSON

VIRIDIAN

TITANIUM WHITE

Step 2

Copy the same grid of squares, suitably enlarged, onto the canvas. Label each square identically to those on the sketch as an extra cross-reference. Copy the main outlines of the image, square by square, from the sketch to the canvas. Confident that the angles and proportions of the image are accurate, you can now begin to paint.

STEP 3
Use a small bright
bristle brush to block
in the main colour
areas with thinly diluted
paint. The short
bristles of this brush
give more control
when painting fine
details. Use cerulean
on the left of the sky
and a warmer mixture
of cerulean, alizarin
crimson and white on
the right. The dark
tone of the sky etches
out the white-painted
parts of the buildings.

STEP 4

Add the detailed features, while still retaining the overall unity of the scene. Paint the water and reflections, then mute the colours with a wash of Payne's gray using a medium round bristle brush. The reflections of objects appear slightly darker than the objects themselves; note how the whites on the buildings, for instance, appear slightly grey in the water. Don't overdo this, otherwise the pattern of white lines that create a chatter across the surface of the water will be lost.

CHOOSING A FORMAT

When composing a picture you need to consider how to show the subject in the most effective way. By choosing the right format (shape) of support you can enhance certain qualities in your composition and create specific moods.

There are two traditional formats used in painting: 'landscape' (horizontal) and 'portrait' (vertical). Both are based on the rectangle, and although the size of the rectangle varies, the classical proportions are 2:3. The horizontal format is traditionally used for landscapes because it can encompass a wide, sweeping view, and the flowing horizontal lines across the picture create a feeling of space and calm. The upright format is naturally suited to portraits and figure paintings because it tends to lead the eye upwards and will enhance both a dynamic, imposing figure and a languid, elegant one.

Of course, it all depends on your subject and how you wish to present it. For example, you might choose a portrait format for a landscape because you want to emphasise the sky or a group of tall trees. A reclining figure such as the one on page 102 fits well in a landscape format and the horizontal lines within the picture create a tranquil mood. A single subject can offer

Portrait format

Landscape format

Square format

several compositional options, as demonstrated by the sketches on this page.

Square formats are more unusual because it is more challenging to create a satisfactory composition, but they can be very effective. The square picture on the right is divided into three horizontal bands of sky, sea and land, offset by the verticals of the buildings. The square format gives a feeling of stability.

Tip

It is useful to have an adjustable viewfinder with which to 'frame' your subject. By sliding the L-shaped cardboard pieces together or apart you can alter the size of the aperture and create a horizontal, vertical or square format, and explore the various compositional options.

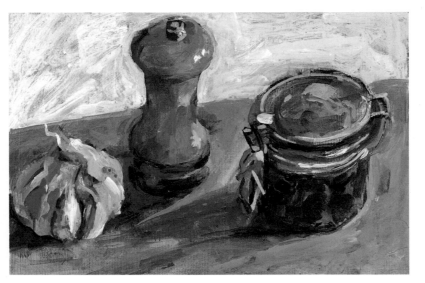

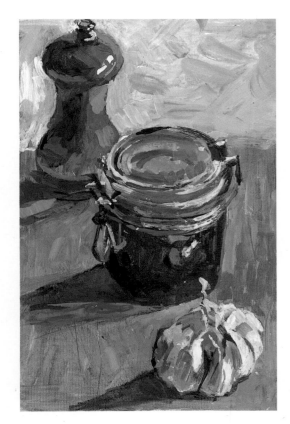

PLACING OBJECTS

The way objects and the spaces between them are arranged within the confines of the canvas can create important nuances within compositions. Simply by moving the objects around, you can create a picture with a very different 'feel'. These still-life paintings illustrate just three arrangements of the same subject, and there are many other possibilities.

Above DIAGONAL COMPOSITION
Diagonal lines create a feeling of movement and energy within a composition. In this painting, the pepper pot, preserve jar and garlic bulb are arranged diagonally. The shapes are linked because they overlap, making a rich and varied series of shapes. The portrait-format canvas enhances the dynamism of the composition.

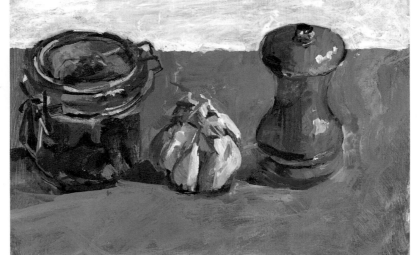

Top left TRIANGULAR COMPOSITION
Here the three objects are arranged on a landscape-format canvas. Together the objects form a triangular composition, with the top of the pepper pot forming the apex. Triangular compositions give a feeling of stability, but they are visually more interesting when they are asymmetrical. Here the pepper pot is placed slightly off-centre, and the spaces between the objects are varied.

Bottom left HORIZONTAL COMPOSITION
Here the objects are deliberately arranged in a regularly spaced line to create a calm, quiet mood. The cast shadows link the objects together, emphasising the stability of the composition.

Still Life

There are many practical advantages to painting still lifes. You have none of the uncertainties of landscape painting, with its changing weather and light; you can choose the objects you want to paint and arrange them in any way you please; and you can even control the lighting by using strategically placed lamps. A still life can be set up in minutes and is an excellent subject with which to explore relationships of colour, tone and shape as well as light and space, texture, form and composition. Once set up, your still life can be painted over several days if you like, so that you don't have the added pressure of finishing a painting in a single session, as you might when painting an outdoor subject.

Aims

- To use still-life subjects to improve skills in drawing and composition
- To understand the importance of positive and negative shapes
- To discover how a monochrome underpainting can simplify the process of painting

SETTING UP

If you haven't tackled this subject before, dont be tempted to include too much. Start with a simple arrangement of, say, three objects (uneven numbers work better than even ones). The kitchen is a rich source of subject matter, but other places can be just as good. Try the potting shed, the tool cupboard, or the attic. Look for items that are compatible or tell a story: flowers and fruits, vegetables and kitchenware, or potted plants and gardening equipment. A block of cheese on a bread board with a knife, an apple and a dish of butter naturally create a harmonious picture because they are related by association.

ARRANGING THE GROUP

When selecting objects for your still life, think about their shape and colour and the rhythms they create when grouped together. Arrange them so that they overlap, creating the illusion of depth, and make sure the spaces between them are interesting. Move the objects around until you are happy with their arrangement, or try moving your own position slightly: as we have seen on page 62, simply altering your viewpoint, or moving in closer, can often reveal much more interesting compositions.

COMPOSITION

Consider the shape of the group you have arranged. It may look pleasing, but the eye takes in everything and is not as selective as your painting will be. Does the group as a whole form a strong overall shape, such as a triangle, an oval or an L-shape? Look through your viewfinder and check for compositional errors such as the line of the table top cutting horizontally across the middle, or having two objects of exactly the same height. Decide which object or area is to be the focal point, and position it off-centre rather than in the middle. If the background looks boring and empty, introduce some draped fabric or a background object to break it up.

A well-composed still life contains both harmony and contrast. Harmony is created

by repeating or echoing shapes, tones and colours. However, too much repetition is visually boring, so introduce contrast. For example, a group of bowls, jugs and fruits is harmonious because it includes rounded forms. But if those objects vary in size, colour and tone, and if you include linear elements in the background, you introduce a note of contrast, which gives the picture more interest.

POSITIVE AND NEGATIVE SHAPES

When we are painting a still life, our attention tends to focus on the objects themselves. These objects are called 'positive' shapes. The 'negative' shapes – the spaces between and around the objects – are often overlooked, yet they are just as important as the subject. A well-designed composition takes account of every area of the picture, including the shapes of the table top and background, the shapes between the objects, the spaces between leaves and flowers, and so on.

It helps if you look at the objects as a series of shapes, colours and tones that link together, just like a jigsaw puzzle, rather than as 'things'. Then you can see how the shapes, colours and tones relate to each other and check whether they are balanced, without the distraction of

Look for positive and negative shapes in your subject. A good exercise is to paint the 'positive' object (*far left*) and then make a separate painting of the 'negative' shapes between and around the object (*right*). Compare them later and see how accurate your first painting is. Drawing and painting well is really about sound observation.

looking at familiar, recognisable objects.

Do some thumbnail sketches of the outline made by the shapes as a mass, shading in the solid areas. This will emphasise the positive and negative shapes created by the composition and their relation to the background.

Learning to recognise the importance of negative shapes will also help you to draw better. Sometimes, a shape such as a cup

just doesn't look right, despite much effort and rubbing out. This can sometimes be because you have drawn what you know, rather than what you see. If you concentrate on drawing the shapes around and between the cup, your drawing will be more accurate. Similarly, plants and flowers can be much easier to draw if you start with the spaces between the leaves, flowers and stems.

LIGHTING

Once you have arranged your group you will need to think about lighting it. Daylight from a window gives the most natural effect, but its quality and direction will change as the day goes on. The easiest solution is to use an adjustable lamp or spotlight. Place it slightly above and to one side of the group so that it throws clear, strong shadows that help to describe forms and link objects together. You could also try placing the group directly in front of a window or in front of a lamp so that it is backlit. This throws a beautiful halo of light around the objects and glows through leaves and flowers so that they appear lit from within.

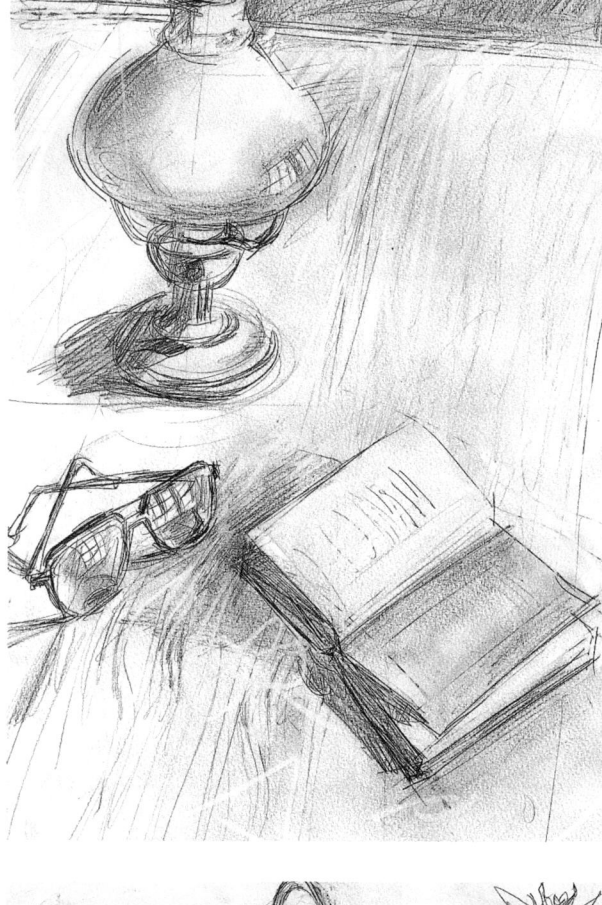

Pencil sketches teach you to see the picture possibilities in ordinary scenes and enable you to understand the shapes of individual objects and how they relate to each other.

The drawing of the shoes is cropped in close to make interesting positive and negative shapes around the edges of the picture as well as creating strong shapes of light and shadow. The gardening group is an example of how man-made and natural objects create interesting contrasts and yet are part of the same story. The group of fruits is linked by the shadows, and the foreground area creates a strong triangular shape which is counterbalanced by the strong diagonals that run through the arrangement.

A still life doesn't have to be a group – it can consist of a single object. Even the most ordinary, everyday object is worthy of study if you have something interesting to say about it. The open scissors create dynamic positive and negative shapes, and I have positioned them to the left of centre to make an asymmetrical composition. Although there is a lot of empty space around the scissors, the use of broken colour and textural brushstrokes helps to enliven it.

MONOCHROME UNDERPAINTING

Monochrome underpainting or 'grisaille' is a classical way of painting in oils that was often used by the Old Masters. Grisaille means, literally, painting in grey mono-chrome, although in practice any neutral colour can be used. The idea is to under-paint the main shapes, masses and tones of the subject in monochrome, using thin paint, prior to developing the painting in colour. You can see at a glance whether or not the composition 'hangs together', and any necessary changes can be made before it is too late. Because the paint is thin, alter-ations can be made by wiping the paint with a rag soaked in turpentine.

This method is a good one for beginners because it breaks down the painting process into manageable parts: having established the composition and the tonal values in the first stage, you are free to con-centrate on colour relationships, textures and details in the second stage instead of having to consider everything at once.

When underpainting in oils, always keep in mind the principle of working 'fat over lean' (see page 26). The paint should be thinly diluted with turpentine and allowed to dry completely before overpainting with thicker paint. To save time, you can use acrylic paints for the underpainting; these

STEP 1

Make a charcoal drawing of the still life on the canvas, focusing on the direction of the light, the shadows, and the structure of the drawing. Draw the central axis of any cylindrical objects in order to keep them symmetrical and solid looking.

You will need:

- Sheet of canvas or board, approximately 51x76cm (20x30in)
- Brushes: large round bristle, medium flat bristle
- Cotton rags
- Jar of distilled turpentine
- Stick of charcoal

dry in minutes and you can begin the over-painting in oils in the same session.

It is important to keep a freshness and a looseness in the underpainting so as not to restrict the freedom of your brushwork in the later stages. Use large brushes and work quickly and loosely, blocking in only the main shapes and masses.

STILL LIFE ON A TABLE

A still-life group illuminated by artificial light is a good one with which to practise underpainting because the tones remain consistent indefinitely. Illuminate the group from slightly above and to one side as this creates a logical pattern of lights, mid-tones and shadows and accentuates the forms.

Start by making a tonal charcoal drawing to establish the structure of the objects and the way the tones are arranged. You can either make a separate sketch on paper or work directly onto the canvas (in which case, don't forget to dust the excess char-coal off before you start painting so that it doesn't sully your colours).

PAYNE'S GRAY

YELLOW OCHRE

COBALT BLUE

CADMIUM RED

CADMIUM YELLOW

VIRIDIAN

ALIZARIN CRIMSON

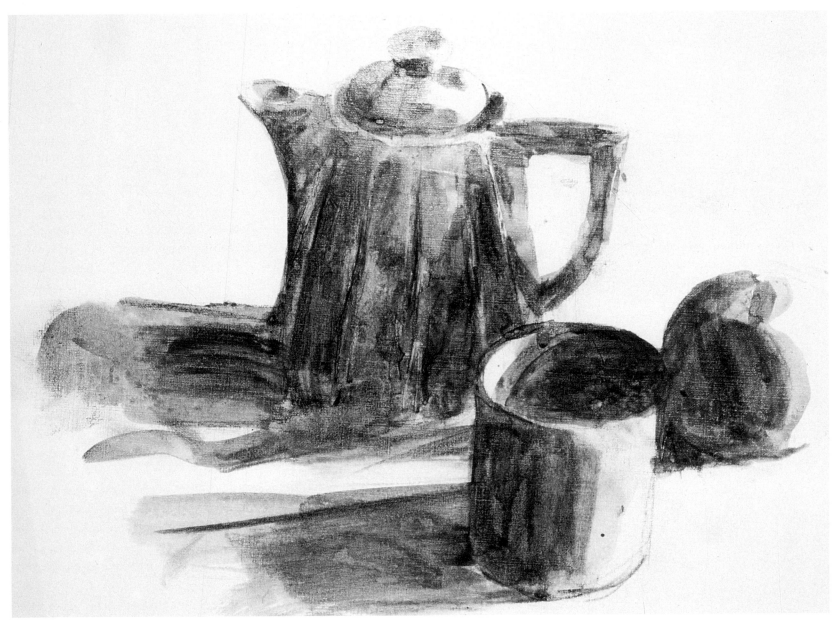

Before applying the first layer of paint, dust the loose charcoal off your drawing. Starting with a mix of yellow ochre, Payne's gray and alizarin crimson, begin to establish a colour mood and concentrate on the lighter mid-tones to give the objects more form. Using a touch of titanium white will help highlight areas of reflected light. By combining it with the other colours, you can also broaden the range of tones to suggest greater depth.

STEP 3

Add the darker mid-
tones to make the
forms of the objects
begin to look more
solid. The under-
painting is beginning to
unify the picture, as
underneath it has a
colour mood which
brings the whole work
together. At this stage
it is particularly
apparent in the
shadows, which can be
overpainted in different
colours whilst retaining
the mood created by
the underpainting.

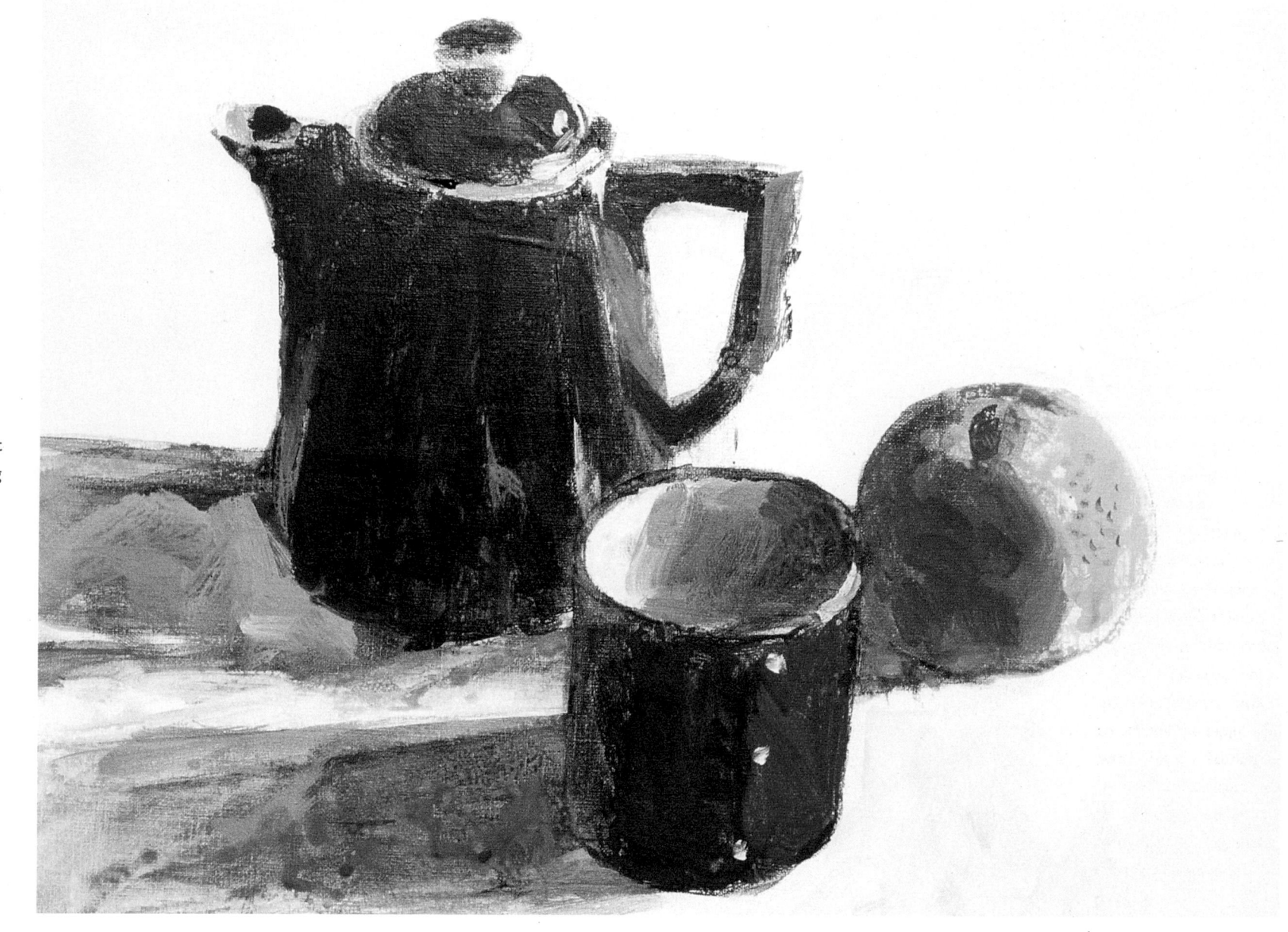

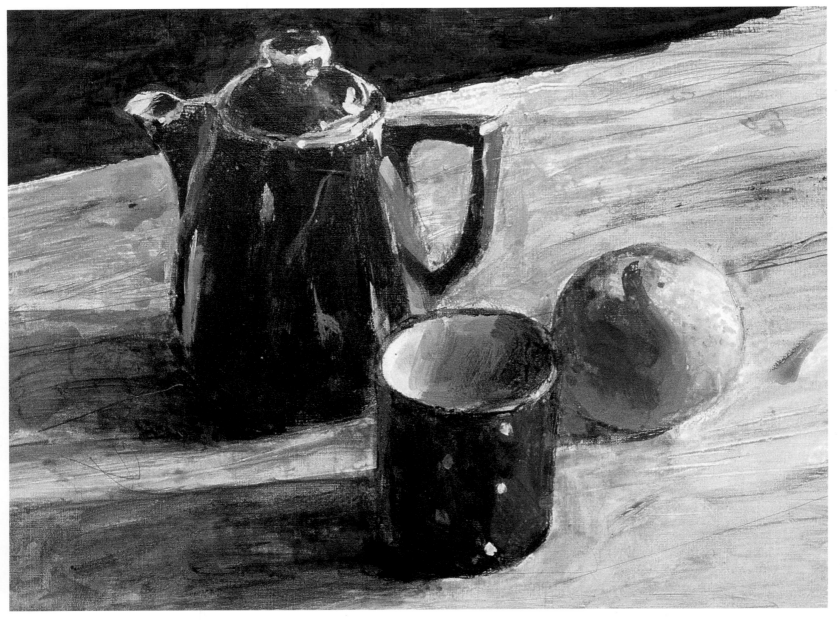

STEP 4

Put the still life in context by establishing the space around it. Apply a transparent wash over the ground colour for the table, then scratch back into it with the end of your paintbrush to represent woodgrain. Anchor the objects to the surface by painting in any remaining fine detail and adding any remaining highlights. The background is cobalt blue mixed with a touch of alizarin crimson. Add some of this to the darkest areas of the pot to make a link across the surface of the picture.

Landscape

Sooner or later you will feel inspired to venture out of doors to paint on location. The landscape, as a subject, provides us with an ever-changing visual feast; not only does it contain lots of different elements – forests, streams, mountains, fields, buildings – but these elements are constantly changed and transformed by the effects of light, depending on the season, the weather and even the time of day.

Ideally, landscapes should be painted on location rather than in the studio or from photographs. Experiencing the landscape and the weather at first hand, you are better able to convey the flavour of a particular place and produce a painting that is fresh and alive.

Generally speaking, the best times to

Aims

- To develop appropriate techniques for representing trees, skies and water
- To create an illusion of space and distance through the use of aerial perspective
- To mix a variety of interesting greens from a selected palette

paint on location are early morning and late afternoon. At these times the sun is low in the sky and so the atmospheric effects are more interesting and there are plenty of cast shadows around, which enliven the composition and help to emphasise forms and textures.

It is best to work on a small canvas or board, no bigger than, say, 23x30cm (9x12in); this is a manageable size and should enable you to complete a painting quickly, before the light changes. Alternatively, you could make sketches, either with thin oil paint or with a drawing medium, and use these as the basis for a larger, more considered painting back in the studio. You can also take photographs, although this is only to be recommended if they are to be used as reference, backed up with sketches based on observation. Paintings copied from photographs tend to lack atmosphere and feeling compared with those painted from life or from sketches made in the field.

You may have to do quite a bit of walking when working on location, so keep your equipment and your range of colours down to the bare essentials. It is difficult to paint well if you are physically uncomfortable, so dress appropriately for the weather and take something to eat and drink.

COMPOSING THE PICTURE

When you are selecting from a stretch of open landscape, home in on something in particular that interests you and make that the focal point – the part of the picture to which the eye is drawn and which holds the viewer's interest. A building, a fence or gate, or a group of figures or animals will provide a strong element in the composition. The focal point doesn't have to be an object as such; you might be attracted by the light on a snow-covered field, or the patterns formed by branches and foliage. Neither does it have to be the biggest element in the composition; it

Working on location, I made this simple drawing in soft pencil and used it as reference for the painting on the opposite page. The bridge – a light shape against the dark background – forms the focal point. I have played down detail and concentrated on the composition and the arrangement of tones.

might be some distance away and therefore quite small, but you can draw attention to it by making it an area of strong tonal or colour contrast. In the painting on this page, for instance, the white stone of the bridge is quite dramatic against the backdrop of dark foliage. Look also for features such as roads, hedges, fences and streams that run through the scene and use them to link different parts of the composition and lead the eye to the focal point.

USING A VIEWFINDER

A still life is a self-contained unit, but a landscape goes on seemingly forever and it can be difficult to decide what to paint. A viewfinder (see page 62) will prove very useful in selecting a landscape composition. Rather like looking through the viewfinder of a camera, it helps you to isolate one part of the scene from its surroundings and decide whether it will work as a picture. It can also help in deciding whether to use a landscape or a portrait format. Look at the whole area within the frame and consider the balance of lines, shapes, tones and colours.

THE BRIDGE
I have exaggerated the bridge's reflection in the water to create an interesting pattern of repeated shapes, and tried to convey the texture of foliage through lively brushwork. The red-leafed tree on the right is an important element; its warm colour advances, while the cool background colours recede, creating spatial depth.

SMALL CHAPEL IN TUSCANY

This painting has a strong sense of space and distance, created by the composition. The terracotta pantiled roof draws us into the middle foreground and up to the peak of the distant mountain, while the strong vertical line of the trees pulls us back down to the bottom again. Compositional elements arranged like this are extremely satisfying because they keep the eye moving in a circular motion; the eye is never led right out of the picture but is constantly held within the composition.

A GLIMPSE THROUGH THE GRASS

This composition gives us a 'worm's-eye' view in which the foreground occupies a large amount of space within the painting. This type of composition creates a truncated, but intimate feeling of space, in contrast to the picture on the opposite page.

The warm-coloured tree trunk (also used as a division of the rectangle of the picture space) pulls the eye forward. The cool red of the house roof takes the eye back but links up with the various pinks and reds in the foreground. Some negative shapes are applied to the tree on the right, letting the sky colour come through.

LESSON SEVEN

AERIAL PERSPECTIVE

One of the challenges in painting landscapes is creating a sense of depth and space that invites the viewer to 'step into' the picture. To an extent we can create depth by using linear perspective, overlapping forms and making objects smaller as they recede into the distance. But more importantly, creating depth in a landscape relies on exploiting a physical phenomenon known as aerial, or atmospheric, perspective.

Imagine you are standing on a hillside with the landscape stretched out before you. As your eye travels from the foreground to the horizon you are looking through increasing amounts of atmospheric haze and dust; this explains why the greens of grass and foliage close to you appear strong and fresh, but become progressively cooler and less intense in the distance, often taking on a bluish tinge. In the same way, tones and tonal contrasts are strongest in the foreground, becoming progressively weaker as they recede into the distance. Finally, textures, details and outlines that can be clearly seen in the foreground become less and less distinct the further away they are.

Use colour to create perspective in your paintings. Warm colours appear to some forward and cool colours recede; likewise, dark tones come forward and light tones recede. You can exploit this to produce a convincing and realistic landscape with a sense of spatial recession from foreground to background. Reserve the warmest colours and the strongest tones and textures for the immediate foreground. Gradually cool down the colours and weaken the tones and textures in the middle ground. As you move back towards the horizon, introduce more cool blues, weaken the tones still further and reduce contrast and detail almost to nothing.

RUINED BARN
Another way to create a sense of distance is to use compositional devices to lead the eye into the picture so that we feel as though we are travelling into the space. This landscape, painted in Normandy, France, is quite a dramatic composition in which the forceful diagonals of the road and the trees propel the eye from the foreground to the small patch of blue sky in the background.

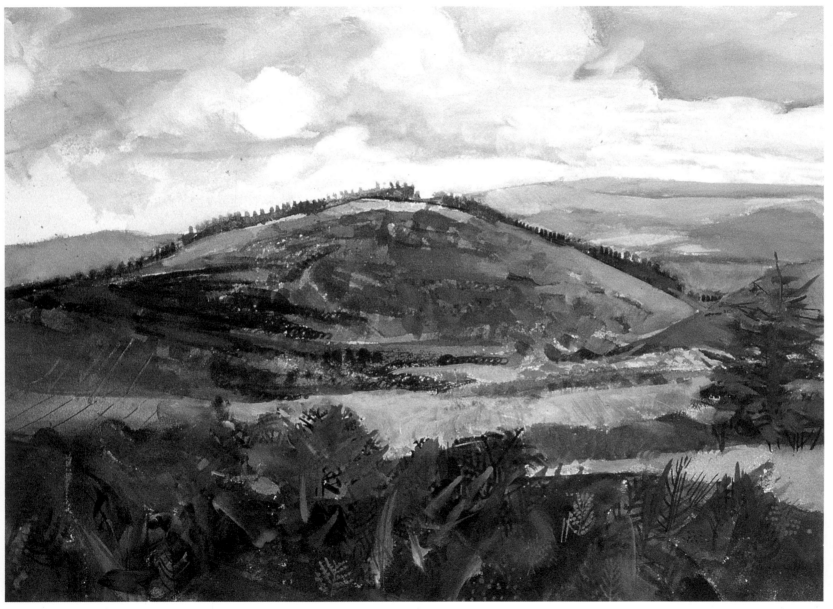

MOORLAND VIEW
This is a perfect example of atmospheric perspective. The tones in the foreground are strong and dark, and have been painted with larger brushstrokes. The distant hills are quite bluish and pale. There is a definite distinction between the foreground, the middle ground and the far distance in terms of colour, tone and marks made with the brush.

PAINTING SKIES

The sky need not be a mere backdrop to your landscape paintings; it can be an important means of creating atmosphere and mood as well as lending energy and movement to the composition.

In order to paint convincing skies you will need to get acquainted with the different cloud types, and I would advise any artist to follow the example of the English landscape painter John Constable (1776-1837), who is well known for having made copious notes and sketches of different cloud formations.

The sky and clouds are constantly changing, so you need to work quickly and simplify what you see. Aim to capture the arrangement of the clouds where you want them in the underpainting. You can then make adjustments when you work over them. Vary your brushwork and the consistency of the paint to portray different types of cloud. Wispy cirrus clouds, for example, can either be lightly scumbled with thin, dryish paint or wiped back out of a wet wash using a rag. Creamy, opaque colour will suggest groups of dense cumulus cloud in the foreground, while thin, transparent colour will suggest distant clouds, thus giving the impression of atmosphere and receding space.

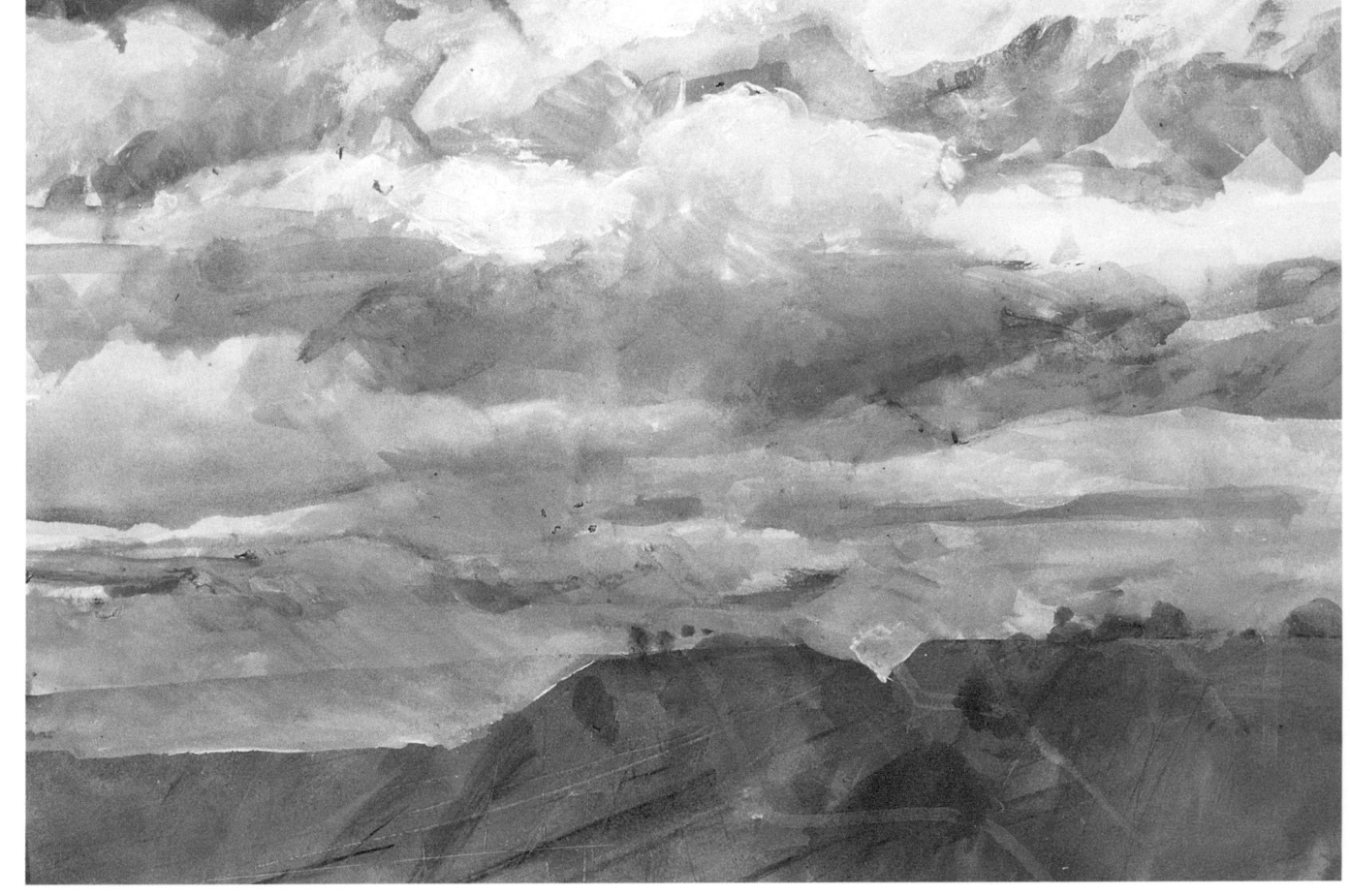

FORM AND COLOUR
Most skies contain a surprising range of colours. Even a blue summer sky may be ultramarine directly above your head, but it turns cooler and paler as it recedes, often softening to a pale turquoise or a pearly white near the horizon. The most useful

SKYSCAPE
This is a simple landscape that is nevertheless full of interest, energy and movement. The laws of perspective apply to the sky just as in the landscape; notice how these clouds overlap each other and become smaller, flatter and closer together as they recede towards the horizon.

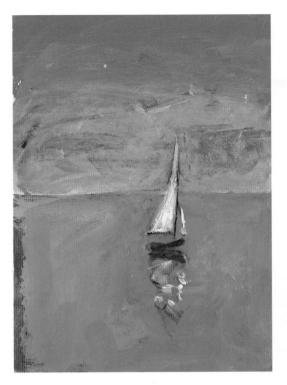

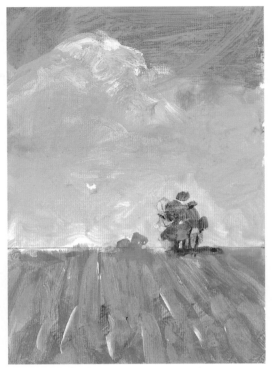

These three oil sketches demonstrate how the division between sky and land can make an immense difference to the visual impact and atmosphere of a landscape painting. *Left* An unusual composition in which the large, empty foreground is countered by the small, busy sky area. *Centre* In this sketch the horizon line cuts across the centre of the picture, creating a rather static composition. However, the horizon is broken by the vertical shape of the yacht and its reflection. *Right* Here, emphasis is given to the sky. It occupies two thirds of the picture space, creating a dramatic effect.

blues for skies are ultramarine, cobalt and cerulean, but they need to be toned down by adding touches of other colours such as alizarin crimson, cadmium orange, raw umber or burnt sienna, plus some white. Similarly, clouds are not simply grey or white; heaped clouds may be bright white or pale yellow where they reflect the sun, while their shadowed parts will contain greys and purples.

In late afternoon the sky and clouds appear warmer in colour, with hints of warm pinks and violets. Heavy storm clouds may contain hints of purple, green and brown. Observing and recording these subtle colours will lend atmosphere and depth to your paintings.

Although vaporous, clouds have three-dimensional form. Mix complementary colours (see page 33) to create a range of warm and cool greys to model them. Be aware of the direction of the light and keep the light and dark parts of the clouds consistent with this.

COMPOSITION

To create balance in a landscape painting, either the land or the sky must dominate. Avoid placing the horizon in the middle of the picture as this creates a static composition. If you wish to emphasise the sky, place the horizon near the bottom of the picture and create plenty of movement and interest in the clouds. If the main area of interest is the landscape, place the horizon high up and keep the sky simple.

PAINTING FOLIAGE

When you paint trees in the landscape, don't be confused by their apparent complexity. It is impossible to paint every branch, twig and leaf, and in any case too much detail can look rather clumsy. Following the example illustrated on these pages, start by drawing the trunk and visible branches with light, sketchy lines, working upwards from the base to convey a sense of the tree's energy and growth. Then look for the broad shapes and masses of foliage and block these in broadly with a large brush and thin paint. Having established the overall shape of the tree, you can now use thicker paint to develop form and texture and add smaller branches with lost-and-found lines. Don't attempt to paint individual leaves but use expressive brushstrokes to suggest clumps of foliage. Use the flat of the brush to make broad directional strokes, twisting it to create energy and movement. Add impastoed highlights using a brush or a painting knife, and use dragging and scumbling to suggest feathery foliage.

Note the direction of the light, and use light and shadow to define the volume of trunks, branches and clumps of foliage. The light side of the tree picks up warm colours, whereas the shadow side is cool and picks up blue from the sky. Because a tree trunk is cylindrical it reflects light from all directions; even on the shadow side it picks up reflected light from the ground. Also note the way the trunk spreads as it goes into the ground.

MIXING GREENS

Foliage greens are enormously varied and can range from yellows and silvers to blues and near-purples. Different species of tree have their own characteristic colours, and of course landscape greens change with the seasons; springtime foliage contains more yellow than summer foliage, which is darker and richer.

You can create a range of landscape greens ranging from light to dark and warm to cool by mixing different blues and yellows together in varying proportions. Experiment on pieces of canvas paper, mixing, say, cerulean blue first with a cool yellow like lemon yellow and then with a warm yellow like cadmium yellow. Vary the colours even further by adding a touch of earth colour such as raw umber. Try some more unusual mixes such as Prussian blue and raw umber, which makes a delicious olive green. Black is rarely used in landscapes because it is a 'dead' colour, but when mixed with yellow it gives some rich,

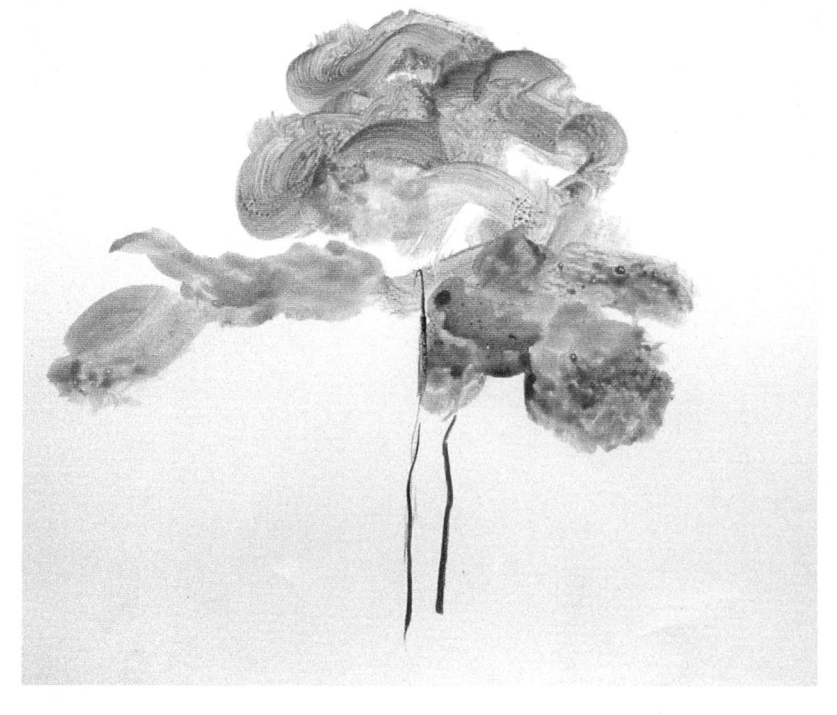

dark greens. Other mixtures to try include yellow ochre and cerulean blue, raw umber and cerulean blue, and lemon yellow and Payne's gray. Be careful about lightening greens by adding white, as this can give a chalky, opaque quality that is inappropriate for landscapes.

You can also create greens directly on the canvas. Try scumbling with yellow over a blue base, or vice versa. This is called optical mixing, and gives life and sparkle to foliage greens.

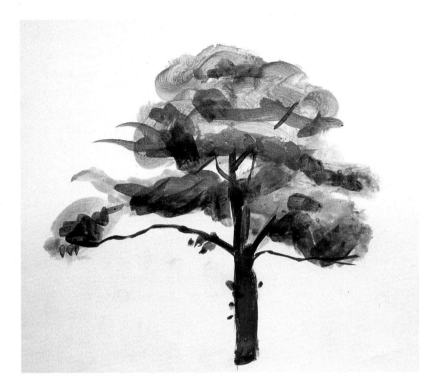

Tip

When you are painting foliage against the sky, put in the little patches of sky after you have painted the foliage rather than leaving spaces and trying to paint around them.

Opposite page Draw the trunk first, then block in the broad foliage masses with thinly diluted paint. Here I have mixed a mid green from cobalt blue and cadmium yellow. Use a large brush or a paint-soaked rag to prevent yourself from adding too much detail. Make sure the tree canopy is in correct proportion to the trunk; it is a common mistake to make the canopy too small.

Above left Observe the direction of the light source and establish which are the main masses of light and shadow in the foliage. Block in the dark greens. Here I have used mixtures of Prussian blue, raw umber and Payne's gray, but you can mix any colours you like. Paint the trunk and branches with a brownish grey.

Above right Use thicker, more opaque paint and smaller brushstrokes to suggest the texture of the foliage. Add some smaller branches. Introduce some mid-tone greens, mixed from cobalt blue and cadmium yellow. Mix viridian and chrome yellow to make a light yellow-green for the highlights, especially around the edges of the tree, which catch more light. Add touches of grey and green to the trunk to create form and give a suggestion of its gnarled texture.

PAINTING WATER

Most people are drawn towards water, and artists are no exception. Often, however, beginners are disappointed in their paintings because the water somehow doesn't convey the depth and transparency of a lake, or the excitement of a waterfall.

Water has three elements that can pose problems for the artist: transparency, movement and reflections. However, all of these problems can be resolved through close observation and using the right techniques. The most important thing to remember is that water looks wetter and more transparent when painted simply. Keep your brushwork broad and fluid and concentrate only on the major shapes of light and dark; painting every ripple and reflection with small, niggling brushstrokes destroys both the sense of wetness and the impression of movement.

RIVER SCENE

The reflections in this riverside scene are generalised. Details and tones are reduced in the background compared with the stronger, more positive colours in the foreground. This helps to establish the river as a horizontal plane receding back in space.

When painting reflections you need to create a sense of depth while at the same time preserving the horizontal plane of the water. This relies on close observation and creating the right tones and colour mixes. Keep your brushstrokes horizontal, with slight undulations to indicate the rippling movement of the water. Observe how the ripples become smaller and closer together the further away they are.

Left WAVES, *Above* WATERFALL
Having built up an underpainting, try splashing and splattering with white paint to capture a sense of the energy and movement of waterfalls and waves foaming and splashing against rocks.

PERSPECTIVE IN WATER

Water is subject to the same rules of perspective as the land and the sky. When you are looking out to sea, for example, the waves appear smaller, flatter and closer together as they recede towards the horizon. To convey this in your picture, paint the waves or ripples in the foreground with bigger, bolder strokes and thicker paint, gradually making them smaller, smoother and more closely spaced as you work back towards the horizon.

COLOURS IN WATER

Water has no colour of its own, but it often reflects some surprising colours; not only is the surface colour influenced by the sky and by the reflections and shadows cast by objects in or near the water, it may also contain suspended mud, algae or vegetation that gives it a murky, olive green colour. Still water will reflect the colours of the sky almost as a mirror, although the colours are slightly muted. Choppy water may contain ochres and greens as debris is churned up from the bottom.

THE ORCHARD

When we think of landscape we tend to think of grand vistas of mountains, fields and rivers stretching into the distance. But if you home in on a small section of the landscape you can create interesting pictures with a more intimate feel. This apple orchard makes a good subject because of the play of light and shadow and the way the trunks and branches create rhythms across the picture surface. In order to capture these rhythms I used a large canvas so that I could work with rags, brushes and fingers in generous sweeps rather than restricted wrist and finger movements.

I painted this picture using water-mixable oil paints. A recent innovation, these paints behave in exactly the same way as conventional oil paints and dry just as slowly, allowing for greater manipulation than do other water-based media such as acrylics. The colours are just as rich as those of conventional oil paints, though they come in a slightly smaller range. But their great advantage is that paint thinning and brush cleaning can be done with ordinary tap water instead of turpentine. This means that there is no unpleasant odour and no build-up of potentially dangerous vapours, making them ideal for working in confined spaces.

PAYNE'S GRAY

CADMIUM YELLOW

BURNT SIENNA

COBALT BLUE

CERULEAN

VIRIDIAN

TITANIUM WHITE

Palette

You will need:
- Canvas board, approximately 50x76cm (20x30in)
- Brushes: large flat bristle and small long filbert bristle
- Mixing palette
- Stick of charcoal
- Clean cotton rags

STEP 1
Draw the main outlines of the trees and branches directly onto the canvas board. Draw from the shoulder, not the wrist, feeling out the rhythms of the lateral branches that spread across the picture surface. Fill in the shadows and darker tones and smudge them with your finger.

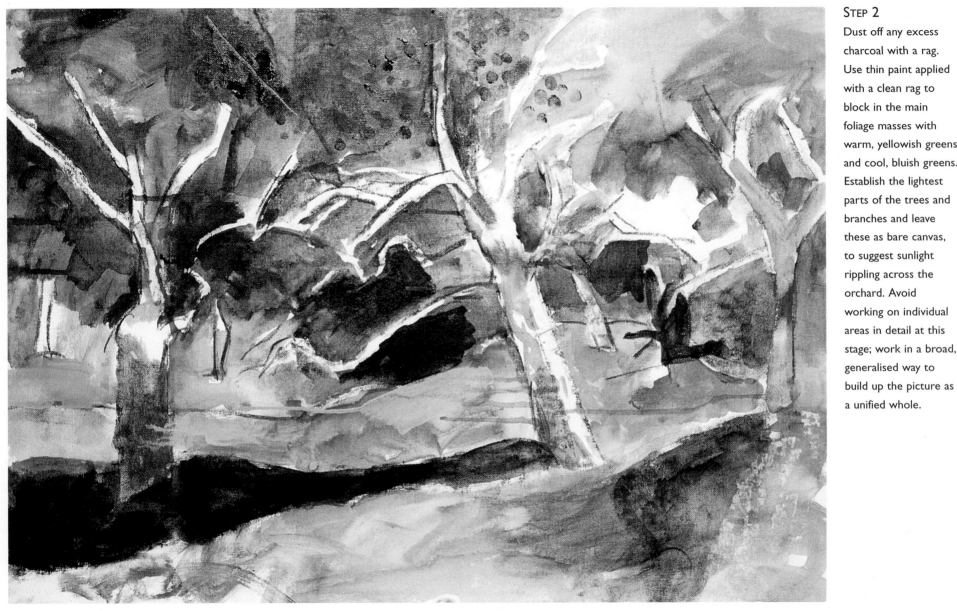

STEP 2

Dust off any excess charcoal with a rag. Use thin paint applied with a clean rag to block in the main foliage masses with warm, yellowish greens and cool, bluish greens. Establish the lightest parts of the trees and branches and leave these as bare canvas, to suggest sunlight rippling across the orchard. Avoid working on individual areas in detail at this stage; work in a broad, generalised way to build up the picture as a unified whole.

STEP 3

Using brushes this time, develop the range of greens, contrasting cool, recessive and darker greens with warmer, more yellowish greens. Work around the light-struck parts of the trees, leaving them as bare canvas. Take care to control the tonal variations, which are particularly important in a painting where one colour, in this case green, is predominant.

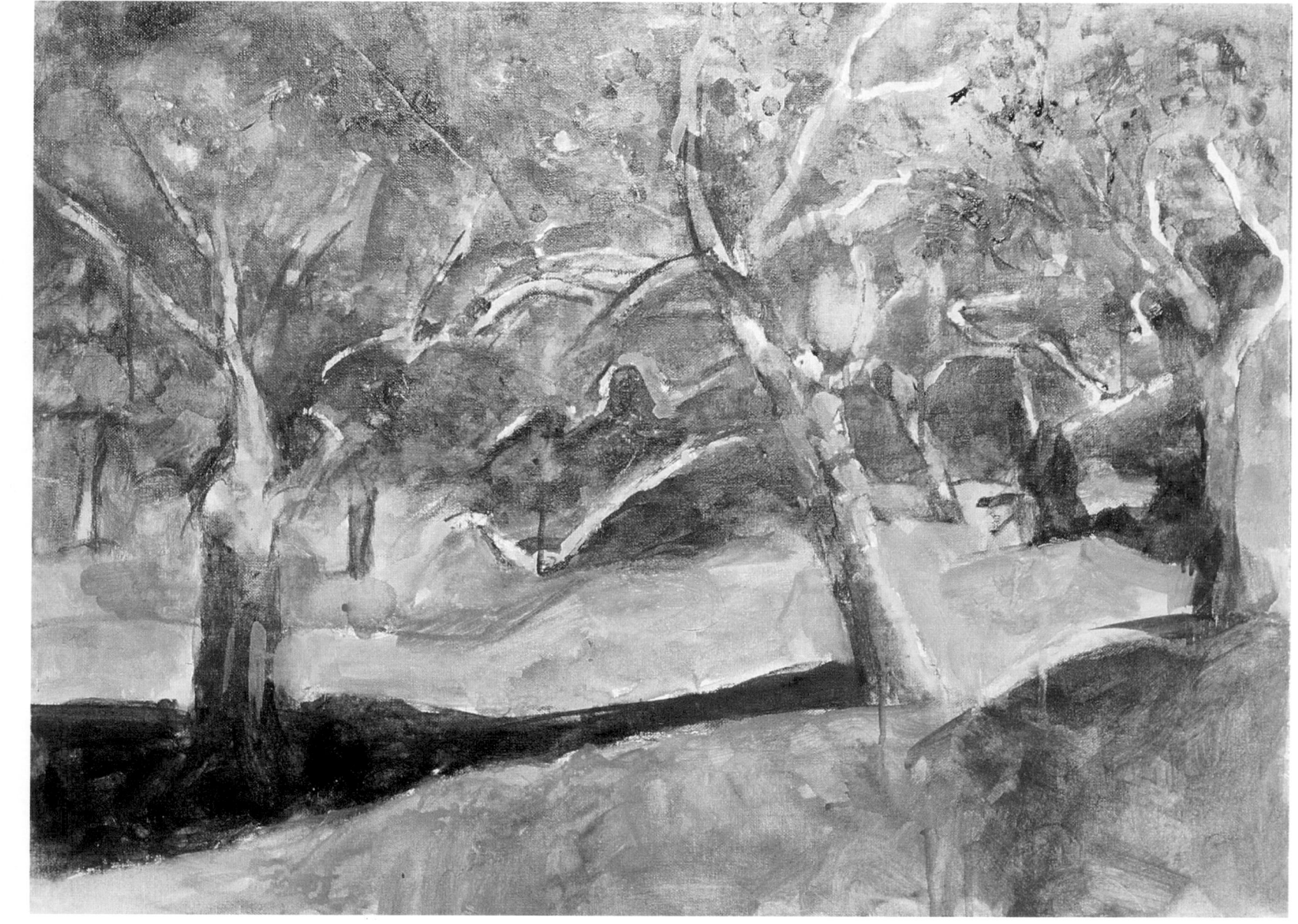

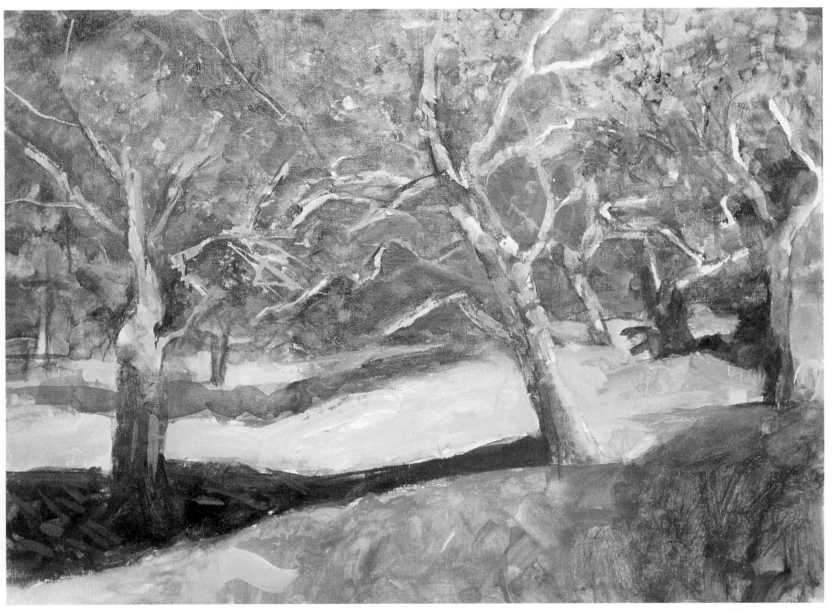

STEP 4

Now work on the stronger lateral cast shadows and develop the tonal variations that suggest the undulations of the orchard floor. The character of the painting contrasts the verticals of the tree trunks and the horizontals of the branches, echoed by vertical and horizontal patterns of light and shadow. Strengthen the foreground greens and link up the shadows cast by the nearest tree trunks.

STEP 5

Continue to strengthen the darker tones while keeping the colours fresh and clean. The 'positive' shapes of the dark tones, echoed by the light areas of bare canvas, lead the eye rhythmically around the 'negative' shapes between the branches and boughs. Suggest the red bush to the right in the middle distance; this forms a focal point in the picture because red is the complementary of green and this area of bright contrast attracts the eye.

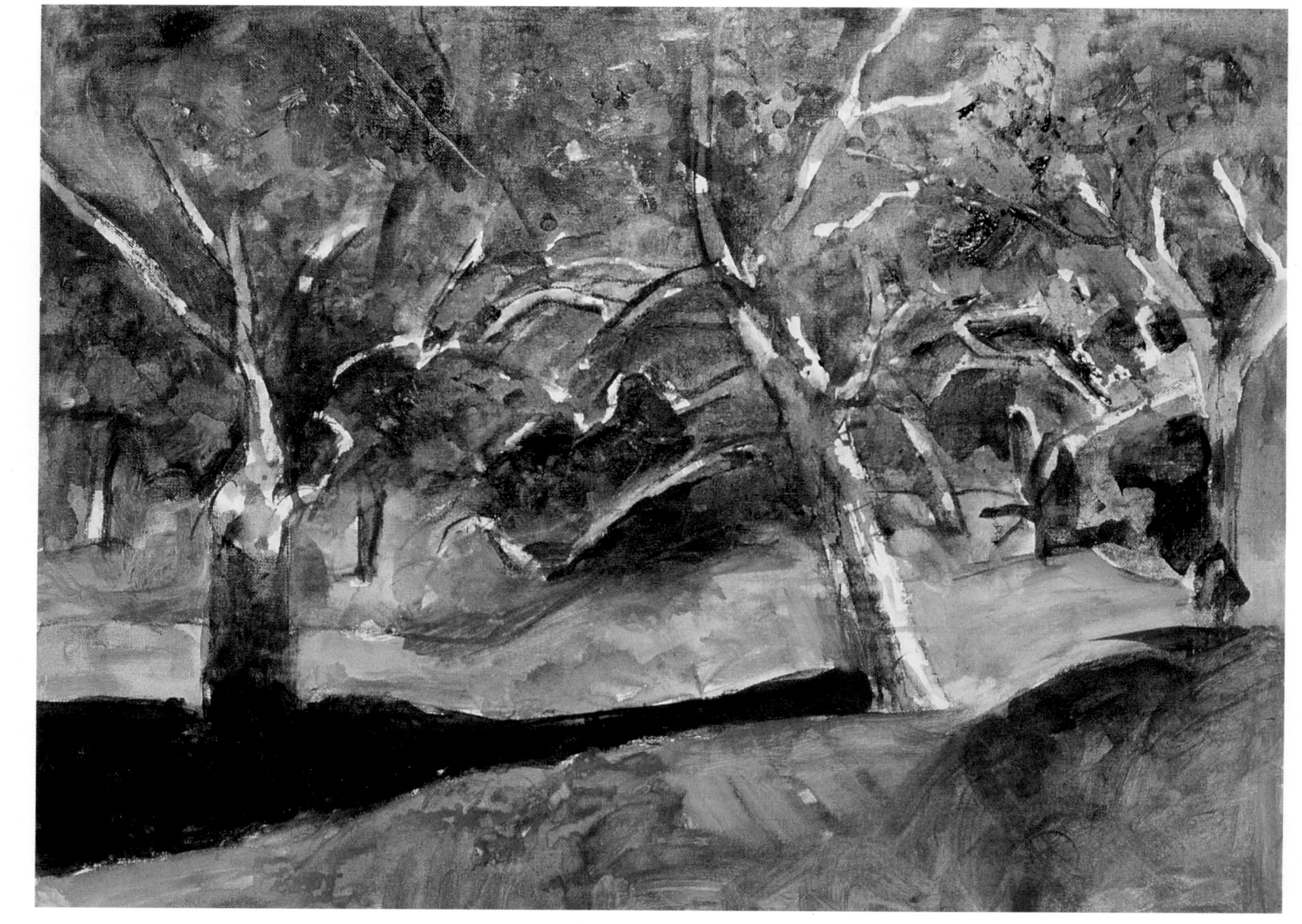

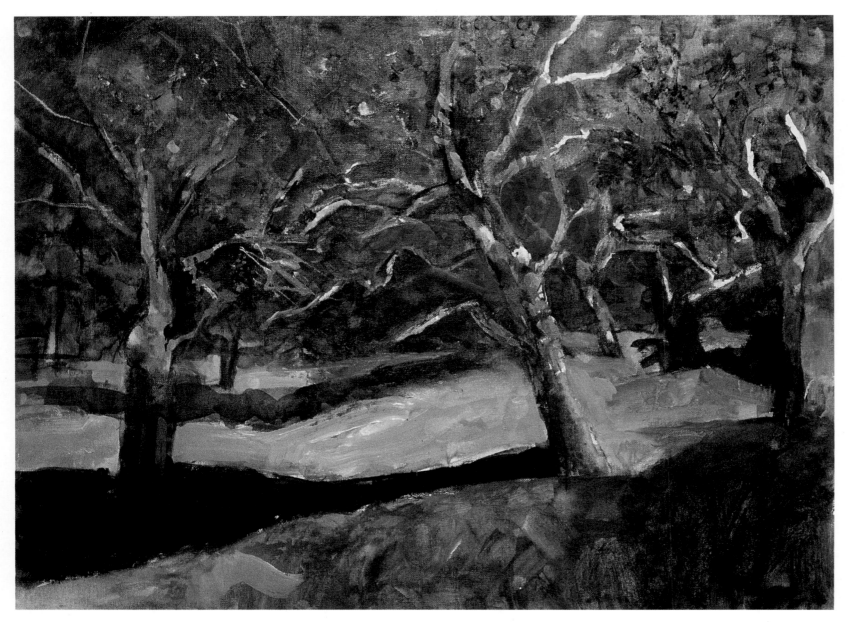

STEP 6

Now that the full tonal range of greens is established it is time to add some textural detail to the trees and suggest some lighter shadows. Use a mixture of Payne's gray, burnt sienna and titanium white to make a light grey and apply it with small, overlaid strokes and dabs using the filbert brush and your fingertip. Accentuate the light-struck parts of the branches with touches of pure white.

Figures and Faces

The human face and figure are subjects most often associated with oil painting. This is partly because there is a long tradition of portraits and figure paintings in oils stretching back to the fifteenth century. Another reason is that oils are ideally suited to painting this challenging subject; because they dry slowly they can be scraped down and overpainted, allowing corrections and alterations to be made at any stage.

With observation and practice, painting people can be a very satisfying achievement. To develop your confidence, carry a sketchbook with you and sketch people going about their normal activities – at the local park or the beach, at sports centres, markets and cafés and on trains and buses. Ask your friends and family to pose for you, or draw self-portraits.

Aims

- To capture a likeness through the understanding of facial proportions
- To mix lifelike skin colours using a limited palette of colours
- To learn to paint figures in the landscape

PLANNING THE PORTRAIT

Part of the skill in making a good portrait lies in making early decisions about how you are going to approach it, because every aspect of the image – the pose, the clothing, the background, lighting and composition – has a part to play in expressing the personality of the sitter.

THE POSE

In choosing a pose, there are many variables. Do you want the model sitting or standing? Do you want to focus on the face alone, or the head and shoulders? Or do you want to be more ambitious and paint a half-length or full-length portrait? The angle of the head is also important. The main thing is to find a pose that is both comfortable for the sitter and expressive of his or her personality.

COMPOSING THE PORTRAIT

Even if you intend painting a very simple portrait head against a plain background, you should still consider the composition. Use two L-shaped pieces of card to 'frame'

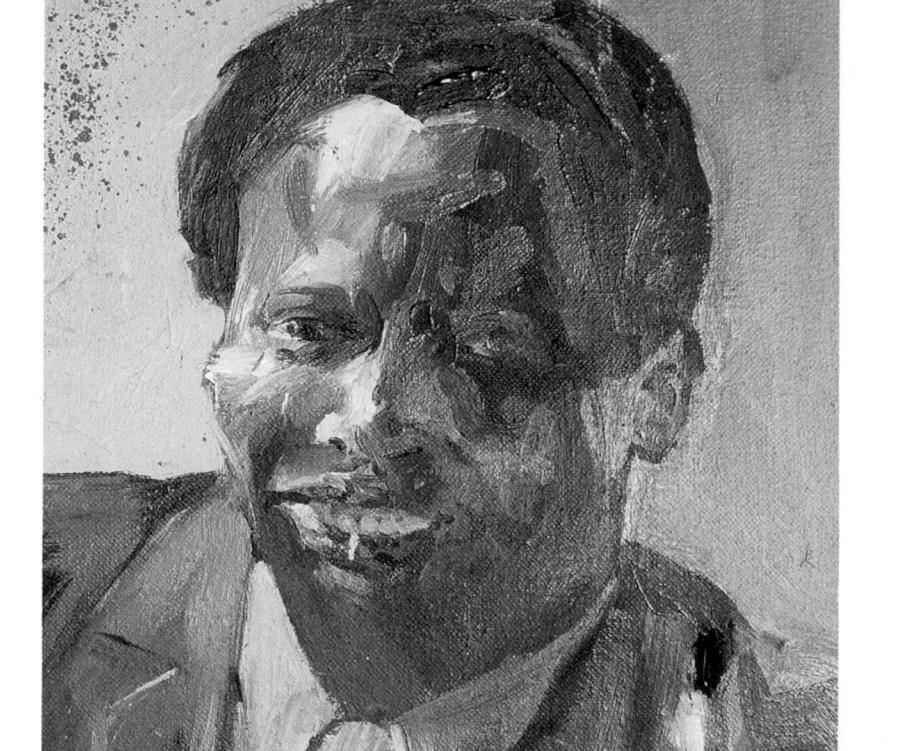

Opposite

A good portrait not only captures a likeness of the sitter but also expresses their character. This may be revealed in body posture, the tilt of the head and the direction of gaze as well as facial expression.

your subject and see how it relates to the edges of the support. For example, check that there is not too much empty space around the sitter, and that the sitter is not cut off at the knees, wrists or ankles, which always looks uncomfortable. Remember that the background is an integral part of the picture, so try to create interesting shapes that complement the subject. Make thumbnail sketches to help you decide on the position of the hands, the angle of the head, what to include in the background, and so on. A Polaroid camera is a useful aid here, but do not be tempted to copy from photographs because they tend to flatten and distort the image.

SKIN COLOURS

The reflective surface of the skin picks up light and colour from its surroundings. Observe how the light-struck parts of the face are warm in colour, containing reds, pinks and yellows, while the shadowed parts are cool in colour, containing blues, violets and green-greys.

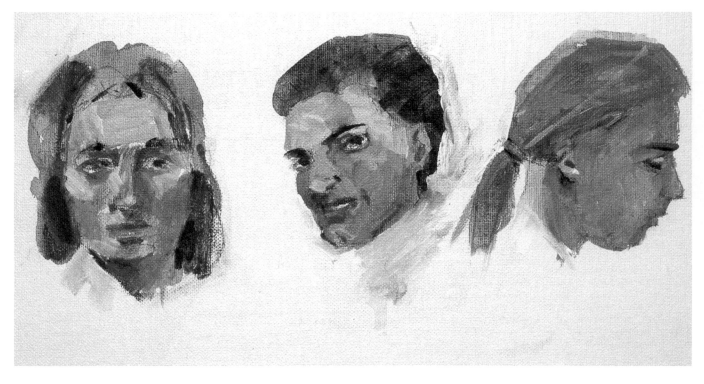

In most portraits, the head is either viewed full-face, from a three-quarter angle, or in profile, as demonstrated by these three oil sketches.

Above left
FULL-FACE
This is where the sitter faces the painter directly and the features are symmetrically placed. It is important to think about lighting, which should ideally be from above and slightly to one side so as to give the head a sense of form.

Above centre
THREE-QUARTER VIEW
This is a more challenging view in terms of drawing but it gives a greater range of expression and more opportunity to exploit interesting effects of light and shadow on the face. The mood of the portrait can be altered by inclining the head upwards or downwards.

Above right
PROFILE VIEW
Some people have very distinctive profiles which make for striking portraits. In a profile view the contour line of the forehead, nose, mouth and chin is important in obtaining a good likeness. Shadows under the lips, nose and eye sockets are also important.

97

The following seven colours can be used to mix flesh tones: alizarin crimson, light red, raw umber, yellow ochre, terre verte, cobalt blue and titanium white. These colours, mixed in varying proportions, are suitable for interpreting any racial type. For light skins the basic flesh colour is a mix of titanium white, yellow ochre and light red, with a greater proportion of white in the highlights. For darker skins the basic colour is a mix of raw umber and light red. Shadow tones can be made with terre verte or cobalt blue; highlights can be made with cobalt blue tinted with white.

ACHIEVING A LIKENESS

It is the subtle differences in facial shape, features and proportions that distinguish one person from another. The distance between the top lip and the base of the nose, for example, differs widely from person to person, as does the set of the eyes. Achieving a good likeness is therefore largely a matter of getting the proportions of the head right, and the features in correct relation to each other.

Observation of a few basic 'rules' of proportion will help you to avoid common pitfalls such as placing the eyes too high in the head and making the features too large in proportion to the rest of the face. Draw a

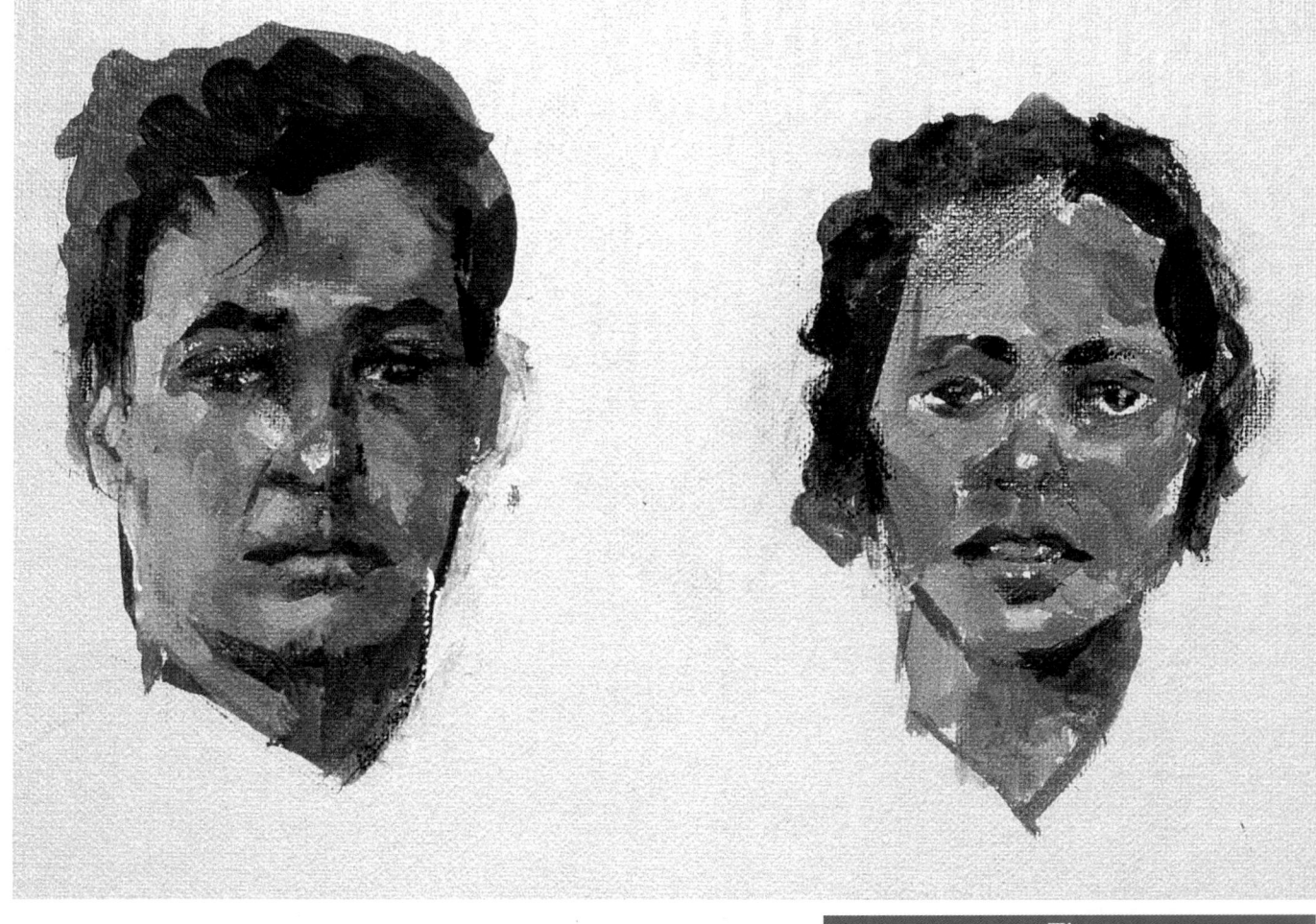

Be aware of the characteristics that distinguish the male face from the female face. In the male, the planes of the forehead, nose and jawline are heavy and angular, the eyes are deep set and the mouth is usually thinner and more elongated. The facial mask (ie the area occupied by the eyes, nose and mouth) is larger in men than it is in women. In the female, the planes of the face are softer and more rounded, the eyes bigger and the mouth softer and fuller.

Tip

There is always a larger space between the eyes than initially observed. A common mistake is to draw the eyes too close together. Generally speaking, there should be space for another eye between the eyes.

simple egg shape for the head, then draw a line across the middle: this marks the position of the eyes. Divide the space between the eyebrows and the chin in half to find the position of the base of the nose. Then draw a line halfway between the nose and the chin to find the position of the lower lip.

Having established these 'normal' proportions, you can now compare them with the proportions of your model's face and make adjustments accordingly. Hold your pencil or brush at arm's length and use it as a measuring tool to check the relationships between the features. For example, how wide is the mouth in relation to the width of the face? Does the tip of the nose align with the base of the ear? Cross-referencing like this will help you to get the proportions right and achieve a likeness.

When painting a portrait, always start by blocking in the underlying structure of the head and the positions of the eye sockets, cheekbones and chin. The details of the features should be built up slowly. Work over the whole canvas at once – figure, face and clothing – to create a unified image.

Left
Achieving a likeness is as much about placing facial features in the correct position and in proportion to each other as painting individual features. Make continual cross-references relating eyes, nose, mouth, ears and the spaces in between.

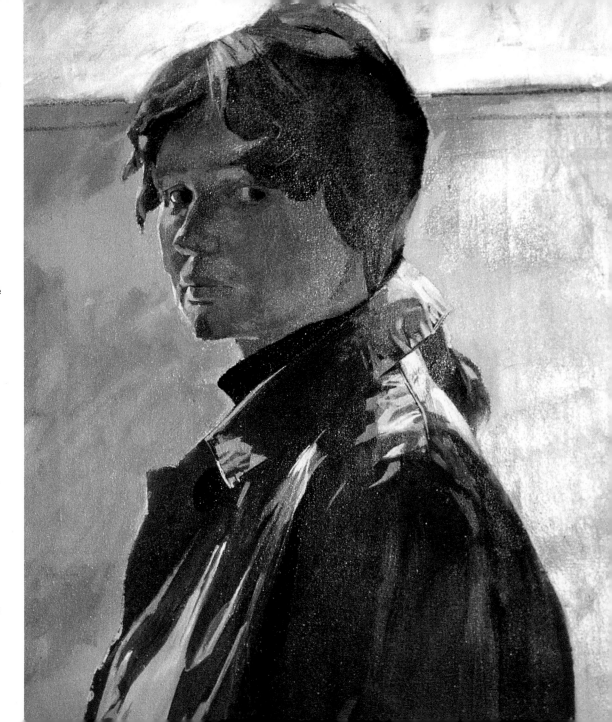

FIGURES IN CONTEXT

Paintings of landscapes and townscapes can feel empty and isolated without the addition of figures, however simple, small and insignificant those figures are. Even where a figure is incidental and occupies only a small part of the picture, it will add an important element to the composition, bringing it to life and defining the scale of the surrounding features. Because we instantly recognise and empathise with the human form, our eye will naturally focus on a figure in a landscape, no matter how small; figures need, therefore, to be carefully placed within the composition and used to their full advantage.

Try to paint figures with a minimum of brushstrokes and avoid too much detail. To make them look convincing, it is more important to get the general bulk and stance right.

The opacity of oil paint is an advantage where an artist has painted a landscape and then decided that it needs the inclusion of a figure. However, it is important to relate the figure to its surroundings and to keep it in scale with other features such as trees or doorways; beginners often make their figures too large. Arrange people in groups rather than stringing them out across the picture.

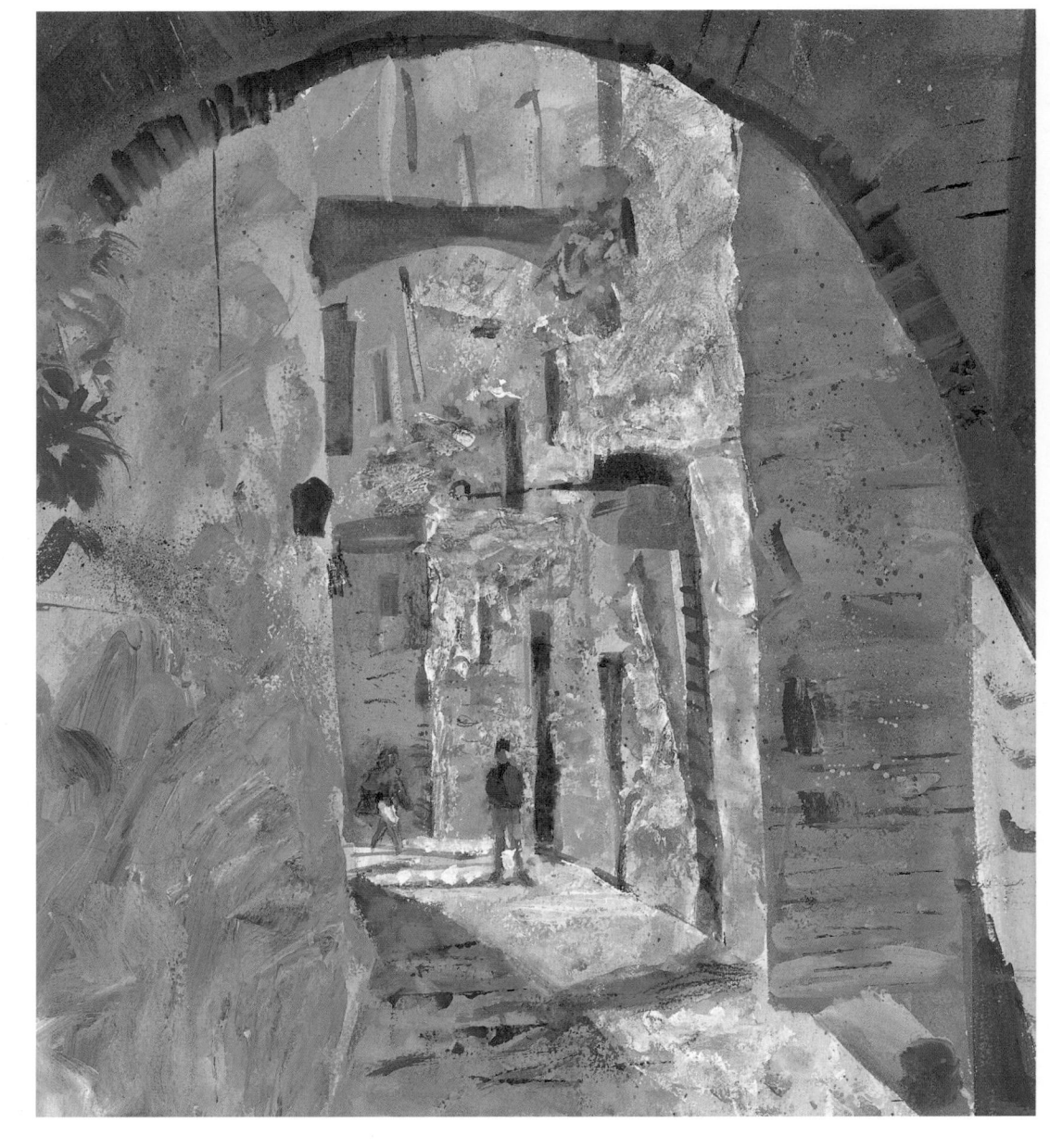

MEDITERRANEAN VILLAGE
The figures in this scene are dwarfed by their surroundings, and yet they provide the focal point of the picture; the eye is inevitably drawn to them because the human figure is something we instantly recognise. The clothing of the figures adds a touch of contrasting colour, which acts as a counterbalance to the small patch of bright blue sky at the top of the picture.

FIGURE BY THE RIVER
Here the picture is dominated by the avenue of trees and their long shadows cast by the setting sun, creating a strong pattern of diagonals and verticals. The figure in white not only helps to animate the scene but also provides a visual 'full stop' that prevents the eye from wandering out of the picture. The tiny figure in red emphasises the sense of scale and distance.

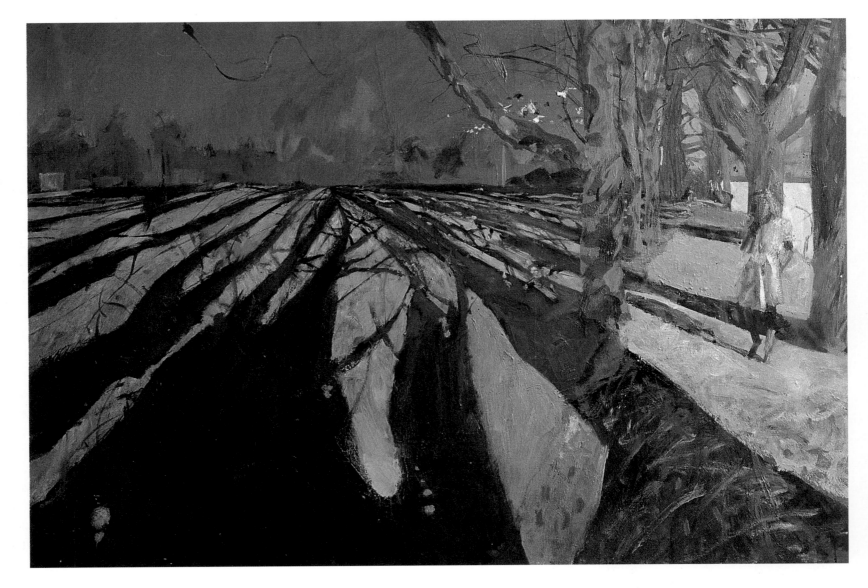

SASKIA AT THE WINDOW

If this is your first attempt at a full-length portrait, it is advisable to choose a relatively simple subject. In this project painting, the figure is viewed in profile, rather than from a frontal or three-quarter view. This makes the actual drawing of the figure much easier because there is no foreshortening of the legs and arms.

When working out the composition of a portrait it is always worth taking the time to consider where you are going to place your model. In this painting, the formal structure of the window and the dark curtains on either side acts like the backdrop of a stage set, helping to frame and accentuate the figure. Notice that the model is positioned to the left of the picture, rather than centrally, thus creating a more lively, assymetrical composition.

Colour and tone are also important aspects of this painting. The figure is backlit by the window, with relatively little light coming from in front; she is therefore viewed almost in silhouette, which lends a quiet, contemplative mood to the picture. There are strong tonal contrasts between the interior, the figure and the window, which create a dramatic composition.

You will need:
- Sheet of canvas or board, 51x76cm (20x30in)
- Brushes: large flat, small flat, medium filbert
- Mixing palette
- Jar of distilled turpentine
- Charcoal
- Cotton rags

Palette

PAYNE'S GRAY

BURNT SIENNA

COBALT BLUE

CADMIUM YELLOW

TITANIUM WHITE

TONAL STUDY

Before you start the painting, it is a good idea to make a tonal study in charcoal to establish the arrangement of light, dark and mid-tones. Once you are happy with the composition and the arrangement of the tonal values, you can start work on the portrait with confidence.

STEP 1

This first stage is what artists call 'ticking in'. Sketch out the composition onto the canvas using charcoal. This drawing is simply to provide guide lines for the next stage, so it doesn't need to be detailed. If the charcoal lines get too dense they can be dusted off with a cloth, leaving a ghost image.

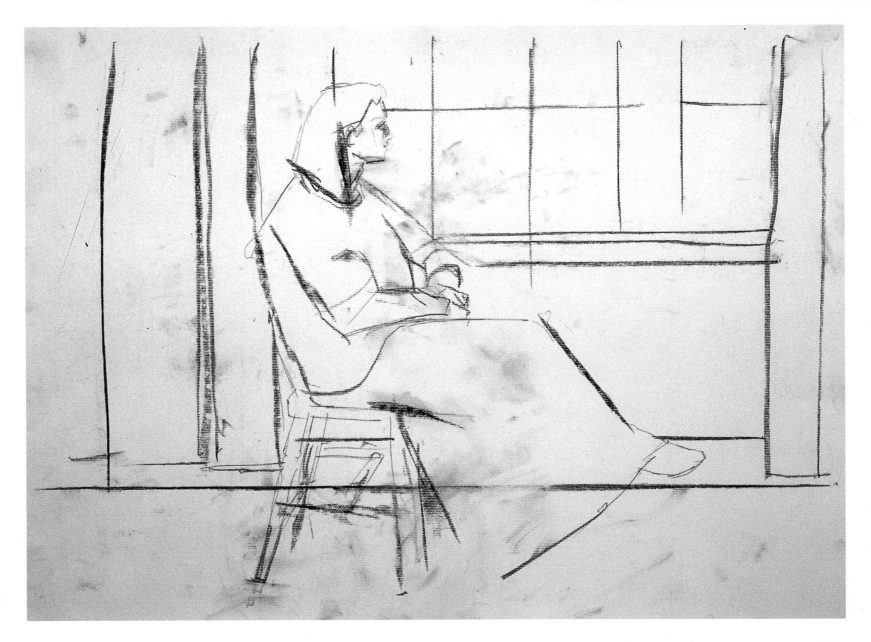

STEP 2

Mix cobalt blue with turpentine to a thin consistency. Using your tonal study as reference, make an underpainting, blocking in the main darks and mid-tones with a medium flat bristle brush. Cobalt blue is a recessive colour and won't influence the final picture.

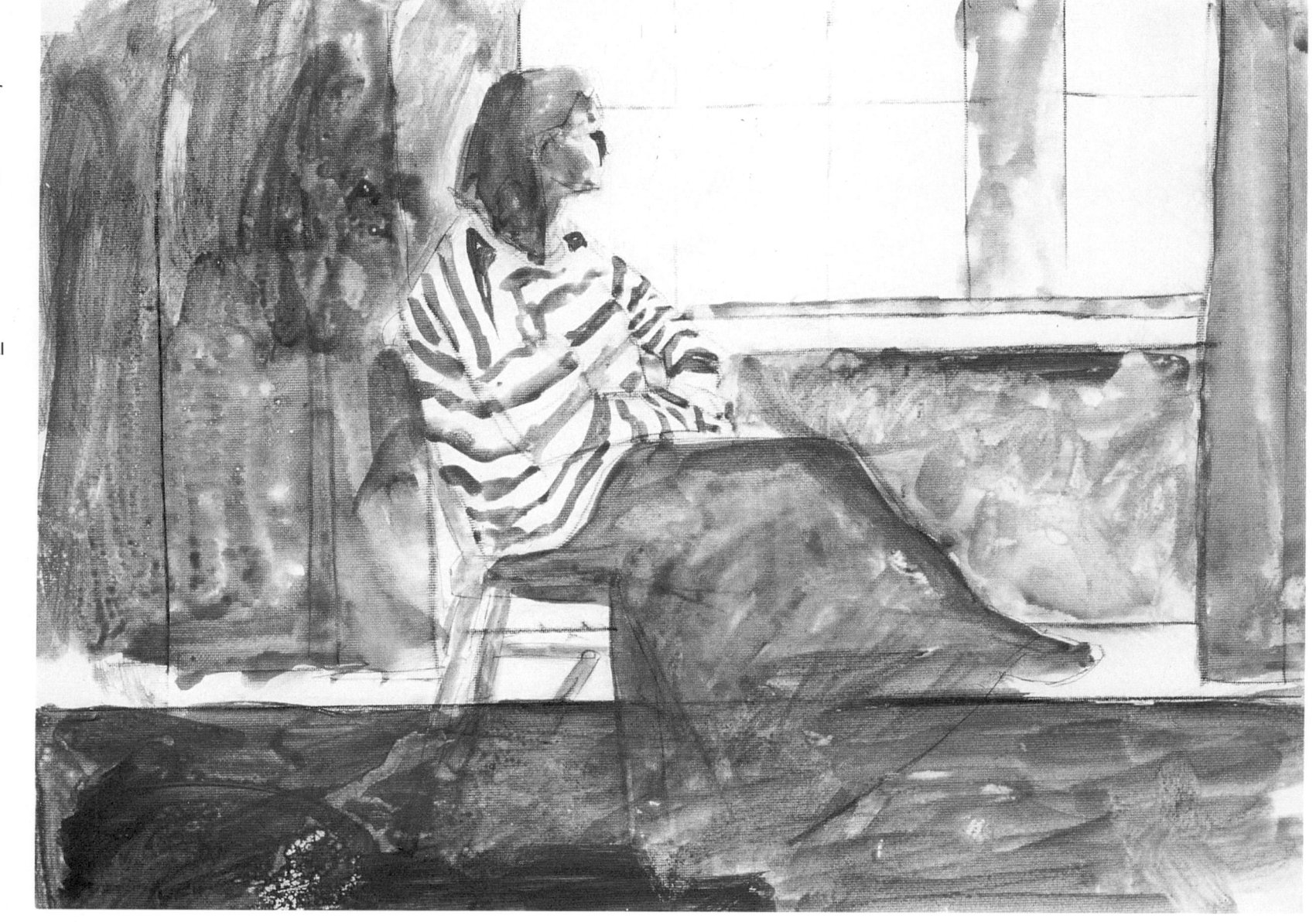

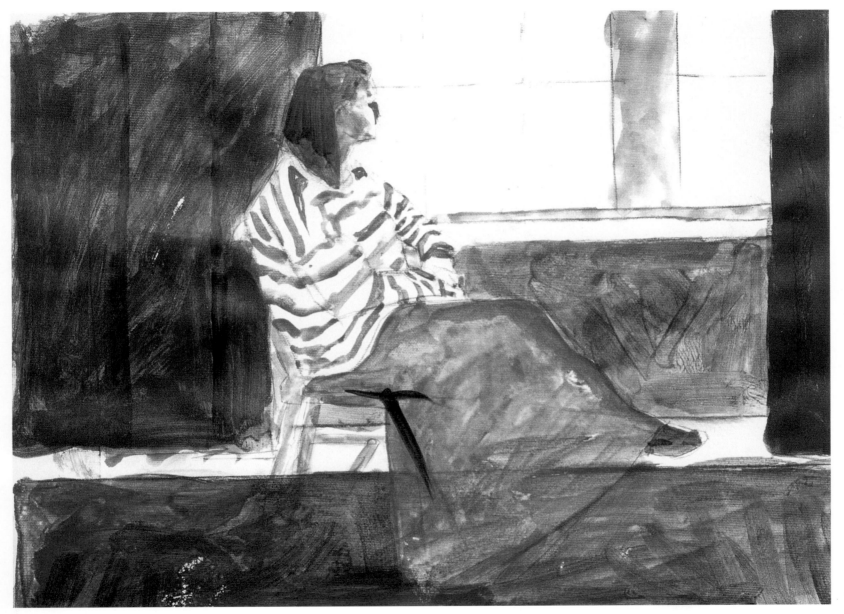

STEP 3

The advantage of making an underpainting is that the hard work of drawing the composition and assessing the tonal values is already done. You can now enjoy manipulating colours and tones to consolidate the previous work. Using slightly thicker paint now, paint the curtains with yellow ochre and burnt sienna, and the dark floor with cobalt blue and burnt sienna.

STEP 4

Paint the dark parts of the blue stripes on the sweatshirt with Payne's gray. Mix Payne's gray with burnt sienna to describe the floor, the chair legs and the skirt. Mix a light tone of cadmium yellow and burnt sienna for the shadows on the face. Add white to this mixture and scumble in a light tone on the wall beneath the window and on some of the glass panes.

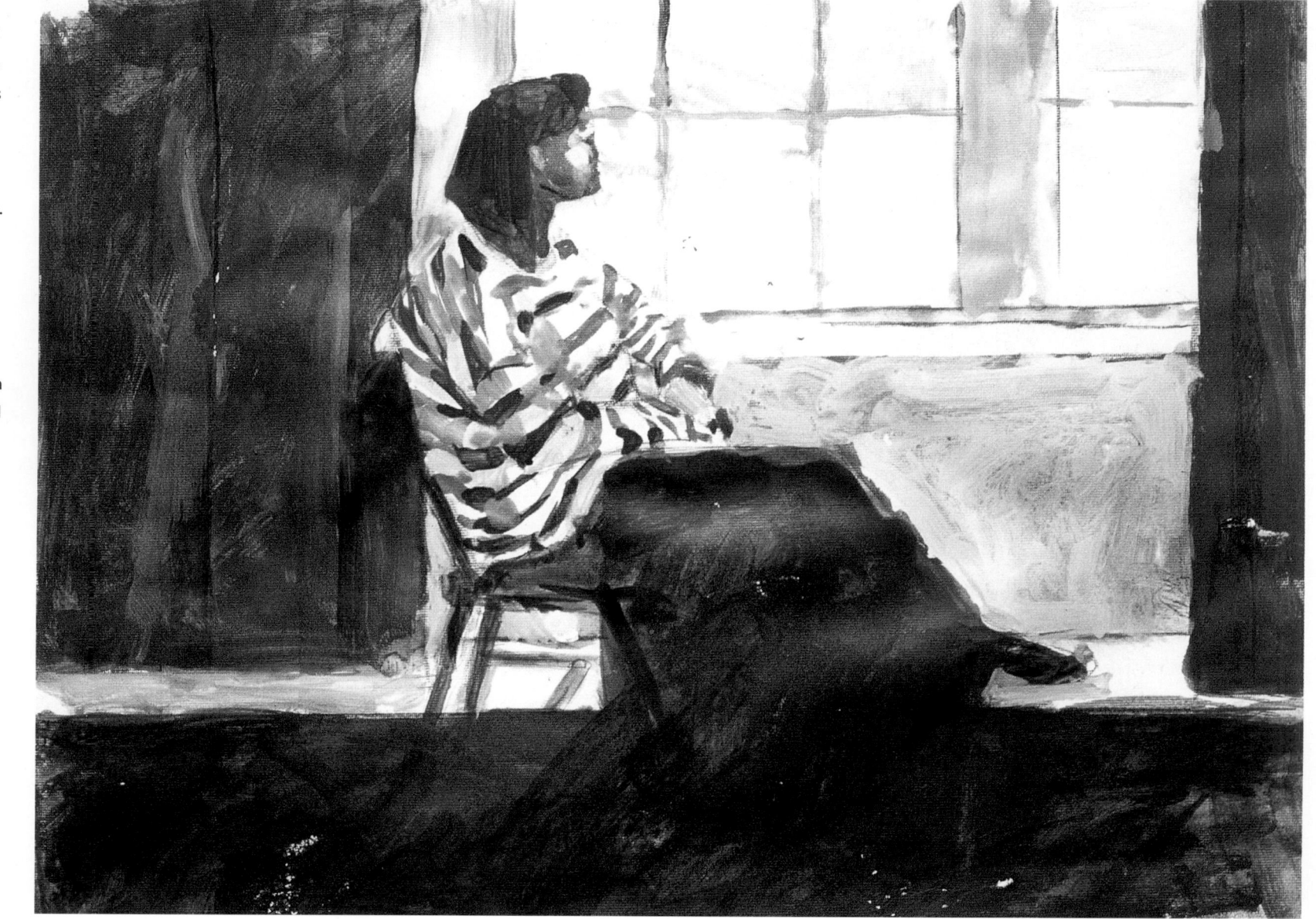

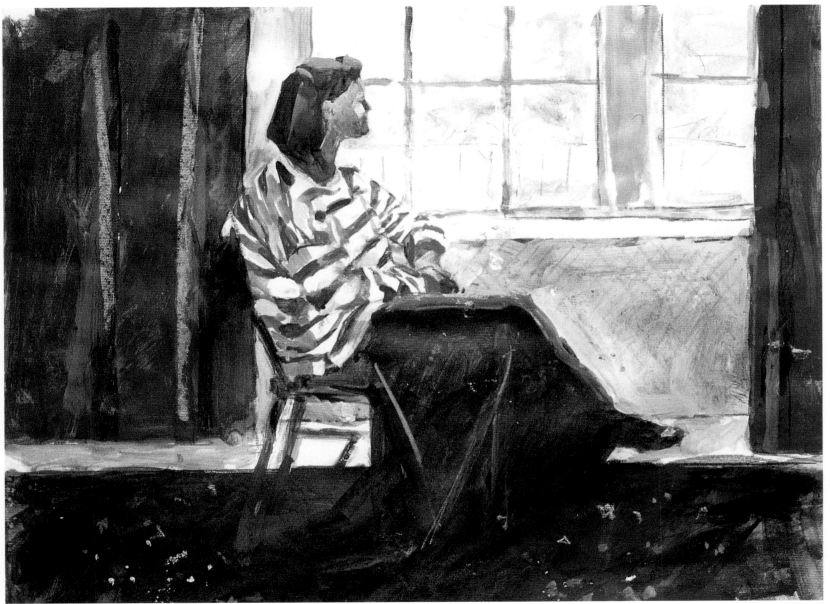

STEP 5

The final touches include adding highlights on the folds of the skirt and the curtains using various tones of the cadmium yellow/burnt sienna/ white mixture. Hint at the pattern on the rug using the same colours, applied with the tip of the brush. Suggest the view from the window with pale tones so that they remain in the background. These final touches should be made spontaneously so as to inject a sense of life and energy into the portrait.

Exteriors and Interiors

Buildings and their interiors have always been popular painting subjects. Whether they have figures placed within them or not, they are so bound up with the lives of people that they intrinsically convey a narrative element which always appeals. You will find a wealth of inspiration in this subject, which can range from a humble kitchen to the grandest cathedral.

LINEAR PERSPECTIVE

Painting buildings and interiors brings us into the area of linear perspective. Many people are afraid of perspective because they think it's terribly complicated. In fact, a grasp of basic perspective, coupled with sound observation, is enough for most

Aims

- To create the illusion of depth and space through the use of perspective
- To learn how to make a composite picture from two different visual sources
- To discover interesting subjects for painting in ordinary domestic interiors

working artists. On these pages I will outline the basic principles, which will enable you to tackle any subject you might come across, from a chair to a busy street.

THE EYE-LEVEL LINE

To draw anything in perspective you must first establish the eye-level line. The eye level is a curious visual phenomenon. Whether you are standing on top of Mount Everest or down in a valley, if you look straight ahead the horizon always corresponds with your eye level. Often there is no obvious horizon. It may be obscured by trees or hills, and there is no horizon as such in an interior or a still life. This doesn't matter, because all you have to do is to hold a pencil horizontally in front of you at arm's length, level with your eyes, and that is the eye-level line or horizon line.

THE VANISHING POINT

Linear perspective is based on the concept that parallel lines that recede into the distance appear to meet at a point on the

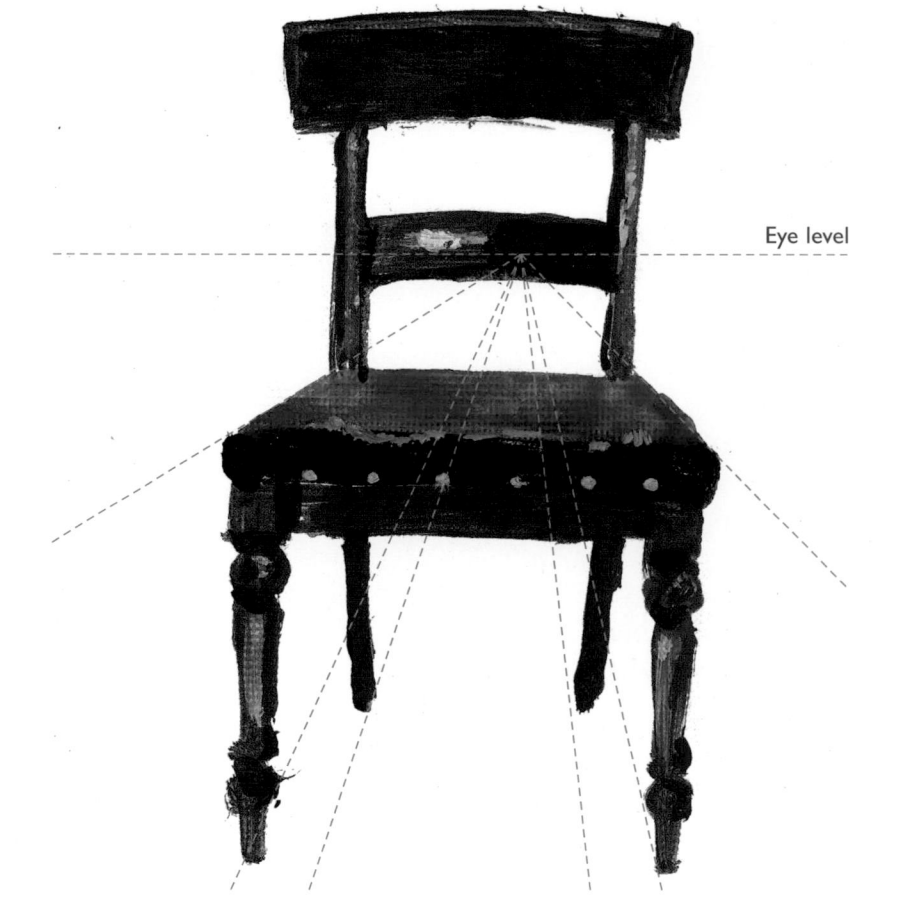

Eye level

ONE-POINT PERSPECTIVE
From a frontal viewpoint, only the front of this chair is visible, so one-point perspective comes into play. When you draw the chair, start by drawing imaginary lines from the front to the back chair legs and extend them to the eye-level line. Do the same with the sides of the seat. The lines will meet at a single vanishing point on the eye-level line. This gives you the correct angle for the chair seat and the correct positioning of the chair legs in space. Notice also how the seat of the chair appears foreshortened because it is viewed from a low angle.

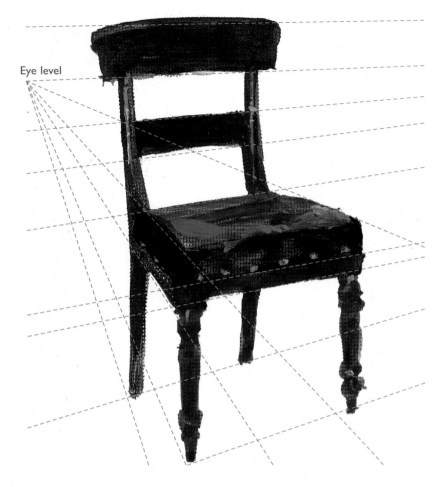

Eye level

TWO-POINT PERSPECTIVE

Viewed from an oblique angle, two sides of the chair are visible, so two-point perspective comes into play. Find the eye-level line, then draw imaginary lines from the front to the back legs and from the side of the seat. Extend the lines to the eye-level line to find the first vanishing point. Now draw imaginary lines from the front of the seat and from the left to right chair legs and extend them to the eye-level line to find the second vanishing point.

horizon if you extend them. This is known as the vanishing point. Depending on your position in relation to the scene, there might be one, two, or even several vanishing points.

ONE-POINT PERSPECTIVE

If you look down a long corridor you will notice how the walls on either side appear to become smaller as they recede into the distance. The lines of the ceiling, above your eye level, appear to slant downwards, and the lines of the floor, below your eye level, appear to slant upwards. If you extend these lines they will meet at a point directly in line with your gaze: this is the vanishing point. This is known as one-point perspective because all parallel lines converge at a single point.

TWO-POINT PERSPECTIVE

Things get a bit more complicated if you look at objects from an oblique angle rather than straight on. If you stand at the corner of a building so that two sides are in your view there will be two vanishing points on the eye-level line, one on either side of the building. The same applies if you look at any three-dimensional object, such as a table or chair, from an oblique angle.

When two-point perspective is involved, it is likely that at least one vanishing point, and often both, will be outside the picture area. You have to imagine the vanishing points in the space beyond your canvas, and estimate the angles of walls and so on by eye. With practice you will be able to do this almost instinctively.

JUDGING ANGLES

Sometimes it can be difficult to judge the angle of a wall or a rooftop accurately by eye. You will find it easier if you hold a straight edge (a pencil or the edge of a sheet of paper will do) in front of you and line it up with the angle of the wall you are looking at. Keep one eye closed. Commit this angle to memory and quickly transfer it to your support.

FORESHORTENING

We know from our physical experience of the world that a table is rectangular or square, and we tend to draw it as we know it, not as we see it. When drawing objects in perspective you have to learn to draw what you see, not what you know. Compare the two paintings of a chair on these pages. In the first one the chair is viewed from quite a low angle and so the seat is foreshortened

to a narrow shape. In the second painting the chair is viewed from a higher angle and so we can see more of the seat. It is still foreshortened, but it is wider from back to front than in the first painting.

As you draw, make constant comparisons between angles and distances. Use your pencil as a 'measuring tool', holding it up in front of your subject and squinting with one eye. Try drawing the negative shapes around and between the subject as this can help you to see more objectively.

USING DIFFERENT SOURCES

Sometimes you may find that you need to make alterations or additions to a painting in progress. You might, for example, decide that the composition doesn't work as well as you had thought. Or you may have started a painting on location and not been able to finish it due to lack of time or bad weather, and you would like to complete it somehow.

In these situations there is no reason why you should not find an alternative source of visual material and use this as a means of completing your picture. If you look through your sketchbooks you can probably find something to use as reference, or you could even take an element from another picture or from a photograph.

The painting on the opposite page, for

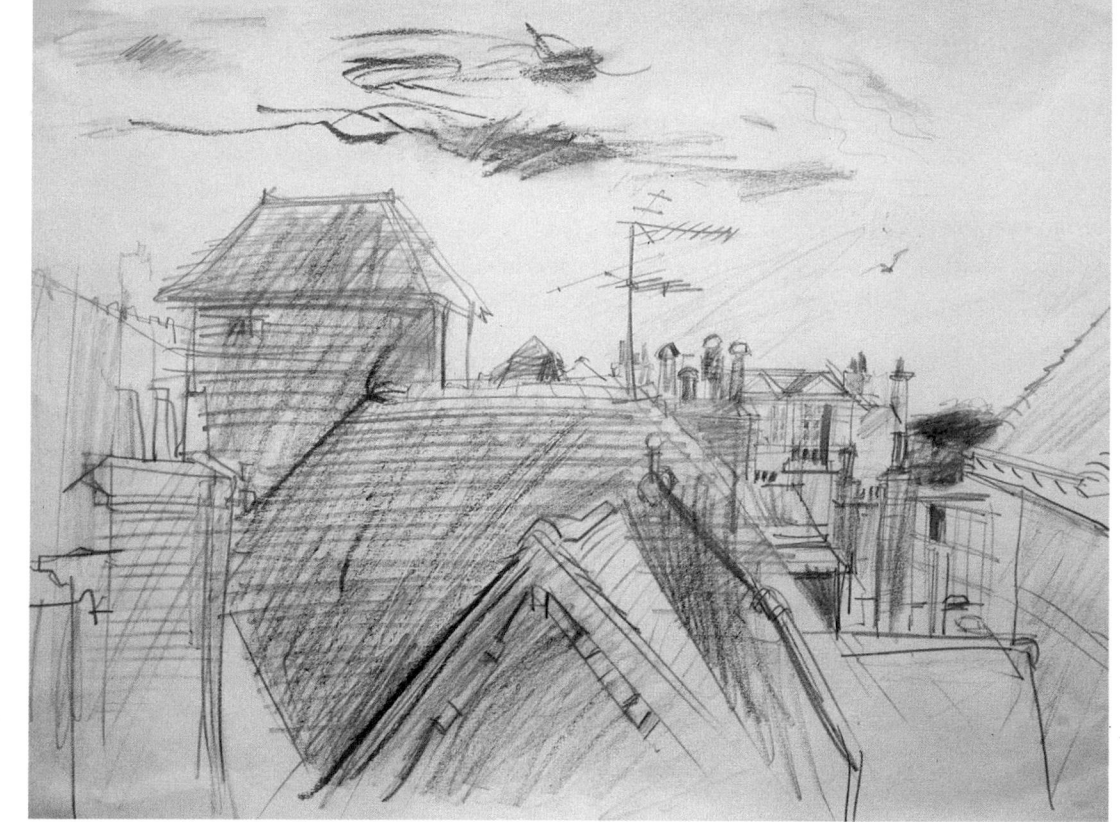

This is the sketch used as reference for the background in the painting opposite. It is a study of the proportions and relationships of the buildings, and actually contains more information than is actually need for the final painted version. Because the view through the window is in the background it needs to be simplified, otherwise it will jump forward in space and destroy the feeling of depth.

example, is actually a composite. The floral still life in the foreground was painted from life, but the original view through the window, of a group of trees, presented too much confused detail that conflicted with the foreground elements. So a bit of artistic licence was used and the background was replaced with a simple view of some buildings and rooftops, based on the sketch

above, which provided a better contrast and was easier to simplify.

If you are in doubt as to whether your composite composition will work, it is advisable to make a final study combining the two elements. You may find the squaring-up technique described on page 64 useful if you need to enlarge your sketch to the same size as the painting.

ROOFTOP VIEW

The rooftop silhouette in the background makes an excellent foil for the foreground elements in this picture. The yellow lilies, lit from behind, stand out against the darker tone of the building and the bright red gladioli stand out against the pale sky. In order to push the buildings back in space, detail is played down, edges are softened and colours are neutralised with blue.

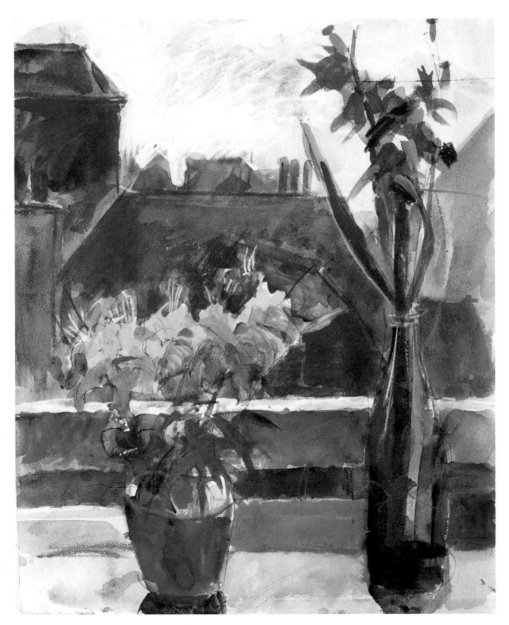

SCALE AND PERSPECTIVE

When you are combining two different visual references in one painting you must obviously make sure that they work together in terms of scale and perspective, and that both elements are seen from the same viewpoint. In this particular case it was a relatively simple exercise to combine the two elements as both are seen from a frontal viewpoint. The buildings work in terms of scale, but they could have been enlarged or reduced so as to either increase or decrease the space between foreground and background.

LIGHT

Another thing you have to watch out for is that the lighting is the same in both reference sources. If the light is coming from the left in your unfinished painting, and from the right in your sketch, there is obviously going to be some confusion! In my picture the light was coming from behind the subject, so I reduced the rooftop view to a near-silhouette. Not only does this tie in with the lighting in the foreground (backlighting tends to flatten forms), it also concentrates our attention on the still life and windowsill instead of competing with it.

INTERIORS

Interiors can make intimate and charming pictures. They inevitably arouse our interest, whether they feature figures or not, since they are spaces inhabited by people. A painting of an empty interior is full of atmosphere and mystery; it begs the question, 'who has just left, or is about to enter that space?' It is like an empty stage set, on which something has just happened or is about to happen.

Even the most unglamorous corner of a room can make a good subject for a painting. The kitchen sink, a dressing-table in front of a window, the inside of an untidy shed, all have their story to tell about the inhabitants of the house.

LIGHTING

Lighting is always an important part of a painting of an interior scene. Whether the light comes from a window or from a source within the room, its quality will help to establish mood and atmosphere as well as creating shadows that help to define form. In my painting of a geranium (right) the light coming from the window throws a shadow of the pot across the table top, which defines its horizontal plane and also anchors the pot to the table. In the paint-

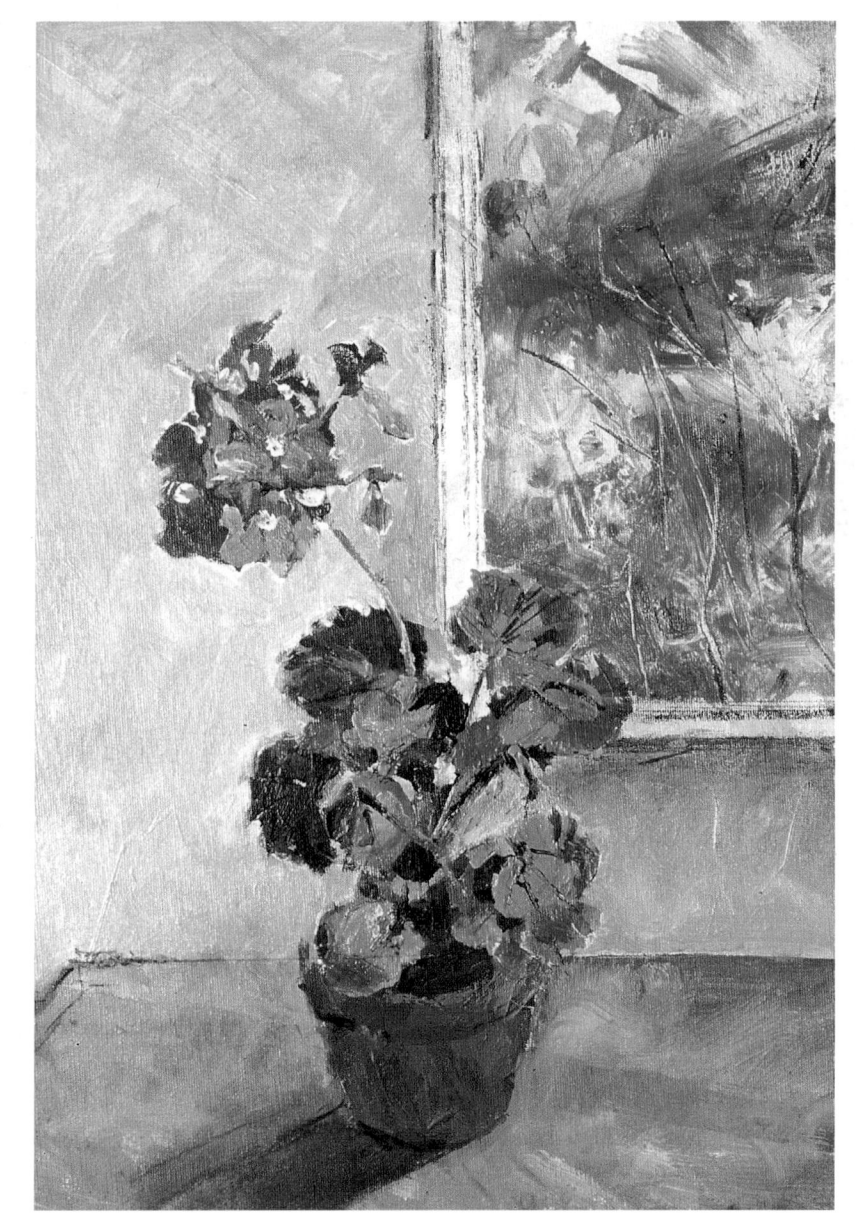

ing on the opposite page the interior is dark and shadowy, creating a quite different atmosphere to the geranium painting.

PAINTING SPACE

Although paintings of interiors often contain still-life motifs, they differ from still-life paintings in that they are concerned with objects within a larger, more noticeable space. Artists use various methods to describe space. One is simply to place one object in front of another so that they overlap. The geranium in the painting here is in front of the window, implying a space between the two. Another way of implying space is through the use of colour. The warm reds and yellow-greens of the geranium come forward, while the cool blue-greens in the background recede back in space. A third way of implying space is to use stronger tones and defined brushstrokes in the foreground, and weaker tones and softer strokes in the background.

GERANIUM IN A POT

In this painting the view through the window provides a 'frame within a frame'. Notice how the tonal contrasts within the geranium are stronger and more defined than those in the background, creating a feeling of spatial recession.

GIRL AT A TABLE

In this picture the girl's gaze is focused on the view through the window, which is implied but not seen. The light comes from outside the room and onto the table, linking inside with outside. Strong directional light makes tonal variations easier to see and this in turn makes form easier to paint. It also creates a strong sense of atmosphere. The background here is simplified with extraneous detail omitted, allowing the focus of the painting to be directed at the sitter.

THE CHURCH YARD

When choosing a subject to paint, always make sure there is one particular visual element within it that has caught your imagination. This will give you an idea to focus on and provide your picture with a centre of interest.

As an artist, whatever your level of experience, your aim should be to interpret the world you see, rather than simply reproducing its likeness in paint. You have to find an equivalent in paint for the actual forms and textures you see. This means that you can have fun with painting, since colours and textures can be re-invented.

The painting in this project is concerned with capturing the essence and character of the ancient stone church. Built centuries ago, its scarred and crumbling facade bears witness to its age and lends it character, just like the face of an old man.

The angles of the tombstones and the triangular shapes in the roof add to the higgledy-piggledy effect. This has been deliberately exaggerated by drawing the verticals at a slight angle. These angular forms, which contrast with the organic shapes of the trees, also give a feeling of dynamism and movement to the picture.

Palette

PAYNE'S GRAY

COBALT BLUE

CERULEAN

RAW UMBER

CADMIUM YELLOW

BURNT SIENNA

VIRIDIAN

TITANIUM WHITE

You will need:
- Canvas board, approx 51x76cm (20x30in)
- Brushes: medium flat, small filbert, small round
- Jar of distilled turpentine
- Charcoal
- Cotton rags

STEP 1

Draw the main outlines of the composition with charcoal. Because the church is viewed from in front, none of the side walls are visible, so you don't have to worry about getting the perspective right. Concentrate instead on capturing the qualities and characteristics of the building. Emphasise the steeply inclined roofs and the imperfect angles of the walls. Suggest the surrounding trees and some of the gravestones in the foreground.

STEP 2

Mix cerulean and a little cobalt blue and block in the sky loosely using a turpsy rag. Mix a range of warm and cool greens using cerulean, cobalt blue and cadmium yellow mixed in various proportions. Start to block in the shapes of the trees, again using a rag. The rag forces you to work in broad, general terms and stops you getting bogged down with detail in the early stages.

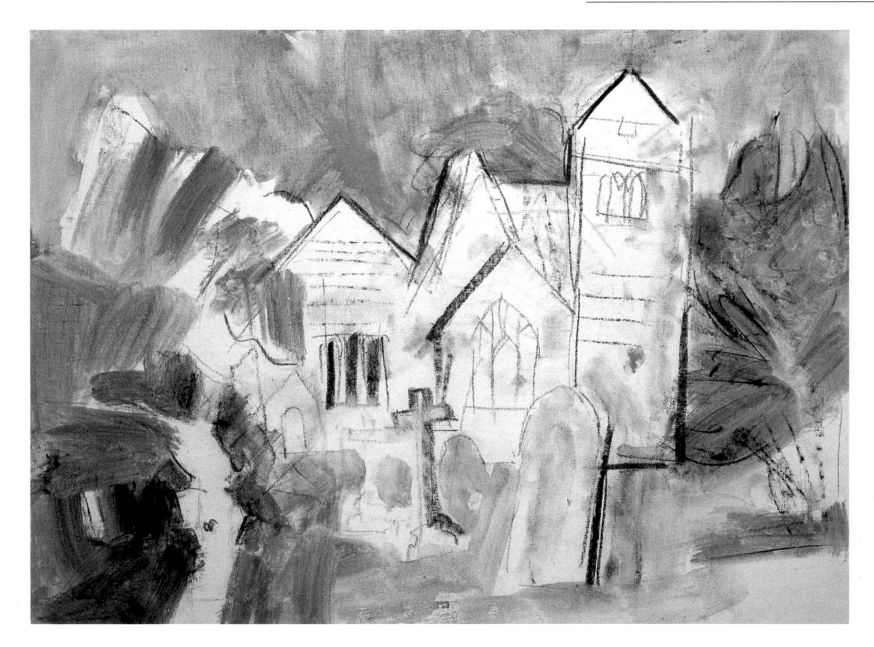

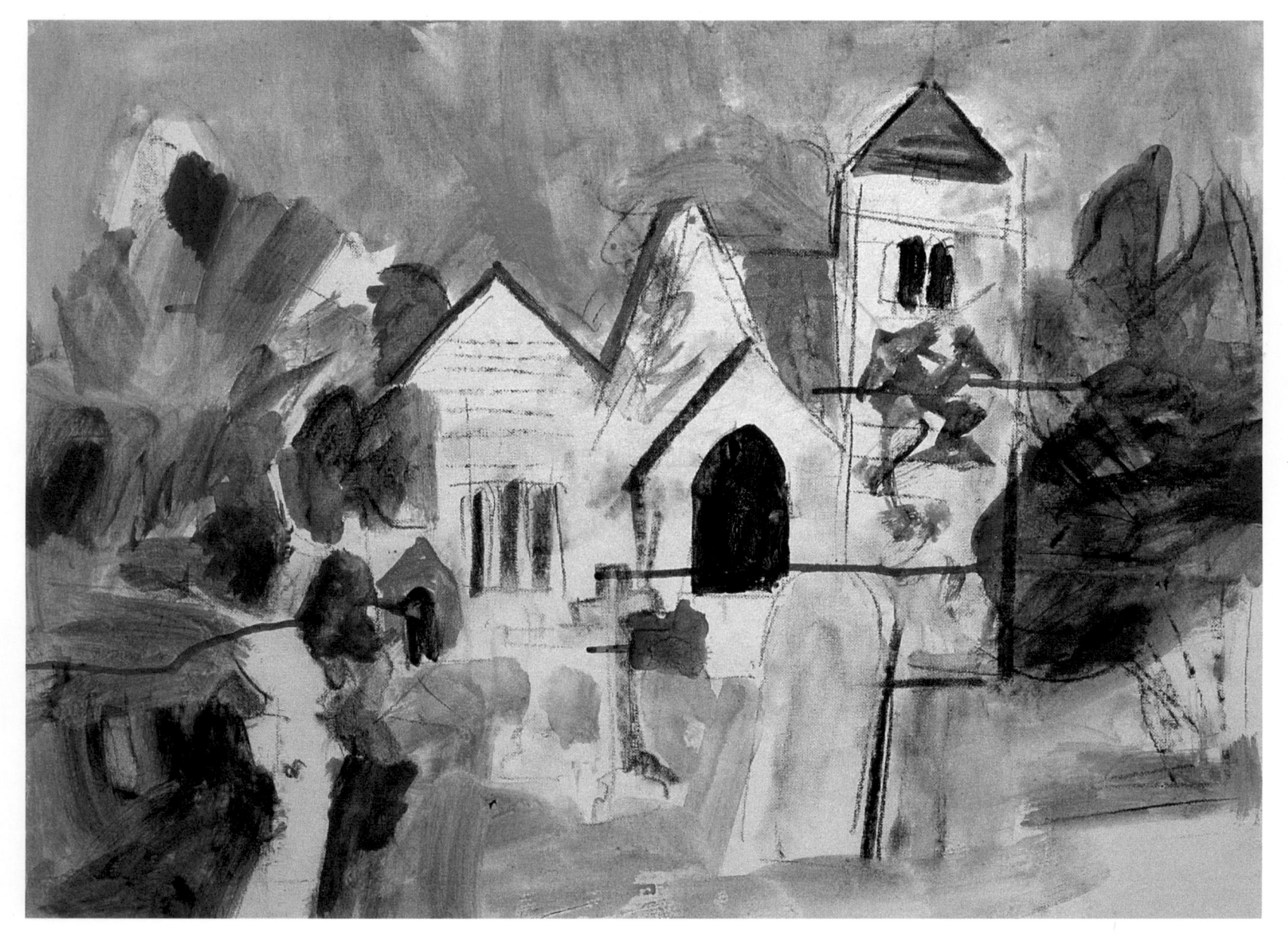

STEP 3

Block in the dark-toned foliage with the rag, adding some Payne's gray to darken the greens. Mix a warm orange from cadmium yellow and burnt sienna and paint the roof tiles using a medium-sized flat brush. Use Payne's gray to indicate the shapes of the windows. The dark tones of the foliage contrast with the light tone of the church. There is already a sense of drama that will be consolidated in the final picture.

STEP 4

Strengthen the dark tone of the tree on the left of the picture using Payne's gray and cobalt blue. This brings it forward in the picture plane and pushes the church into the distance. Make some greys and browns by mixing titanium white with the blues and browns on your palette. Start to suggest the stonework on the church walls with small, angled strokes, using the tip of a small filbert brush.

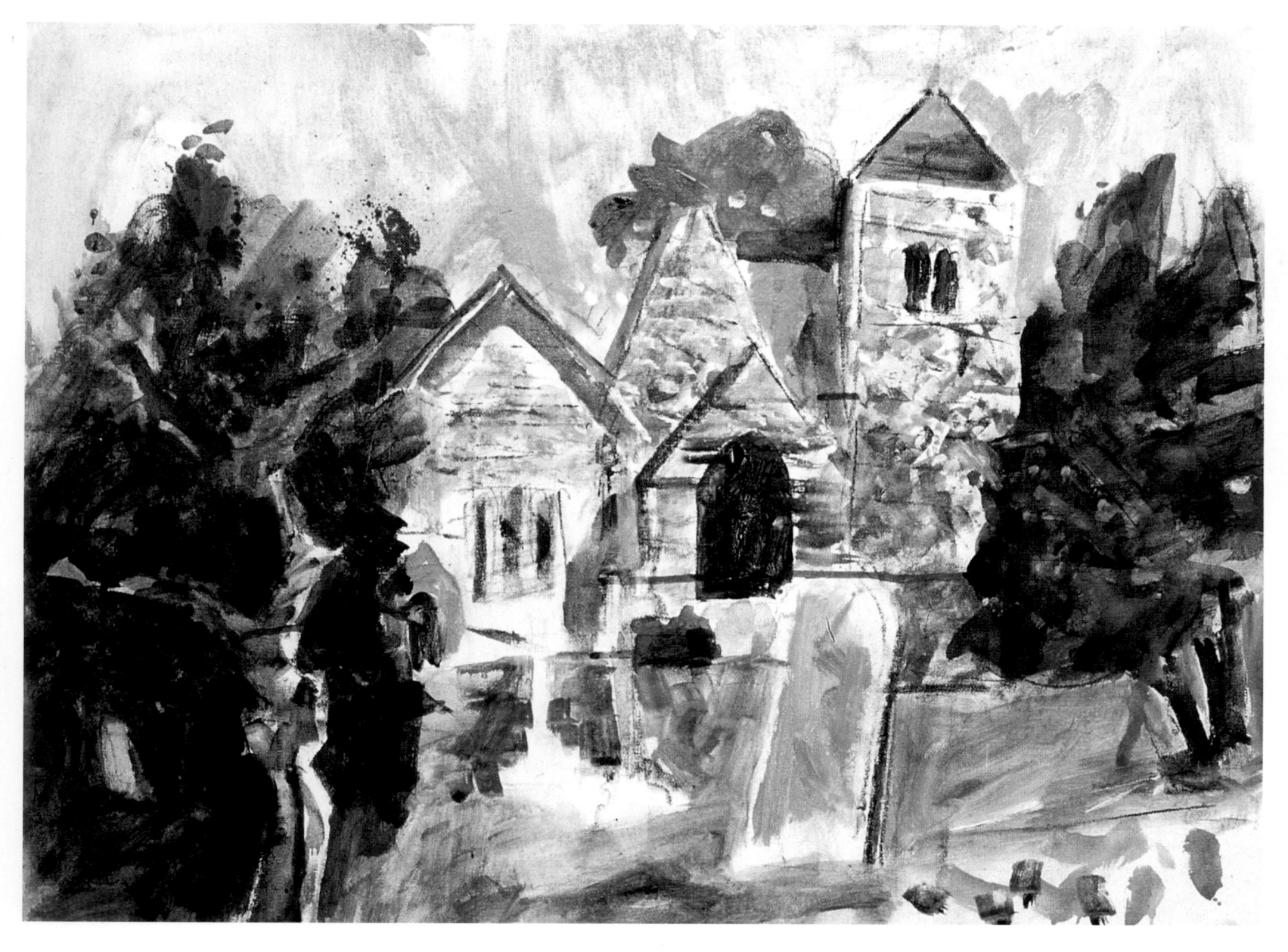

STEP 5

The basic colours and tones have now been laid down and from here it is just a matter of consolidating these and starting to develop texture and detail. Work across the whole painting at once rather than trying to perfect one area at a time, and keep everything quite loose and open at this stage. Add some richer yellow-greens in the foreground.

STEP 6

Now you can work on the finer details using smaller brushes and thicker, richer paint. Add more texture to the roofs and walls of the church. Suggest some clouds in the sky. Strengthen the tones and colours in the trees and grass and block in the shadowy tones of the gravestones.

If you build up the image as a whole, rather than in piece-meal fashion, your finished picture will have a unity and completeness.

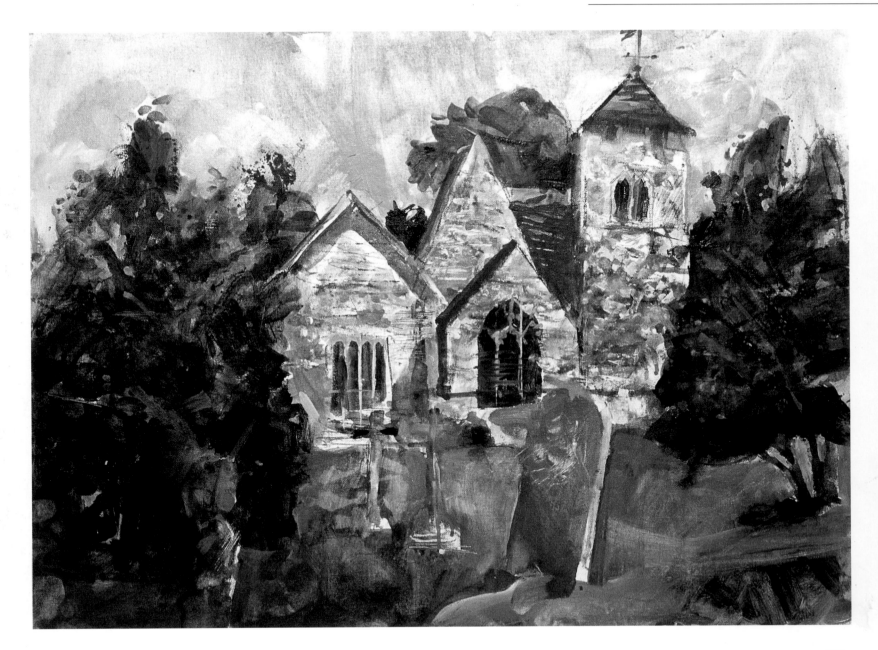

Mixing Media

Although the strong tradition of oil painting often dictates the sequence through which a painting progresses, new materials and a greater freedom in the way they are used mean that artists today are more broad-minded in their approach to making pictures. Combining different techniques and media in the same painting can be very liberating, and will increase your confidence in handling paint.

The only rule to bear in mind when mixing different media with oils is never to apply water-based paints over oil-based paints because they won't adhere. You can, however, use fast-drying water-based acrylics, alkyds, watercolours or gouache to lay the first stages of the painting and then overwork with oils.

Aims

- To discover the potential of new materials
- To experiment with creative techniques
- To learn how to interpret a subject in a personal way instead of merely copying it

OIL BARS AND OIL PASTELS

These are the most compatible materials to use with oil paint because, like oils, they can be easily layered and blended. Oil bars are basically oil paints in stick form and can be used as either a drawing or a painting medium. Colours can be applied in thickly impasted layers, or blended together on the canvas using a brush or a rag dipped in turpentine. Oil pastels, being smaller, can be used for finer, more linear work.

PAINTING AND DRAWING

The contrasting textures created by mixing painting and drawing media can be highly expressive. For example, oil paint, once dry, can be worked over with oil bars, oil pastels, charcoal and graphite pencils to create energetic linear marks that contrast with the broader paint mass.

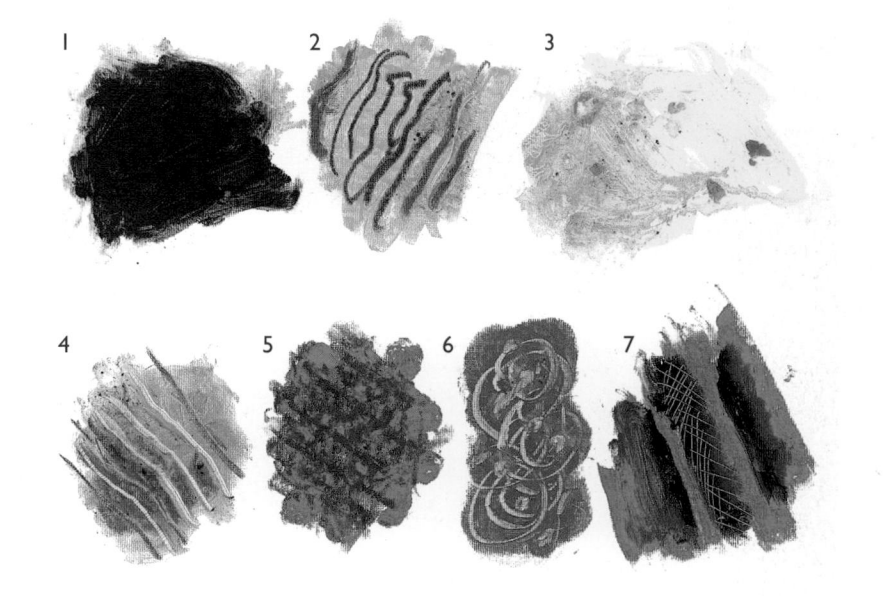

Before you embark on a mixed-media painting, experiment with different techniques and combinations of media on sheets of canvas paper and make notes of which colours and materials you have used.

1 Oil bar rubbed into a quick-drying alkyd medium.
2 Oil pastel overlaid with linear marks in pastel.
3 Oil bar rubbed on vigorously and heavily impastoed in places, overlaid with oil paint thinly diluted with alkyd medium.
4 Oil paint rubbed into the canvas with a turpsy rag, overlaid with light lines scratched out with the end of a brush handle and black charcoal lines.
5 Chalk pastel with red paint finger-printed over the top. Overlaid with black pencil and oil pastel lines.
6 Circular patterns lifted out of wet oil paint using a turpsy rag wrapped round the end of a nail.
7 Orange and blue oil paint partially blended with a rag soaked in turpentine. Lines scratched out with the end of a brush handle to create a sgraffito effect.

LANDSCAPE

This is a moody landscape which uses a broad, energetic attack followed by lighter scribbles and touches applied with oil bars and oil pastels. The advantage of using these media is that they allow you to draw in a vigorous, linear way which is easier to control than working with a brush.

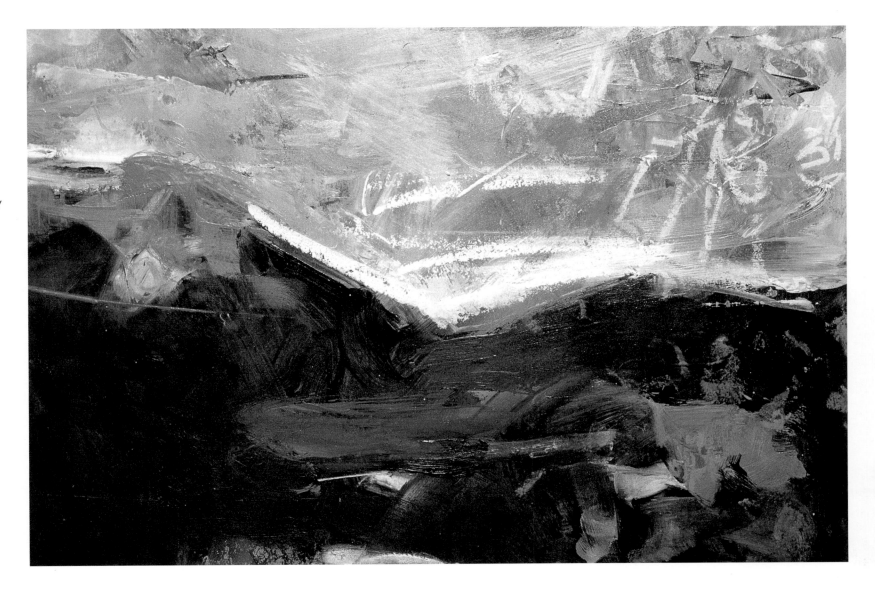

LOBSTER

Since working with mixed media can be so varied in its approach, it is impossible to lay down hard-and-fast rules about what to do and what not to do. I have suggested using a combination of oil paints, oil bars, oil pastels and charcoal for this project, but there are many other possibilities. Only by experimenting will you discover which combination of materials best expresses what you want to say in your paintings.

Using mixed media is often a journey of discovery, and you will be travelling in uncharted territory. The choice of technique, approach, colours and materials is up to you, but do bear in mind that some preliminary planning will be necessary if you are not to end up with an ill-disciplined mess. On the other hand, too much planning can risk losing spontaneity. The best approach is to work out the basic design of the picture, allowing enough latitude to leave you free to incorporate any new ideas that present themselves as the painting develops. It is a good idea to make a preliminary drawing in order to work out the tonal structure of the piece, the direction of the light and the general composition.

When you start painting, remember to work across the whole piece, beginning

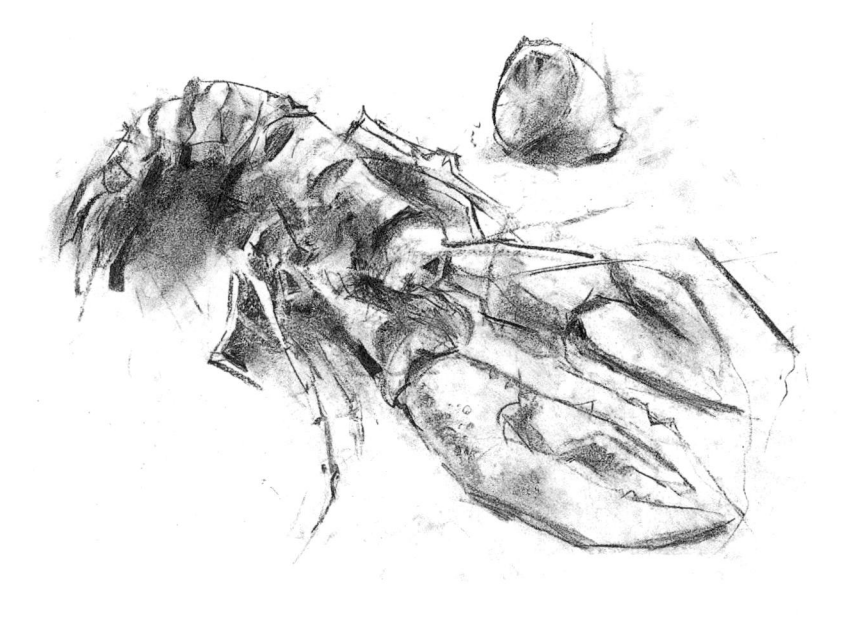

You will need:
- Sheet of canvas paper, 38x51cm (15x20in)
- Brush: large flat bristle
- Sheet of drawing paper
- Charcoal
- Distilled turpentine
- Cotton rags

with broad generalisations and gradually working up to the finer details. You need to keep an overview. Don't be tempted to focus on one particular area exclusively, no matter how seductive or enjoyable it might be, otherwise you will find your

Above
TONAL DRAWING
Before you start working in paint, make a preliminary drawing in charcoal on a large sheet of paper. Charcoal is the perfect medium here, as it is broad, expressive and gives the drawing a generous feel in anticipation of the final piece. Blend the charcoal marks with your finger to create tonal areas and to suggest the shadows underneath the body. Draw the piece of lemon in the background also.

composition becoming disjointed. Every area of a picture has to relate to the rest so that the composition forms a unified whole.

Palette

OIL PAINTS

PAYNE'S GRAY

COBALT BLUE

CADMIUM RED

CADMIUM YELLOW

OIL BARS

FRENCH ULTRAMARINE

CADMIUM RED

CADMIUM YELLOW

OIL PASTELS

BLACK

CRIMSON

BLUE

WHITE

STEP 1

Use a charcoal stick to define the edges and contours of the lobster on the sheet of canvas paper. Make sure your drawing is large enough to fill the sheet. Mix a thin, turpsy wash of Payne's gray and cobalt blue and brush this in all over the background. Use the flat brush for this, applying the paint in broad, fast sweeps and working it in different directions to create a feeling of energy and dynamism. Block in the shape of the lobster with a thin skin of cadmium red oil paint applied with a rag. Add touches of cadmium yellow to the lighter parts of the lobster.

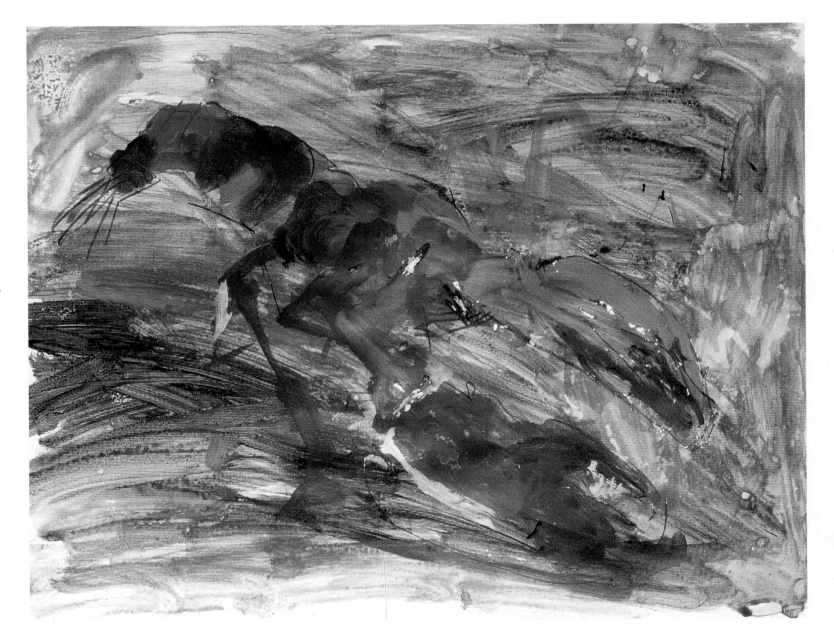

123

STEP 2

Strengthen the colours on the lobster with slightly thicker paint, lightening the colour with white in the lighter parts. Deepen the background colour with more cobalt blue and Payne's gray. Keep working across the whole surface of the picture rather than trying to complete one section at a time. Leave to dry. Use charcoal to define the segments on the lobster's tail, and suggest a cast shadow on the table with hatched lines.

STEP 3

Continue to build up the colour in the background, keeping your brushmarks lively and working the colour right out to the edges of the paper. Use oil bars to add more definition, detail and texture to the lobster and build up stronger, richer colours. Define the feelers and the segments on the body with charcoal lines.

STEP 4

Use cadmium yellow and white oil bars and oil pastels to define the lemon half in the background. This helps to give depth and scale to the image, and introduces a cool, sharp, acidic note that contrasts with the warm blues, reds and oranges in the rest of the picture. Define the lemon's cast shadow with black oil pastel and charcoal. Finally, add more crisp details and highlights on the lobster using oil pastels.

GLOSSARY

aerial perspective (also known as atmospheric perspective) a visual phenomenon in which distant objects and scenery appear paler, bluer and less distinct than foreground objects due to intervening atmospheric haze.

binder a liquid or viscous medium which is mixed with powdered pigment to produce paint.

composition the arrangement of shapes, colours and forms within a picture.

earth colour pigments derived from metal oxides, for example yellow ochre and terre verte.

fat used to describe paint which contains a high oil content (see also *lean*).

ferrule the metal part of a paintbrush that holds the bristles in place.

glazing applying a layer of transparent or semi-transparent colour over another colour to modify it.

grisaille a monochromatic *underpainting*.

ground a surface laid on the *support* to prepare it for oil painting, eg primer or acrylic paint.

impasto paint that is applied thickly to the support to create a textural effect.

lean used to describe paint thinned with turpentine and which therefore has a low oil content (see also *fat*).

linseed oil the binding agent in oil paint. Also a constituent in many oil-painting *mediums*.

linear perspective a system used by artists to record the location of objects within a given space. Based on the law that objects appear smaller the further away they are and that receding parallel lines appear to converge at the same imaginary point on the horizon, the *vanishing point*.

linseed oil the binding agent used in oil paint. Also a constituent in many oil-painting *mediums*.

local colour the actual colour of an object, disregarding the effects of light on it.

medium (1) the binder which is mixed with pigment to form paint, eg linseed oil is the binder in oil paint. **(2)** an additive that is mixed with paint to alter its consistency and handling, eg linseed oil and turpentine. **(3)** the material in which a picture is executed, eg oils, watercolour, pencil, etc.

monochrome a painting undertaken in one colour but with a full range of *tones*.

oil bars oil paints in stick form, made by blending pigments with drying oils and special waxes. Often used in mixed-media work as they are compatible with all painting and drawing media.

oil paint a slow-drying paint in which the pigment is traditionally suspended in linseed oil and which is diluted with turpentine. Also more recently available as a water-mixable paint.

palette surface on which to lay out and mix paints. Also, the range of colours used by an artist.

pigment the colouring substance of painting and drawing media, obtained from natural or man-made sources.

primer a special paint, usually white, that is brushed over an oil-painting *support* to seal the surface and make it more suitable to receive paint. Many types of primer are available, with oil, acrylic or emulsion bases.

scumbling the technique of dragging a thin layer of dryish opaque paint over a bottom layer so that the underlying colour shows through in parts.

size a form of glue used to seal and protect oil-painting supports prior to the application of *primer* and paint.

stretcher the wooden frame over which canvas is stretched to make a *support* for painting.

support the surface on which a painting or drawing is executed.

texture the tactile quality of a paint or the painted surface.

tone the relative light and dark values of a colour.

underpainting the initial blocking in of the main elements of a composition to establish the distribution of tones.

vanishing point in *linear perspective*, the imaginary point on the horizon where receding parallel lines appear to converge.

wash a layer of transparent paint, usually broadly applied.

wet-in-wet applying colours over and into one another while still wet in order to create soft forms or edges.

INDEX